TURNER

LUKE HERRMANN

TURNER

Paintings, Watercolours, Prints & Drawings

PHAIDON · OXFORD

For Mark and Jeremy

Phaidon Press Limited, Littlegate House, St. Ebbe's Street, Oxford OX1 1SQ

First published 1975
Second edition 1986
© Phaidon Press Limited 1975

British Library Cataloguing in Publication Data

Turner, J.M.W.
 Turner: paintings, watercolours prints &
 drawings.—2nd ed.
 1. Turner, J.M.W.
 I. Title II. Herrmann, Luke
 760′.092′4 N6797.T88

 ISBN 0–7148–2420–8

Printed in Spain by Heraclio Fournier, S.A., Vitoria

Contents

Acknowledgements

THE PUBLISHERS are grateful to the following for allowing works in their collections to be reproduced:

Bedford, Cecil Higgins Museum: 39,80; Birmingham City Art Gallery: 101; Boston, Museum of Fine Arts: 148; Bury Art Gallery, Lancashire: 110; Cardiff, National Museum of Wales: 19; Cleveland Museum of Art, Ohio: 133; Edinburgh, The National Gallery of Scotland: 63, 149; Farnley Hall, Yorkshire, G.N. Le G. Horton-Fawkes: 70; Glasgow Art Gallery: 154; Indianapolis, Museum of Art: 3, 23, 71, 73, 119, 172; Lisbon, Calouste Gulbenkian Foundation: 32; Liverpool, Walker Art Gallery: 24, 160, 183; Lockinge, Berkshire, Christopher Loyd: 66; London, British Museum: 2, 9, 17, 25, 26, 29, 36, 37, 46, 47, 48, 50, 51, 59, 82, 87, 88, 91, 95, 96, 97, 98, 99, 100, 102, 103, 105, 112, 114, 115, 116, 129, 130, 131, 132, 135, 166, 167, 170, 171, 184, 185, 186, 187, 189, 190; London, Courtauld Institute of Art, University of London: 14, 60, 74, 104, 171; London, The Iveagh Bequest, Kenwood: 31, 85; London, National Gallery: 11, 27, 30, 77, 106, 107, 142, 146, 175; London, Royal Academy of Arts: 22; London, Tate Gallery: 1, 10, 18, 20, 21, 33, 34, 43, 44, 52, 53, 55, 56, 57, 58, 72, 78, 81, 83, 84, 89, 90, 108, 109, 118, 120, 121, 122, 124, 125, 126, 127, 134, 136, 137, 140, 144, 145, 147, 150, 151, 153, 155, 156, 158, 161, 164, 165, 170, 173, 174, 176, 177, 178, 180, 181; London, Victoria and Albert Museum: 15, 44, 138, 157; Manchester, Whitworth Art Gallery, University of Manchester: 16, 61; New Haven, Yale Center for British Art, Paul Mellon Collection: 38, 69, 86, 139; New York, Frick Collection: 94, 117; Oxford, Ashmolean Museum: 5, 6, 7, 8, 12, 35, 67, 68, 75, 76, 92, 111, 113, 162, 163; Petworth House, Sussex: 42, 45, 54, 62, 64, 123, 128; Philadelphia Museum of Art: 141; Private Collections: 40, 168, 169; Reading, Ruskin Collection, University of Reading: 4; Sheffield, Graves Art Gallery: 41; The Toledo Museum of Art, Ohio: 159; Toronto, University of Toronto: 28; Washington, National Gallery of Art: 143; Windsor Castle, Her Majesty Queen Elizabeth II: 13.

Foreword

THE ILLUSTRATIONS form the core of this book. They have been chosen to provide a balanced visual survey of the work of Turner; at the time of writing this book provides the largest body of illustrations of his work yet published. Turner was one of the most prolific and varied artists that the world has known, and to achieve such a survey within the limitation of 190 plates was not easy. But Turner is an artist, as he himself was the first to realise, who must be looked at as 'a whole'. The plates are supported by the *Introduction*, which can be read as a running commentary on them, though in itself it furnishes a chronological account of the life and work of Turner. The essential 'catalogue' information relating to each work reproduced is given in the caption, and, where relevant, further points and references are to be found in the *Notes on the Plates*. The basic facts about Turner can be found in the *Biographical Outline*, while the selection of *Contemporary Reviews and Comments* will give the reader a fuller idea of the artist's character and reputation.

The sources of most of this material can be found in the *Bibliography*. It is at this point that I must acknowledge my indebtedness to all previous writers on Turner, notably, among my predecessors, A. J. Finberg, and, among my contemporaries, John Gage. I also owe much to those curators and private collectors in Britain and the United States who have assisted me in my studies of the art of Turner, many of whom have now generously granted permission for works in their museum or collection to be reproduced in this book. In the case of several items from private collections Evelyn Joll was instrumental in obtaining reproduction permission and providing photographs.

The illustrations for this book had been chosen and the bulk of the text written some months before the opening of the great Turner Bi-Centenary Exhibition at the Royal Academy in November 1974. Selected and organised by Martin Butlin, John Gage and Andrew Wilton, this presented a much larger survey of Turner than the present work could hope to do. However, the two surveys coincide at numerous points, especially in closing with a retrospective section devoted to Turner's depiction of Norham Castle on the Tweed. In the final stages of writing *Turner* I have been considerably stimulated by the Exhibition and its *Catalogue*, though they in no way affected the overall conception and realisation of my book. It has been most encouraging for a confirmed addict of Turner that the Exhibition has opened the eyes of a vast public to the wealth of treasure in the Turner Bequest. That paintings, drawings and prints have been available for study under the same roof has been especially welcomed by those who hitherto have had no idea of the unity of Turner's work. For nearly a century the housing of the Turner Bequest was a matter of recurring controversy, but in recent decades the present arrangements have been taken for granted. There is now again hope that a permanent Turner Gallery may at last become a reality; only then can full advantage be taken of the artist's unique gift to the Nation.

This book owes much to a number of people at the Phaidon Press. Keith Roberts initiated the book and guided it skilfully through its early stages. Virginia Chapman devoted considerable time and energy to obtaining photographs and reproduction permissions. Susan Waterston has been a helpful and perceptive editor, and Jean-Claude Peissel an ideal designer who seemed to 'take naturally' to Turner. To all these I am immensely grateful. I must also thank Phyl Walker, who did the typing with great efficiency, though usually working against the clock. My final debt of gratitude is to my wife, Georgina, who exercised her editorial skills to excellent effect, even though, in this case, the author was prone to growl at her.

Clipston, 31 December 1974. L.H.

Foreword to the Second Edition

This book was first published in 1975 to coincide with the bi-centenary of Turner's birth. In the decade since there have been great advances in the appreciation and study of Turner, and his work has reached the highest prices on the art market. It is good to report that by the time of Turner's 212th birthday (23 April 1987) the new Clore Gallery for the Turner Collections will be open at the Tate Gallery.

The final item of the *Bibliography* in this book is the Catalogue of the 1975 R.A. Turner Exhibition. Among the outstanding contributions to the copious literature published since then is the work of two of the scholars responsible for that exhibition, Martin Butlin and Andrew Wilton. With Evelyn Joll, the former has compiled *The Paintings of J. M. W. Turner* (1977), an exemplary *catalogue raisonné* (revised edition: 1984). Andrew Wilton included a pioneering Catalogue of Watercolours in his *The Life and Work of J. M. W. Turner* (1979), and is the author of several other books and exhibition catalogues, including *Turner and the Sublime* (1980) and *Turner in Wales* (1984). There have been many other Turner exhibitions in the last ten years.

In 1975 a group of enthusiasts founded the Turner Society, a lively meeting point for all lovers of the artist. 1981 saw the launching of the journal *Turner Studies*, which twice a year publishes articles, notes and reviews on Turner and his contemporaries. The present book appears almost exactly as it did in 1975, and has not been updated to keep abreast with the intervening Turner studies outlined above.

The Coombes, September 1985. L.H.

Introduction

TURNER WAS BORN IN LONDON, where he lived all his life. He was exceptionally endowed with the cockney qualities of curiosity and forthrightness. To these were added outstanding powers of observation, assimilation and expression. It was the combination of all these gifts that made him one of the most exciting and original of British artists. It is often the fate of a pioneering artist to be ignored in his own time and to achieve little material success. There was no period in Turner's long career of sixty years when he was not making money, and during the last fifty he was generally regarded by the majority of his fellow artists and by many critics and connoisseurs as the leading British painter of the day. During the final twenty years of his life he enjoyed acclaim throughout Europe, and since his death he has never lost his place on the list of Europe's greatest artists. What Shakespeare is in the realm of British literature, Turner is in the realm of art.

Both these great Englishmen were born on St. George's Day, 23 April. The year of Turner's birth was 1775; the American War of Independence had just begun, and the Royal Academy in London under the Presidency of Sir Joshua Reynolds was only seven years old. When Turner died, at the close of 1851, Napoleon III was seizing power in France, the Great Exhibition had taken place, and Sir Charles Eastlake had recently been elected the sixth President of the Royal Academy. In the year of Turner's birth the Norwich coach was waylaid in Epping Forest by seven highwaymen; by the time of his death the chief main lines of the modern railway system of England had been largely completed or authorised. In every sphere Turner's life-span was a period of tremendous change and development, and he is the only British painter of the time whose work truly reflected the spirit of progress of these years. In art the normal tendency was to look back to the past rather than to create a style in keeping with the advances in other fields; to this tendency Turner's work in the last twenty-five years of his life was a notable exception. Another such exception was, of course, John Constable (1776–1837), but in retrospect his advances in landscape painting appear more insular and limited than those of Turner. Constable's work exerted a strong influence on contemporary artists in Britain and France, which Turner's painting did not do, because it was too advanced and individual. On the other hand Constable never travelled abroad and even travelled relatively little in the British Isles, while Turner visited and drew in most counties of England, Wales and Scotland, and made numerous journeys on the Continent.

We do not really know Turner as a man, because both at home and abroad he kept himself very much to himself. Though he is two centuries closer to our own time the unresolved mysteries of his life are almost as great as those in the life of Shakespeare. Turner's withdrawn and introspective character is reflected in the obscurity of his

own poetry and other writing, which usually add to the mystery rather than helping to resolve it. The same is true of much of his painting, especially in the second half of his working life. Many of his later exhibition canvases elude interpretation in anything other than abstract visual terms. There are also several phases in his development as an artist which defy confident dating and assessment, while in the explanation of matters of technique numerous paintings and drawings by Turner continue to defeat the experts. All these negative elements in the study of Turner are outweighed by the fact that the majority of his paintings and drawings provide sufficient visual pleasure and satisfaction to ensure our appreciation. This was the case in his own day when the much publicized adverse criticism was more than equalled by the writing of critics who were inclined to praise, though they too were often puzzled by what they had seen.

In modern times appreciation of Turner's work has changed quite considerably from generation to generation. It is only in relatively recent years that his late work, including the 'unfinished' canvases and watercolours not intended for exhibition or sale, has come to be valued as highly as the more traditional earlier Turner. For a time this change took place at the expense of the popularity of such earlier work, but today we have, perhaps, reached a stage when the art of Turner is looked at as a whole — a whole in which each phase of development plays an essential part. This is how Turner himself regarded his art and wanted it to be judged by posterity. Hence his elaborate plans, including the buying back of crucial canvases, for a Turner Gallery. These plans have never been fulfilled, but as more and more of the Turner Bequest becomes known to the public an all-round picture of Turner is at last a possibility. It is the aim of the present volume to provide such a picture in miniature, and every effort has been made to strike a balance between all the phases of Turner's output in all media.

Despite his greatness it is possible to be critical of Turner in a way that is not usually practised in relation to other great artists, such as Raphael or Rembrandt. Thus much has been made of Turner's apparent difficulties in drawing or painting human figures and animals. On rare occasions Turner succeeded in overcoming this weakness in a conventional way; on others he achieved convincing abstractions. He was no doubt aware of this weakness, but would not allow his art to be limited by it. As the variety of his subject matter shows Turner was far more than just a landscape painter. Apart from portraiture he tackled almost every aspect of painting known in his day, and in all of them he found material to enrich his art. The 'all-round' qualities of Turner's art have been too little appreciated, but such appreciation is essential if he is to be considered as a whole.

Turner's success as an all-round painter was based on two factors; his close study and recording of nature on the one hand, and his deep knowledge and understanding of the painting and drawing of earlier and contemporary artists on the other. These two factors, combined with his incredible visual memory and his inexhaustible imagination, lie at the heart of all his own work. It is the interaction between them that leads to the extraordinary dichotomy between the traditional and the revolutionary that is found in so much of Turner's work.

Turner's artistic training and early work were, however, wholly traditional. Warmly encouraged by his father, a Covent Garden barber, Turner had already been drawing for several years when he became a student at the Royal Academy Schools late in 1789. At about the same time he was also taking lessons from one of the leading architectural draughtsmen of the day, Thomas Malton, whose influence is much in evidence in works such as *The Pantheon, the Morning after the Fire*, which is signed and dated 1792 (Plate 9). He exhibited his first watercolour at the Royal Academy in 1790; this is a somewhat crude view of *The Archbishop's Palace, Lambeth*, in which, however, the young artist has mastered the complex problems of perspective which he set himself. In the Lambeth drawing the influence of Paul Sandby (Plate 13) can be traced; other artists to whom Turner looked at this time were J. R. Cozens and Edward Dayes. By adopting the standards established by such men, which had recently made the watercolour school a major element of English art, he quickly developed as a topographical watercolour artist of exceptional ability. In the 1790s Turner undertook sketching tours in many parts of Britain, and in the second half of the decade he already had more commissions for drawings of specific views and places than he could cope with, while he was also beginning to work for the engravers. Thus the pleasant view of *Chepstow Castle* (Plate 14) was engraved for the *Copper-Plate Magazine* in 1794.

At this time Turner was on very friendly terms with Thomas Girtin, his senior by only two months, who had also achieved a leading position among the topographical artists of the day (Plate 15). Girtin and Turner were often together in the winter evenings in London, working for Dr. Thomas Monro, who employed them to make copies of drawings by J. R. Cozens and others (Plate 16). In such copies and in other drawings of these years their work is often virtually indistinguishable; if it were not in one of Turner's sketch-books, such a study as '*Nunwell and Brading from Bembridge Mill*' (Plate 17) could well be mistaken for the work of Girtin. It is often said that in the later 1790s Girtin made greater progress in the development of watercolours than Turner, but at their best Turner's drawings of these years, such as the elegant *Transept of Tintern Abbey* (Plate 8), certainly equalled those of his friend. But while Girtin was content to devote himself entirely to watercolours for the rest of his tragically short life

(he died in 1802), Turner also began to paint in oils. He was the more ambitious of the two, and he knew that he could only achieve the much coveted membership of the Royal Academy by exhibiting oil paintings; he showed his first, *Fishermen at Sea* (Plate 18), in 1796.

Apart from the work of the watercolour artists there was no strong current style in English landscape painting in the closing years of the eighteenth century. Thus for his oil painting Turner had to seek inspiration from earlier masters. At first he looked to such seventeenth-century Dutch marine artists as the Van de Veldes (see Plate 30) and Aert van der Neer, then to the first of the great British landscape painters, Richard Wilson, who had died in 1782, and finally, through the example of Wilson, to the leading artists of the classical landscape tradition, Claude and Poussin. Turner was never strongly influenced by the landscape painting of Thomas Gainsborough or his precursor Rubens, though he owed much to the similarly atmospheric landscape compositions of Salvator Rosa and Rembrandt. Rembrandt's influence may be detected in one of Turner's greatest early watercolours, the richly lit and evocative interior of *Ewenny Priory* (Plate 19), which he exhibited at the Academy in 1797.

Turner's early concern with the depiction of atmosphere is seen again in one of the four oil paintings that he showed in 1798, *Buttermere Lake with Part of Cromackwater, Cumberland, a Shower* (Plate 10). Each of the four paintings and one of the watercolours exhibited that year has an indication of time of day, season or weather in its title, and such indications were to be a constant feature of Turner's catalogue entries. In *Buttermere Lake* Turner has made full use of his powers of observation in the presentation of an English scene which he had visited, and recorded in his sketch-book, in 1797; in *Aeneas and the Sibyl, Lake Avernus* (Plate 20) which was also painted in about 1798, he has relied on another artist's drawing and on his imagination in effectively depicting an Italian scene some twenty years before his first visit to Italy. Here the influence of Richard Wilson is paramount (see Plate 21), and it is to be found again in the *Dolbadern Castle* (Plate 22), which Turner exhibited in 1800. In this emotive painting of a gaunt ruin in North Wales we witness the development from the picturesque qualities of works such as *Chepstow Castle* and *Buttermere Lake* to a vision that is already truly romantic. That quality is even more strongly displayed in Turner's first exhibited historical painting, *The Fifth Plague of Egypt* (actually the Seventh Plague), which was also shown in 1800 (Plate 23). Here again there are echoes of Wilson, but the most positive influence is that of Poussin.

The Fifth Plague was bought by William Beckford, the builder of Fonthill Abbey, of which Turner made a series of large watercolour drawings, four of which were also shown at the Academy of 1800. Turner's watercolours continued to be much in

demand, both with patrons like Beckford and Sir Richard Colt Hoare of Stourhead, and with engravers and publishers, such as the Oxford University Press, who commissioned the first two of ten drawings for the headpieces of the *Oxford Almanack* in 1798. The first of these drawings, *South View of Christ Church, &c. from the Meadows* (Plate 12) was engraved in 1799. It shows Turner at the height of his powers as a topographical artist. His ability to use watercolour in even more ambitious ways was displayed by such forceful compositions as *Pembroke Castle, South Wales: Thunder Storm approaching* (Plate 28), shown at the R.A. in 1801, and *The Fall of the Clyde, Lanarkshire: Noon* (Plate 24), exhibited in 1802. In these relatively large works Turner is clearly trying to achieve the impact of an oil painting in the less respected medium of watercolour. He also continued to use watercolour in a more natural manner in on-the-spot studies like *Edinburgh from St. Margaret's Loch* (Plate 25), a page in one of the sketch-books used on his visit to Scotland in 1801.

A series of vivid studies made on the Scottish coast was probably to hand when Turner was at work on one of his first mature marine compositions, *Fishermen upon a Lee-Shore, in squally Weather* (Plate 31). He showed this in 1802, the year in which he was elected a full member of the Royal Academy, only two and a quarter years after he had been made an Associate. It will be remembered that his first exhibited oil painting was a sea-scape; the sea in all its moods was to remain one of Turner's most constant and fruitful themes. He found in it an absorbing subject for study; in addition to numerous Scottish shore sketches he filled two small sketch-books with pencil, pen and ink, and occasionally wash, drawings specifically connected with *Fishermen on a Lee-Shore*, such as that reproduced here as Plate 29. The best known major marine painting of the first decade of the century is *Calais Pier, with French Poissards preparing for Sea: an English Packet arriving* (Plate 11), which was exhibited in 1803. This, like *Fishermen on a Lee-Shore*, is concerned with an ordinary, albeit dramatic, occurrence at sea, which Turner himself had experienced at the end of his first crossing of the Channel in 1802, as opposed to the more traditional subject matter, in the Dutch manner, of the sea paintings that immediately preceded these, such as "The Bridgewater Sea-piece" of 1801. In these paintings of real happenings at sea, which culminated in the *Wreck of a Transport Ship* (Plate 32), painted in about 1807 and now in Lisbon, Turner shows his preoccupation with achieving vivid effects of light and atmosphere—raging sea and stormy sky are linked by the play of light on the boats and figures. In striking contrast with such dramatic scenes but equally atmospheric in its effect, is the calm of *Sun rising through Vapour: Fishermen cleaning and selling Fish* (Plate 27), which was exhibited in 1807.

In the summer after his election to the Academy Turner took advantage of the Peace of Amiens and made his first tour abroad, spending some five months in France

and Switzerland. He was particularly inspired by the Swiss mountains; here he was in the midst of that grandeur and scale which his increasingly romantic outlook demanded. During this tour he used six sketch-books, in the largest of which he made several studies which he coloured (probably at his inn in the evening) such as the *Mer de Glace, Chamonix* and *The Old Devil's Bridge, St. Gothard* (reproduced as Plates 37 and 36). Here again Turner had moved away from recording topography and was preoccupied with achieving specific effects of light and tone. He used these studies to work up some of the most spectacular subjects for large exhibition watercolours. Despite their scale and degree of finish these achieve a remarkable feeling of immediacy; in *The Mer de Glace and Source of the Arveyron, Chamonix* (Plate 38) there is a sense of movement in the weather and the trees as there would be on a stormy day in the mountains. This is rendered by the skilful use of the pen or point of the brush, while the high-lights—the snow, the clouds and the goats—are achieved by leaving the white paper bare and by scratching out (scraping away the pigment to reveal the paper where a highlight is desired). Such a watercolour as *The Mer de Glace* demonstrates Turner's experimental methods, which were always most strongly brought out in his work when he was faced with a fresh experience, such as his first visit to the Alps. These same experimental methods were used to equal effect in *The Great Falls of the Reichenbach* (Plate 39), which was probably among the works shown by Turner in 1804 at the first exhibition in his own gallery, which had just been completed in Harley Street.

For his first oil paintings of the continental scenery Turner chose more placid subjects than for his watercolours. *Bonneville, Savoy, with Mont Blanc* (Plate 40), one of two versions of this scene exhibited at the Royal Academy in 1803, contrasts the dominating grandeur of the mountains with the quiet scenery at their base. The composition has strong 'classical' characteristics, and reflects the influence of such classical landscape painters as Poussin and Gaspard Dughet, whose work he studied in the Louvre on his return journey from Switzerland. While in Paris Turner spent much of his time in the galleries, making copious and detailed notes in two sketch-books in which he concentrated especially on matters of colour and light. Though these notes do not include any reference to the work of Claude it is most probable that he studied that master's canvases while in the Louvre. The impact of Claude, who was, of course, exceptionally well represented in British collections (see Plates 42, 79), is seen in another of Turner's 1803 exhibits, *The Festival upon the Opening of the Vintage at Macon* (Plate 41), a traditional 'historical' landscape distinguished by its magnificent rolling distance. The fifth canvas shown by Turner in 1803 is different again, and leans heavily on the example of Titian, whose work was particularly well represented in the

Louvre in 1802. This was the *Holy Family* (Plate 43), which one fellow-artist, Fuseli, called 'the blot of a great master of colouring'.

Understandably the majority of artists and critics were puzzled by the diversity of Turner's contribution to the 1803 exhibition, five canvases and two watercolours, of which five are reproduced here (Plates 11, 38, 40, 41, 43). This was the first exhibition for which he had been able to prepare properly since his election as an R.A., and the choice of works which he showed was certainly a deliberate one. The *Calais Pier* and the two watercolours illustrated his advances and aims in two aspects of his work already familiar to the public; the remaining canvases announced his ambition to rival the achievements and reputations of some of the greatest old masters. Turner was just twenty-eight when the exhibition opened, but his work was discussed, however critically by some, as that of an established master. In one paper it was reported that he had 'so much debauched the taste of the young artists in this country by the empirical novelty of his style of painting that a humorous critic gave him the title of *over-Turner*'.

Turner's first tour abroad had an immense effect on his work, but because of the continuing war he was not able to repeat the experience until 1817. It seems that he was not tempted to recommence his lengthy sketching tours in the British Isles and now undertook longer journeys only when commissions for paintings of specific houses were involved. In 1806 and 1807 he exhibited several canvases of scenes on the Thames, and the evocative painting of *Windsor Castle from the Thames* (Plate 45) is thought to date from about this time, though a date of about 1812 has also been proposed for it. In its execution as well as in its mood this formalised view of Windsor has much in common with *The Goddess of Discord choosing the Apple of Contention in the Garden of Hesperides* (Plate 44), which Turner showed at the first exhibition of the British Institution in 1806. In the bold masses that feature in both compositions the influence of Poussin can again be seen, and even the preparatory study for the *Windsor Castle* (Plate 46) has a peculiarly seventeenth-century feeling about it.

This comes as no surprise when it is remembered that in 1806 Turner launched on an enterprise which was his most obvious imitation of a seventeenth-century precedent. This was the *Liber Studiorum*, a series of engravings of which the first Part of five plates was issued in June, 1807, the fourteenth and final Part was published in 1819, making a total of 71 published plates in all. The conception and the execution were based on Claude Lorrain's *Liber Veritatis*. That book of drawings, which is now in the British Museum, was begun by Claude in about 1635 and continued until the year of his death; in it he made careful copies of his paintings in order to combat forgeries and imitations. The book reached the Devonshire Collection (where Turner may well have seen it) quite early in the eighteenth century, and achieved widespread renown with the

1. *(opposite) Self-portrait.*
 c. 1798.
 Oil on canvas;
 $29\frac{1}{4} \times 23$ in.
 (742×584 mm.)
 London, Tate Gallery.

publication of Thomas Earlom's striking engravings after all the drawings in the 1770s.

The drawings for the *Liber Studiorum* plates are usually in pen and brown ink and wash, and are often close to those of Claude both in feeling and execution, as can be seen in *Isleworth* (Plate 47), which dates from about 1815. From that drawing Turner executed an etching (Plate 48), which was then engraved in mezzotint by H. Dawe (Plate 49) and issued in 1819 in Part XIII of the *Liber*. The process from drawing to engraving can be studied again in the series of reproductions of works depicting Norham Castle (Plates 187, 188). As in the case of the *Isleworth* the majority of the plates were etched by Turner himself, and he also closely supervised the work of the engravers who completed the plates, many of which he published himself. Thus this series was very much Turner's own work, and differs from most of the other engravings after his paintings and drawings, for which he simply provided the originals.

It was planned that the *Liber* should have a total of 100 plates, but it was never completed. The series was divided into a number of classifications such as 'Mountains', 'Pastoral' and 'History', and the compositions range from country scenes in the manner of George Morland to landscapes in the grandest Claudian vein. Turner's aim was to display his mastery and versatility in the most popular traditional and contemporary modes of landscape and marine painting. This policy was clearly demonstrated by the five plates of the first part, which consisted of a simple pastoral scene, *Bridge and Cows*; a Claudian classical landscape, *The Woman and Tambourine*; an atmospheric shore scene, *Scene on the French Coast*; a townscape, *Basle*, and an historical landscape, *Jason* (of which he had exhibited a painting in 1802).

While the work connected with the *Liber Studiorum* was somewhat reprospective in character Turner was not neglecting that search for new material which was essential to the development of his art. As usual this advance is to be seen first in his drawings; in this case confident watercolour studies in a large roll sketch-book, drawn on the spot at various points in the Thames Valley. One of these, *Scene on the Thames* (Plate 50) illustrates his preoccupation with problems of masses and light. The watercolour has been applied with a dry brush in a technique close to that of oil painting, and it comes as no surprise to find Turner making similar studies in oils on paper at about the same time. There is a small group of these in the Turner Bequest, which includes the *Chevening Park, Kent* (Plate 51) with its lovely evening atmosphere. These studies probably preceded the well-known series of 'pure' landscape sketches in oils on thin board, of scenes on the River Thames between Walton and Windsor, and on the smaller River Wey, a tributary of the Thames. Many of them, such as *The Thames near Walton Bridges* (Plate 33) appear to be taken from a boat—on board which, as a keen angler,

16

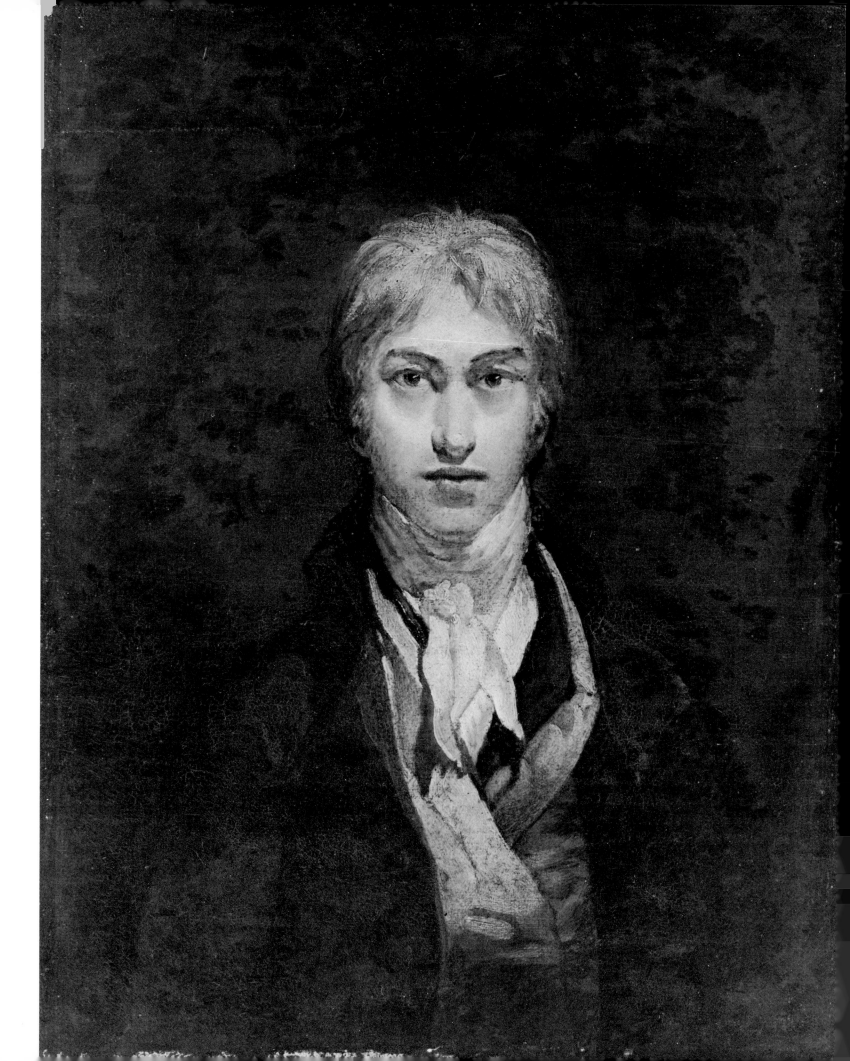

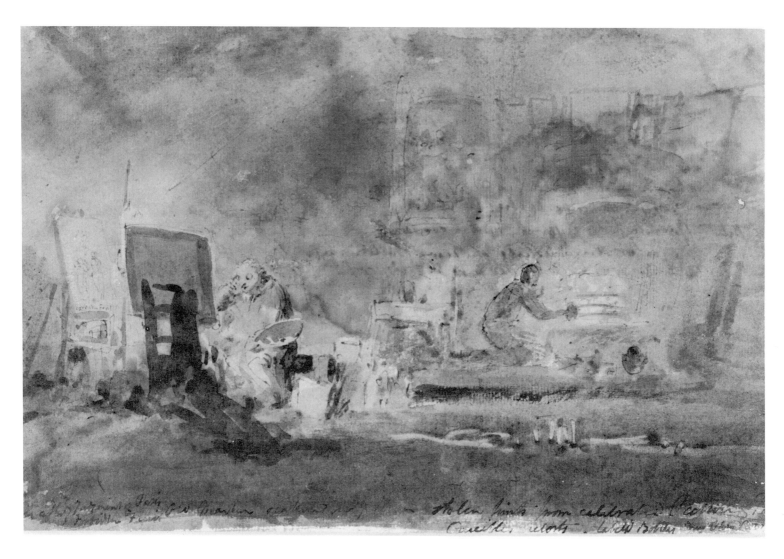

2. *The Artist's Studio. c.* 1808.
 Pen and ink and watercolour;
 $7\frac{1}{4} \times 11\frac{3}{4}$ in. (184×299 mm.)
 London, British Museum (CXXI B).

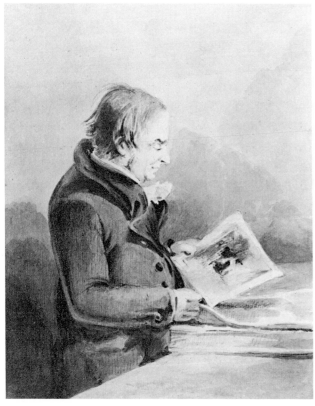

3. J. T. Smith,
 Turner in the Print Room at the British Museum. c. 1825.
 Watercolour;
 9×7 in. (228×178 mm.)
 Indianapolis Museum of Art, Pantzer Collection.

Turner probably also had a rod. In contrast to the breadth of the river scene is the more detailed study of *Tree Tops and Sky, Guildford Castle* (Plate 34), in which the movement of the sky and the trees on a windy day is strikingly conveyed. There is a similar feeling of immediacy in the *Willows beside a Stream* (Plate 53), though this much larger painting, on canvas, is unlikely to have been painted entirely on the spot. Nevertheless it certainly belongs to this period of *plein-air* studies in which Turner appears to have been on the path which Constable later made his own. While the dating of about 1807 proposed by Finberg seems generally acceptable for these studies, some more recent scholars have suggested later dates such as 1812 for some of them. It must be remembered, in favour of Finberg's dating, that Turner rented a house on the river at Hammersmith in 1806, and though he continued to use his studio and gallery in Harley Street, he lived in Hammersmith with his father. He almost certainly owned a boat or boats, and excursions on the Thames must have been part of his everyday life.

The calm of the Thames studies was repeated in the majority of Turner's exhibited works in the closing years of the first decade of the century. We have already noted this quality in the *Sun rising through Vapour* (Plate 27), one of the two paintings shown at the Royal Academy in 1807. The second was a placid rural genre scene—*A country Blacksmith disputing upon the Price of Iron, and the Price charged to the Butcher for shoeing his Pony* (Plate 52) which, in its execution, resembles two interiors sketched in oils on paper at Knockholt when Turner was on a visit to his fellow-artist and friend William Wells. In his own gallery that year Turner showed several restful river views and there were more in the following year, when *The Forest of Bere* (Plate 54) was also exhibited. This has a wonderful quality of inner light which renders, as one contemporary critic put it, 'the mild radiance of a warm summer evening'.

In the summer of 1808 Turner travelled to Cheshire to paint two views of Tabley House, Sir John Leicester's seat near Knutsford. The resulting 'house portraits', in which the actual house is a minor feature, are a pair of somewhat Dutch compositions entitled when exhibited at the Academy in 1809, *Tabley, the Seat of Sir J. F. Leicester, Bart.: Windy Day* (Plate 61) and *Tabley, Cheshire, the Seat of Sir J. F. Leicester, Bart.: Calm Morning*. The idea of such contrasting portrayals of the same seat was not a novel one—George Lambert and Paul Sandby were among earlier artists who had produced such pairs—but the views of Tabley were exceptionally well received, and their success led to further commissions for paintings of their houses from the Earls of Egremont and Lonsdale. *Petworth, Sussex: Dewy Morning* (Plate 62) is an evocative scene which convincingly depicts the harmony of the great house at Petworth and its beautiful park. The atmosphere of the more rugged Westmorland surroundings of the rather brash Lowther Castle (it was still being built at the time of Turner's visit in

1809) is also subtly conveyed in the mid-day and evening portrayals of that house, and in one of the three drawings connected with this commission which are in the Ashmolean Museum (Plate 35). In this preliminary study just enough watercolour is used in the distance and in the finely drawn thistle in the foreground to achieve this effect. The fine country house 'portraits' of these years, in which Turner displayed his understanding of the variations of the English countryside and weather, reached their climax with the well known view of *Somer Hill, Tonbridge*, which was exhibited in 1811 (Plate 63). Here the sheet of water in the foreground, reflecting the gentle lights in the sky, enhances an overall feeling of harmony and unity in the scene, into which the house fits with absolute naturalness.

In all these compositions water plays a vital role, as it does in the glowing Dutch landscapes of Aelbert Cuyp (Plate 64) which strongly influenced Turner at this stage of his development. This is most clearly seen in such a tranquil riverside scene as *Dorchester Mead, Oxfordshire* (Plate 65) which dates from 1810. A misty summer morning in the Thames valley is rendered with great skill, and, as in so many of Constable's slightly later Stour valley landscapes, the animals and figures play an essential role in achieving this effect of 'truth to nature'. Though they are smaller in scale, the same is true in the more classical *Whalley Bridge and Abbey, Lancashire: Dyers washing and drying Cloth* (Plate 66), which is based on a sketch-book drawing made on his way to Tabley House in 1808. The painting was exhibited at the Royal Academy in 1811.

Another influence on Turner was that of his neighbour at Hammersmith, the veteran fellow-member of the Royal Academy P. J. de Loutherbourg (1740–1812), who was the last survivor of the leading British landscape painters of the eighteenth century. In 1804 Loutherbourg had exhibited what was to become his best-known work, *An Avalanche in the Alps* (Plate 55), in which his experiences as a stage designer and as a landscape artist are combined to produce a truly romantic vision. Six years later, in 1810, Turner showed in his own gallery his *The Fall of an Avalanche in the Grisons* (Plate 56). In this somewhat smaller canvas the romantic drama of the scene is enhanced by the subdued and sombre colouring, and the whole composition focusses on the huge rock about to crush the cottage in its path. Nature is left to speak for itself—there are no figures.

In the caption for *The Fall of an Avalanche* Turner printed some lines of his own verse based on a passage from Thomson's *Winter*; for the vast historical landscape of *Apollo and Python*, which he showed at the R.A. in the following year, he produced his own paraphrase of some of the eighteenth-century translations of Callimachus's *Hymn to Apollo*. When he exhibited his great *Snowstorm: Hannibal and his Army crossing the Alps*

(Plate 57) in 1812 the title was accompanied in the catalogue by an eleven-line 'quotation' from his own manuscript poem, *Fallacies of Hope*. This was the first of many such 'quotations', for with his immense inventiveness Turner found it easier to create his own poetic captions than to hunt for suitable ones by established poets. As has been shown by several recent writers, Turner was deeply read in English poetry—Milton, Thomson, Gray and Akenside being among his favourites. His own verse was usually stilted and pompous, relying rather on the sound of the words than their meaning. He considered the connection between painting and poetry to be a vital one, as he postulated in some of his lectures as Professor of Perspective at the Royal Academy. Having been appointed to that position in 1807 he did not deliver his first series of lectures until 1811. The surviving records and notes of these lectures, which he continued to deliver spasmodically until 1828, are confused and uncertain, and they have yet to be adequately deciphered and edited. However, for Turner the lectures were of great importance, as the long time of careful preparation he needed before giving the first course demonstrates. The period during which he gave these lectures was one of immense significance in Turner's own development as an artist, and if they can ever be intelligibly presented, the lectures should provide a valuable insight into that development. Unfortunately both Turner's prose and poetry prove that his skill with words left much to be desired.

While Turner certainly gained inspiration from reading poetry and even from writing his own poetry, the main source of his art was his constant study of nature. Thus the *Fall of an Avalanche* is yet another product—however indirect—of his visit to the Alps in 1802, while the conception of the *Hannibal* is associated with a severe thunderstorm he witnessed when on a visit to Farnley Hall in Yorkshire during which he was seen to be making notes; after the storm had passed he told his host's son, 'in two years you will see this again and call it Hannibal crossing the Alps'.

Having travelled relatively little for some years, Turner undertook another of his long sketching tours in 1811. He visited Dorset, Devon, Cornwall and Somerset, travelling over 600 miles in some two months and filling at least four sketch-books, with drafts of descriptive verse liberally interspersed among the drawings. The object of this journey was to collect material for a series of engravings to be published by W. B. Cooke, and it seems that Turner may have had the idea of also supplying a verse text for this publication, *Picturesque Views of the Southern Coast of England*. The forty engravings appeared at intervals (without the verses) between 1814 and 1826, and were the first of a considerable number of such topographical series which took up much of Turner's time and energy in the middle years of his career. These engravings quickly enhanced Turner's reputation with a public far wider than the London exhibitions

attracted and the income they brought the artist provided the basis of his fortune. It is possible that he first undertook such work because of his need for money—early in 1811 he had made major alterations to his London house and gallery, including moving the entrance from Harley Street to Queen Ann Street West, and a few months earlier he had bought some land in Twickenham, on which he built an elegant small house of his own design, first called Solus Lodge and then Sandycombe Lodge (see Plate 7). Now in his late thirties, Turner was firmly established as a man of some means, and in the background he had his mistress, Sarah Danby, and her family, including his own two daughters, to maintain.

He made a second such sketching tour, to Devonshire, in 1813, and it was probably during this that Turner executed another of his rare series of oil studies from nature, of which this distant view of *Falmouth Harbour* (Plate 59) is one of the most successful. The paint is broadly and economically applied and the colouring is entirely naturalistic. The same somewhat dry technique is found in the watercolours of this period, such as *Sunshine on the Tamar* (Plate 67), which is based on a pencil sketch also made during the second Devonshire tour. Turner was definitely adapting his watercolour methods to suit the needs of the engraver working on copper. While more fluid and translucent watercolours and washes could be adequately reproduced in mezzotint or aquatint, for copper engraving somewhat firmer tones and outlines were desirable. That precision and firmness is seen in the foreground and middle distance of the watercolour of *The Junction of the Greta and Tees at Rokeby* (Plate 68). This was executed about 1816–18 and engraved in 1819 for Whitaker's *History of Richmondshire*, as was *The Crook of Lune* (Plate 60) in 1821. In both these fine drawings Turner has used an elaborate stipple technique in which the numerous strokes of the pointed brush are reminiscent of the small lines and dashes made by the engraver's burin. The colour schemes are subtle and harmonious within quite a narrow range, largely of yellows, greens and browns, which again coincides with the variations in tone available to the engraver. The same technique can be seen in the drawing of *Leeds* (Plate 69), dated 1816, though when this was reproduced for a history of the city lithography was used, perhaps because it was considered a better method to render the smoke shrouding the city in the middle distance.

The three watercolours which have just been discussed are all of Yorkshire subjects. From 1810 onwards Turner paid regular visits to the county, where he was a welcome guest at Farnley Hall, the home of his early patron and friend Walter Fawkes, whose first purchase of a work by Turner was the large Alpine watercolour shown at the Royal Academy in 1803 (Plate 38). Walter Fawkes, who was only six years older than Turner, was a man of advanced ideas who had read and travelled widely. He was an enlightened landowner, and took a particular interest in the breeding of cattle. Farnley

Hall is an attractive house, splendidly situated overlooking the valley of the Wharfe, and Turner was clearly at his happiest and most relaxed while staying there. The house was soon filled with his watercolours, and the lovely *Valley of the Wharfe from Caley Park* (Plate 70) is among those that are still there today. There is also an album of beautiful small watercolour studies of birds, which Turner drew for members of the family and in which he again proved his instinctive feeling for colour and texture. A few of the bird studies made at Farnley were dispersed, among them the *Sketch of a Pheasant* (Plate 76), which belonged to John Ruskin, and which he may have been given on his first visit to Farnley in 1851. Another Farnley drawing owned at one time by Ruskin, which in its meticulous detail contrasts strangely with the bold study of the dead pheasant, is *A Frontispiece (at Farnley Hall)* (Plate 75), which is dated 1815. This was drawn as a frontispiece for 'Fairfaxiana', a set of drawings Turner made of subjects relating to the Fairfax property which had come into Mr. Fawkes' family. Though damaged, the drawing still convincingly illustrates the absolute precision with which Turner could use watercolours.

Turner showed only two paintings at the Royal Academy in 1813—there had been some unpleasantness about the hanging of the *Hannibal* in the previous year. One of these two, *Frosty Morning* (Plate 58) was well received, though, like so many of Turner's paintings in these years, it did not find a buyer. In the following year Turner somewhat surprisingly submitted *Apullia in Search of Appullus* (Plate 72) as a candidate for the British Institution's annual premium for landscape painting. Here was an heroic landscape in the best Claudian tradition—a complete contrast to the natural simplicity of the *Frosty Morning*—but it did not win the prize, which was awarded to T. C. Hofland for a marine in the Dutch manner. One of the judges was Sir George Beaumont, whose violent criticisms of Turner's work reached a head in the following year. Turner had three canvases and five watercolours at the Royal Academy—of which four, one painting and three drawings, had been shown in his own gallery some years earlier. The remaining two paintings were *Crossing the Brook* (Plate 78) and *Dido building Carthage; or the Rise of the Carthaginian Empire* (Plate 77). These were widely praised by numerous critics and fellow-artists, and have always been recognised as Turner's outstanding masterpieces in his two Claudian manners. However, Sir George was reported as saying of the latter that 'the picture is painted in a false taste, not true to nature; the colouring discordant, out of harmony', and of *Crossing the Brook* that 'it appeared to him *weak* and like the work of an Old man, one who no longer saw or felt colour properly; it was all of *pea-green* insipidity'.

Despite its Italianate character *Crossing the Brook* is, in fact, based on drawings made in Devonshire in 1813, when Charles Eastlake was Turner's travelling companion.

Eastlake later recorded 'the bridge is Calstock Bridge; some mining works are indicated in the middle distance. The extreme distance extends to the mouth of the Tamar, the hills of Mount Edgcumbe, and those on the opposite side of Plymouth Sound. The whole scene is extremely faithful.' *Dido building Carthage* on the other hand, is an imaginary composition, closely related to Claude's *Seaport: The Embarkation of the Queen of Sheba* which was then in the Angerstein Collection in London. One of the many critics who praised these two paintings so profusely, wrote of the *Dido building Carthage*: 'the eye rests but a moment on this picture before its transcendent qualities completely occupy the mind, and it is felt to be one of those sublime productions which are seldom met with. . . . This is a fine work which, in grandeur and ideal beauty, Claude never equalled.' Turner was just forty years old, and judging from the general reception given to his Academy exhibits of 1815 there can be no doubt that he was considered not only the leading landscape painter of the day, but also an artist to be thought of side by side with some of the greatest of the old masters.

The Napoleonic wars had confined Turner to the British Isles since 1802, but he waited for two years after the Battle of Waterloo before crossing the Channel again in August 1817. This time he sailed to Ostend, and after a few days in Belgium, including a visit to the Waterloo battlefield, he spent just under two weeks exploring the banks of the Rhine from Cologne to Mainz. He then travelled for a similar period in Holland, sailing back from Rotterdam to Hull in the middle of September. Turner filled four sketch-books—three small and one large—on this tour with slight and rapid pencil drawings usually confined to the bare outlines of the scene he was recording, occasionally annotated with colour and other notes. Some two months after his return Turner arrived at Farnley Hall and brought with him the now well-known series of fifty-one watercolours of views on the Rhine which Walter Fawkes purchased for £500. Between landing at Hull and arriving at Farnley, Turner had visited Durham and other places in the North-East. He also spent some time at Raby Castle working on the commission for a painting of that house (now in Baltimore) for Lord Darlington. It was possibly while staying there that he worked on his Rhine watercolours.

These introduce a new element of confidence and fluency; the meticulous technique of watercolours made for the engravers is replaced in many of these Rhine drawings by a more fluid and luminous application of the medium. This is evident in the painting of the background hills of the *Marksburg* (Plate 73), in which the foreground details are however, still dryly painted and considerable use of body-colour is made. One important aspect of the Rhine series is the variation of technique and approach among the drawings as a whole; there is also considerable diversity of touch and method in many individual drawings, as can be seen again in the *St. Goarshausen and Katz Castle* (Plate

74), which is one of the most enclosed of these compositions. For Turner this large group of finished watercolours executed apparently without a positive commission in the space of a few weeks must have been in the nature of an experiment—an experiment which shows once again the impact that new visual experiences so often had upon this artist.

The few days spent in Holland had an even more spectacular result: the beautiful painting known as *The Dort* (Plate 86), which was shown at the Royal Academy in 1818 and also purchased by Walter Fawkes, this time for 500 guineas. While there is no doubt about the overall debt in this composition to Cuyp, who was a native of Dordrecht (see Plate 85), in detail it is based on a number of pencil drawings made in three of the sketch-books that Turner had used in 1817. These show once again Turner's acute powers of observation, and his ability to record with the greatest economy sufficient material to ensure accuracy in all aspects of such a large canvas as *Dort or Dordrecht: The Dort Packet Boat from Rotterdam becalmed*. As well as being accurate in its topographical and nautical details, this work is notable for the truth of its atmosphere and for the tones of sky and water. We have already had ample proof of Turner's knowledge of the different qualities of the ever-varying sea; his determination to be equally knowledgeable about the sky is shown by a sketch-book which he was using between about 1816 and 1818, and which he himself labelled 'Skies'. This contains over seventy watercolour studies of a wide range of sky effects, both by day and night, of which many are likely to have been made on the spot. There are numerous other watercolour studies of sky and weather effects in the Turner Bequest drawings, but this aspect of Turner's work has never gained the same attention as Constable's cloud and sky studies, the most important group of which dates from the early 1820s, some years later than the 'Skies' sketch-book. Near the end of this are two pencil drawings of the Fourth of June celebrations at Eton, which Turner is known to have witnessed in the company of the Fawkes family in 1818.

Further evidence of Turner's versatility in the use of watercolours is found in a strikingly different drawing, the well-known *A First Rate taking in Stores* (Plate 80). This is reputed to have been completed in one sitting between breakfast and lunch during his autumn visit to Farnley Hall in 1818. When breakfast was finished, we are told by the Fawkes' eldest son, Hawksworth, who witnessed the operation, 'Turner took a piece of blank paper—outlined his ships, finished the drawing in three hours and went out to shoot . . . he began by pouring wet paint onto the paper until it was saturated, he tore, he scratched, he scrubbed it in a kind of frenzy and the whole thing was chaos—but gradually and as if by magic the lovely ship, with all its exquisite minutia, came into being.'

Before this visit to Farnley, Turner had spent two or three weeks in Scotland to make studies for his illustrations for *The Provincial Antiquities of Scotland*, which was to be published by Cadell of Edinburgh with a text supplied free of charge by Walter Scott. Later the publisher presented eight of the finished drawings, including the *Roslin Castle* (Plate 71), to Scott, who had them all arranged in one frame made from an oak felled at Abbotsford at the time of Turner's visit there in 1831. In this drawing a variety of techniques has been used, including stipple and scratching out, and it illustrates the results of the various experiments which Turner had made with watercolours in the two or three preceding years.

In April 1819 the range and beauty of Turner's watercolours could be studied by a relatively wide public in London, when Walter Fawkes included over sixty examples in an exhibition of part of his collection of watercolours by contemporary British artists in his town house at 45 Grosvenor Place. As a Royal Academician Turner had not been able to join the Water-Colour Society founded in 1804, and he had long not shown more than a small group of watercolours in the exhibitions at the R.A. and in his own gallery. Turner's pre-eminent place among contemporary watercolour artists was clearly demonstrated by the Fawkes exhibition, and when Walter Fawkes printed a catalogue which included extracts from the many favourable press comments, he dedicated it to Turner (see p. 57). In opening his collection to the public Fawkes was probably following the example of Sir John Leicester, who, having just completed a new gallery at his house in Hill Street, opened it to the public in March. His well-known collection of British paintings included eight canvases by Turner, and the critics of this exhibition had also focussed their attention on his works. Thus Turner was already very much in the public eye when the Royal Academy opened its annual exhibition in which he had two large paintings, the *Entrance of the Meuse: Orange-Merchant on the Bar, going to Pieces* (Plate 81) and *England: Richmond Hill, on the Prince Regent's Birthday* (Plate 83). Notwithstanding its specific, narrative title the former is essentially a composition of sea and sky (reflecting the experience gained in the 'Skies' sketch-book), and the boats and ship play a relatively small role. Despite its Claudian character, the vast *Richmond Hill*—it was the largest painting that Turner exhibited— succeeds in conveying very naturally the mistiness of this breathtaking view of the Thames valley. It too was probably based on drawings made on the spot, of which the fine *View from Richmond Hill* (Plate 82) may have been one.

Early in August Turner crossed the Channel on his way to Italy—a few days before his departure Sir Thomas Lawrence had written to Joseph Farington from Rome; 'Turner should come to Rome. His genius would here be supplied with materials, and entirely congenial with it. . . . He has an elegance, and often a greatness of invention,

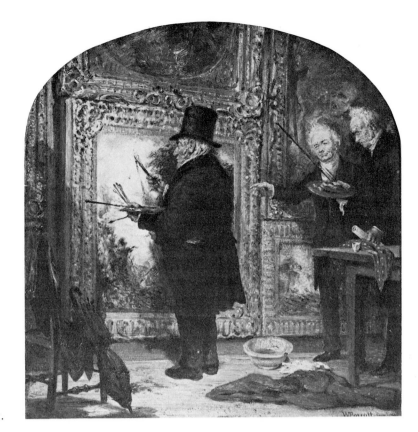

4. S. W. Parrott,
 Turner on Varnishing Day. c. 1846.
 Oil on panel;
 Reading, Ruskin Collection, University of Reading.

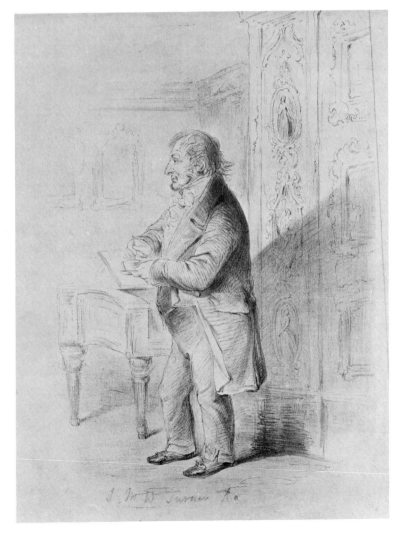

5. Comte Alfred d'Orsay,
 Turner at a Reception. c. 1850.
 Lithograph;
 12 × 9½ in. (305 × 242 mm.)
 Oxford, Ashmolean Museum (Hope Collection).

that wants a scene like this for its free expansion.' Turner spent some four months in Italy, touring most of the principal cities including Turin, Milan, Venice, Bologna, Rome, Naples and Florence. The initial impact of his first visit to Italy has often been exaggerated, and it took Turner several years to assimilate the wealth of his Italian experiences—it must be remembered that he was already in his mid-forties.

The immediate result of the Italian tour was twofold. He filled over twenty sketch-books, mostly with rapid pencil drawings, which became noticeably less detailed as he proceeded on his travels. Thus he recorded a wide variety of scenery in town and country and was at last able to familiarise himself with the landscape which had inspired Claude and Wilson. He also studied many of the masterpieces of earlier Italian painting, especially the warm and rich colouring of the Venetians. Turner tried to sum up all these experiences in a great public statement, the *Rome from the Vatican: Raffaele, accompanied by La Fornarina, preparing his Pictures for the Decoration of the Loggia* (Plate 84), which he exhibited as his only work at the Royal Academy in 1820 having executed it in the few weeks since his return from Italy. This vast composition, with its surprising allusion to Raphael as a fellow-painter of landscape, was not well received, and was particularly criticised for its gaudy colours.

Though Rome made a great impression on Turner, the impact of Venice was to have a more lasting influence. He spent over two weeks there, filling the larger parts of two sketch-books with pencil studies which clearly show how much he was attracted by the unique qualities of Venice (Plates 95, 96). The drawings in the second of these sketch-books are much less detailed than those in the first, a sure sign that he was now confident that the essential features of the city were stored in his powerful visual memory. He also used a few leaves of a much bigger roll sketch-book for a series of four superb watercolour studies in which he was principally concerned with recording the breath-taking light effects that can be experienced in Venice. In these he made full use of the white of the paper and of the translucent qualities of the medium to achieve his effects with greater economy than ever before. The delicate light of sunrise is the theme of three of these drawings (Plates 87, 88); the fourth, a close-up view of the Campanile and the Ducal Palace, features the strong blues that so often dominate the sky and waters of Venice. These few Venetian drawings are far in advance in technique and confidence of the other watercolours that Turner executed on his Italian tour, which are closer to those he had made of the Rhine and of English subjects in the years just before this. For his views of Rome (Plates 97, 98) Turner used grey tinted paper, on which the grandeur and solemnity of the city is seen to full effect. Naples (Plate 99) and Tivoli (Plate 100) are again drawn on white paper. In these direct and natural coloured drawings Turner was clearly working for himself to record the variations of light and

6. *(opposite)* George Jones R.A., *Interior of Turner's Gallery: the Artist showing his Works.* Oil on millboard; $5\frac{1}{2} \times 9$ in. (140 × 228 mm.) Actual size. Oxford, Ashmolean Museum.

7. W. B. Cooke after William Havell, *Sandycombe Lodge, Twickenham.* 1814. Engraving; $4\frac{5}{16} \times 7\frac{7}{8}$ in. (110 × 200 mm.) Actual size. Oxford, Ashmolean Museum (Hope Collection).

colour, which he could not do in the numerous pencil sketches; he used few of them as the basis for finished watercolours for his patrons—he produced no more than a handful of Italian subjects after his return—but he certainly turned to them to refresh his memory when he began to paint Italian subjects more frequently in the 1830s.

On his return journey across the Alps Turner found that the Mont Cenis Pass was officially closed because of heavy snowfalls. However, he and a group of others decided to hire a private coach, and the hazardous drive went well until the top of the pass was reached. Here the coach capsized and the passengers had to proceed down the pass on foot. Turner recorded all this in several rapid pencil drawings; when back in England he executed a watercolour, *The Passage of the Mont Cenis* (Plate 101), for Walter Fawkes, which shows once again how fully Turner understood the moods and characteristics of mountainous country; his understanding of Italian scenery, on the other hand, took several more years to develop. After the disappointing reception of *Rome from the Vatican* Turner did not exhibit at the R.A. in 1821, and showed only one painting in 1822 and 1823. In the latter year he selected an Italian subject, *The Bay of Baiae, with Apollo and the Sybil* (Plate 89). Though still basically a Claudian composition, this does show, especially in the translucent qualities of the distant sea, the beginnings in an oil painting of that greater freedom and spontaneity which Turner had already developed in his watercolours.

For his painting in oils the mid-1820s were on the whole years of pause and reflection. In watercolours he was as busy as ever, mostly in work for the engravers, whose demand for drawings had increased with the introduction of steel plates which meant that many more impressions of each subject could be printed. In 1822 and the two following years, W. B. Cooke showed groups of the drawings that Turner had made for his publications in his gallery in Soho Square, and these were again well received by the critics. One of Cooke's publications was *The Rivers of England* for which Turner made sixteen drawings, including the lovely *Totnes on the River Dart* (Plate 102), of which the mezzotint on steel was engraved by Charles Turner (no relation of the painter) in 1825 (Plate 103). From the commercial point of view many of W. B. Cooke's publications were unsuccessful. In 1827 Turner started working for a new publisher, Charles Heath, who launched the ambitious *Picturesque Views in England and Wales*, of which 96 plates (engraved on copper) had been published by 1838. This again was a commercial failure (Heath went bankrupt), despite a successful exhibition of some of Turner's watercolours in the Egyptian Hall in 1829. The wonderfully atmospheric drawing of *Colchester* (Plate 104) was included in that exhibition; it had been engraved for this series by R. Wallis in 1827. Here Turner combines broadness of effect with minuteness of detail, and the composition is enlivened by the 'narrative' element of the hare being

chased by the dog in the foreground, which also helps to draw it together. In the later *Richmond Hill and Bridge, Surrey* (Plate 105), engraved for this series in 1832, the jaunty figures play a similar role. No such gimmicks were needed in his 'private' and spontaneous watercolour drawings of this period, such as the bold *Storm Clouds: Sunset* (Plate 91), which is the sort of study on which Turner based his fine rendering of atmosphere in his finished compositions. Yet it is in itself a complete and balanced composition.

Though the series of British topographical prints were meeting with limited commercial success Turner was still kept busy with work for the engravers. In 1830 a new and luxurious edition of Samuel Rogers's poem *Italy* was published with a large number of vignette illustrations of which twenty-four were after drawings by Turner. This handsome volume was well received and its success launched Turner on a new aspect of his output for the engravers; he became one of the most sought-after illustrators of literary works and in the 1830s fine editions of the writings of Milton, Byron (Plates 111, 112), Scott and others were published with steel engravings after drawings by him. There were also to be one or two topographical series, among which *The Rivers of France* is pre-eminent. Published in three volumes in 1833, 1834 and 1835, these engravings and the outstanding drawings from which they were made, represent the apogee of this aspect of Turner's career. The bulk of the drawings connected with the series form part of the Turner Bequest, but there is also a fine group, which once belonged to Ruskin, at the Ashmolean Museum in Oxford, and a few more are dispersed in other collections.

Turner was in France on several of his journeys abroad between 1826 and 1833, and it is impossible to date the *Rivers of France* drawings at all precisely. Drawn on blue paper, which in numerous cases has faded to grey, these small and compact compositions combine a surprising amount of meticulous detail with a wonderful rendering of overall atmosphere. One of the most atmospheric is the *Scene on the Loire* (Plate 92), which was not engraved and which Ruskin described as 'the loveliest of all' the Loire series. Here, as in many of these drawings, body-colours and watercolours are used together, and large areas of the paper are left untouched, to render the misty effect of the calm of evening. In the *Château of Amboise* (Plate 113) black ink is used to strengthen the details of the bridge, the castle and other features; these details have naturally become rather more precise in the engraving after this drawing (Plate 114), which is on a considerably reduced scale. Despite this the engraving succeeds in retaining the atmospheric qualities of the drawing. This was happily the case in most of the 61 *Rivers of France* plates, of which twenty-one are devoted to the Loire and forty, in two volumes, to the Seine. In some cases the engraving even adds to the effect of the drawing; in the

Rouen, looking down River (Plate 115), for instance, the indefinite white streak in the sky on the right has become a rainbow in the engraving.

The three volumes were planned as the beginning of a large series devoted to the great rivers of Europe, but in the event they were the only ones published. But it should be remembered that the majority of Turner's *Rivers of France* drawings are rapid studies probably made on the spot and not prepared for engraving (Plate 116). In addition to the coloured drawings there are in the Turner Bequest over a hundred pencil and ink drawings, again on blue paper, connected with this series, to which Turner clearly devoted a great deal of hard work. This kind of work reaped its rewards not only in financial gain but also in a great boost to Turner's reputation. When Dr. G. F. Waagen, Director of the Berlin Gallery, wrote of his first visit to a Royal Academy exhibition in 1835, he records that he made a point of 'looking for the landscapes of the favourite painter, Turner, who is known throughout Europe by his numerous, often very clever, compositions for annuals and other books, where they appear in beautiful steel engravings'. Without the engravings Turner could not have achieved the international reputation that he enjoyed in the later years of his life.

Having again sent no works to the Royal Academy exhibition in 1824, Turner showed a painting and a watercolour in the following year. The former, *Harbour of Dieppe (changement de domicile)* (Plates 93, 94), was given a mixed, but on the whole adverse, reception. One critic described it as 'perhaps the most splendid piece of falsehood that ever proceeded from the brush of Turner or any of his followers'; another called it 'a brilliant experiment upon colours, which displays all the magic of skill at the expense of all the magic of nature'. For the artist this canvas represents a turning point. The composition continues to bring to mind an old master precedent, the harbour scenes of Claude. The execution is entirely 'different'; in its beautiful rendering of a busy scene in clear morning light it achieves on a greatly magnified scale the atmospheric effects of the watercolours of this period, and it does so by adapting in oils some of the methods that he had developed in watercolour. To the modern eye all seems real and alive in this scene, from the fine details of the household goods in the right foreground to the lovely blue grey effect of the distance. The *Harbour of Dieppe* heralds the fifty-year-old Turner's maturity as a painter in oils, and shows that the few years of reflection he had allowed himself since his Italian visit had been used to excellent effect.

In 1826 he showed four oils, including a companion piece for the *Dieppe, Cologne, the Arrival of a Packet Boat, Evening,* which is also in the Frick Collection in New York. Another of that collection's outstanding group of Turners was also exhibited in 1826; this is *The Seat of William Moffat, Esq., at Mortlake. Early (Summer's) Morning* (Plate 117).

Again the composition of this exquisite Thames-side scene is a conventional one, but its colouring and tones are Turner's own, as they are in the companion evening view shown in the following year and now in Washington. In 1827 Turner was tempted to practise his new oil painting methods in one of his rare series of on-the-spot studies in that medium. That summer he spent several weeks on the Isle of Wight as the guest of the architect John Nash at East Cowes Castle. His visit coincided with the Regatta, of which his host commissioned him to paint two pictures. As usual Turner made numerous preparatory pencil drawings, concentrating particularly on the yachts under sail. It seems probable that these pencil studies preceded the oil sketches. Of these Turner made nine, using a six by four foot canvas cut in two, with each part divided into four and five respectively; they were not cut up and put on stretchers until 1906. Six of these vivid direct studies can be connected with the two paintings of the regatta which were commissioned by Nash. Thus *Yacht Racing on the Solent, No. 1* (Plate 118) has several features, including the guard ship in the centre, in common with one of the two finished canvases, *East Cowes Castle, the Seat of J. Nash, Esq.; the Regatta beating to windward* (Plate 119). In this, like in its companion, a placid sunset scene showing 'the Regatta starting for their moorings', the architect's remarkable neo-Gothic house is seen in the distance on its hill above the river.

Though he made no oil studies of the house, Turner made a considerable number of drawings of it and its grounds on blue paper, mostly in pen and ink with white chalk. The Castle features prominently in *Boccaccio relating the Tale of the Birdcage* (Plate 120), which, like the two regatta scenes, was shown at the Royal Academy in 1828. Here the white castle in the background adds greatly to the mystery of the Watteau-esque figures in the foreground, which re-echo some of the figure drawings that Turner made inside and outside East Cowes Castle. The direct oil sketches also include one remarkable figure study, *Between Decks* (Plate 121), in which a group of sailors and their girls are shown casually seated around a gun-port on board a man-of-war. It has been suggested that Turner painted the oil studies of the Regatta from on board a boat or ship; *Between Decks* would seem to confirm this supposition, and together with the figure drawings made during this visit to the Isle of Wight it heralds the remarkable interiors with figures drawn and painted at Petworth a year or two later.

Walter Fawkes had died in 1826, and with his death Turner's regular visits to Yorkshire came to an end. It has usually been surmised that several years elapsed before the place that Farnley Hall had played in his life was taken by Petworth, the Sussex home of the Earl of Egremont, who had, in fact, commenced his patronage of Turner slightly in advance of Fawkes. However, it now seems probable that Turner's regular and frequent visits to Petworth had already begun by 1827. A recently recognised pass-

age in the published correspondence of Thomas Creevey recording a visit to Petworth in August, 1828, refers to Turner's paintings of Petworth Park already hanging as part of the decoration of the panelled Grinling Gibbons Room, which was then used as a dining room. Having described some of the great portraits in this room Creevey continued: 'Immense as these pictures are with all their garniture there are still panels to spare, and as he [Lord Egremont] always has artists ready in the house, in one of these compartments, you have Petworth Park by Turner, in another Lord Egremont taking a walk with nine dogs, that are his constant companions, by the same artist'. The mention of the dogs means that *Petworth Park: Tillington Church in the Distance* (Plate 108) is here being referred to. This is one of the so-called 'sketches' in the Turner Bequest for the four well-known elongated views of Petworth Park, Brighton and the canal near Chichester, which are still at Petworth today. It now seems probable that the 'sketches', or at least two of them, were hung first in the Grinling Gibbons Room, and were later replaced by the slightly smaller and considerably altered versions still at the house, such as *The Lake, Petworth: Sunset, fighting Bucks* (Plate 123). How much later it is impossible to tell, but the newly discovered evidence does provide a *terminus ante quem* of the summer of 1828 for the commencement of this series, hitherto usually dated *circa* 1830.

In style and technique the Petworth 'sketches' follow on naturally from the studies made on the Isle of Wight, and from the watercolour compositions of the mid-1820s. *Petworth Park: Tillington Church in the Distance* is a bold and simple composition of the sweep of parkland on to which the great west front of the house faces. This is given complete cohesion by the running dogs on the left and the feeding deer on the right, and, of course, their shadows. That cohesion is not so successfully retained in the less broad version of the same view with the fighting bucks on the right and the cricket match on the left. In the *Chichester Canal* (Plate 109) Turner uses the dark silhouette of the ship to achieve another perfectly balanced composition despite the unprecedented freedom of technique.

With this great series of Petworth compositions we witness the first full flowering of Turner's own personal style as a painter of landscape, and it is now clear that this point had been reached *before* the artist set out on his second visit to Italy in 1828. On this occasion he spent most of his time in Rome, where he took a studio that Charles Eastlake had found for him. However, it took him nearly two months to reach Rome, during which he filled a number of small sketch-books with pencil drawings of scenes in the South of France and Northern Italy. On arriving in Rome Turner wrote to George Jones, one of his closest friends among fellow-painters: 'Two months nearly in getting to this Terra Pictura, *and at work*; but the length of time is my own fault'. His real object on this second visit to Italy was not to collect more material, but to do some

painting, beginning with a major work for Lord Egremont as a companion to his Claude. The resulting canvas was the *Palestrina* (Plate 122), which in the event did not enter the Petworth collection. In a letter written to a friend not long after Turner's departure from Rome in January, 1829, Charles Eastlake stated: 'he worked literally day and night here, began eight or ten pictures and finished and exhibited three, all in about two months or a little more. More than a thousand persons went to see his works when exhibited, so you may imagine how astonished, enraged or delighted the different schools of artists were, at seeing things with methods so new, so daring, and excellences so unequivocal.' The three exhibited paintings, which it is reported that Turner framed with a rope nailed round the edges of each, were painted with considerable freedom, but retained, and this especially in the case of the *Regulus* (Plate 126) and the *View of Orvieto* (Plate 124), a strong element of Claudian classical precedent.

While in Rome Turner also painted a number of oil sketches, some of which were probably done on the spot. These latter, painted on board, are small semi-classical compositions with very misty tones and muted colouring, such as the *Coast Scene near Naples* (Plate 125). Another group of seven larger and more colourful studies, among them the *Ariccia?—Sunset* (Plate 90), was painted on one huge canvas, perhaps so that they would be more easily transportable back to England. Most of these also have an overall classical character, and it seems clear that Turner's deliberate plan to paint in 'the light of Rome' confirmed his life-long allegiance to the basic formulae of classical landscape painting. In the setting and atmosphere that formed the art of Claude and Wilson, Turner did not forget his discipleship of these masters; this was, indeed, an influence that Turner did not lose entirely at any stage of his career.

Much to his dismay Turner's exhibited and other paintings completed in Rome did not reach London in time for the Academy exhibition of 1829. However, he showed four works, including the spectacular but basically classical *Ulysses deriding Polyphemus* (Plates 106, 107), which, in its rendering of light and colour, illustrates the full effect of the months spent painting in Rome as the culmination of the advances made on the Isle of Wight and at Petworth in the two preceding years. Turner had had this great composition in mind for some twenty years, for there is an outline drawing for it in a sketch-book that he was using in about 1807. The next known stages in its development are two of the seven oil studies painted in Rome on the one canvas (which he must have had rolled up in the baggage that he himself brought back with him). The exhibited painting was certainly executed in the few weeks between Turner's return from Rome and the opening of the Royal Academy. Its reception was mixed, though *Ulysses deriding Polyphemus* has come to be regarded as one of Turner's greatest imaginative masterpieces. Another painting shown at this exhibition which has gained similar

reputation for its painter is Constable's dramatic *Hadleigh Castle*, now in the Paul Mellon Collection. Both these works represent a vital stage in the development of their artists, for in each there is a wholly successful fusion of nature and imagination which marks the achievement of full maturity. For Constable, who died in 1837, *Hadleigh Castle* was near the end of the road; for Turner *Ulysses deriding Polyphemus* marks the beginning of the full flow of his later masterpieces.

At the R.A. exhibition of 1830 Turner chose once again, as he had done in 1803 and 1815, to demonstrate his versatility. He showed seven works—more than in any year since 1815—including one watercolour, a large 'sketch from memory' of the funeral of Sir Thomas Lawrence, which is so free in technique that Finberg listed it in his *Inventory* in that all embracing category of 'Colour Beginnings'. Three of the paintings were ones that he had worked on in Rome—*Palestrina* (Plate 122), *View of Orvieto* (Plate 124) and *Jessica* (Plate 128). This, which was acquired either by gift or purchase by Lord Egremont, displays a considerable debt to Rembrandt, as does *Pilate washing his Hands* (Plate 127). The remaining two paintings—and they were the ones that gained the most general approval—were peaceful shore scenes, *Fish-market on the Sands—the Sun rising through Vapour* and *Calais Sands, low Water, Poissards collecting Bait* (Plate 110). The latter, with its beautiful rendering of the reflection of sunrise light on wet sand, perhaps records the memory of a scene witnessed during a brief trip to Northern France in the late summer of 1829. Turner had intended to return to Rome—indeed he had kept on his rooms there—but he changed his plans probably because of the poor health of his father, who died on 21 September, not long after his son's return from France.

Turner's relationship with his father had been a close one. The older William had always encouraged his son, and shown great pride in his achievements as an artist. After the death of his wife in 1804 he went to live with Turner and he came to play an important part in the running of his household, studio and gallery. It is understandable that Turner was reported as being 'fearfully out of spirits' after his father's funeral, but some authorities have made too much of the long-term effect of his death. It is certainly difficult to see 'a poignant note of sorrow' in the *Calais Sands*, as Finberg does. Indeed this is one of the most peaceful of Turner's later works, in which all the hopes and imponderables of a new day can be sensed.

In the next few years Turner spent much of his time in the congenial surroundings of Petworth, where the elderly and eccentric Lord Egremont kept open house. His guests —and there were generally some artists among them—were free to come and go as they wished and were in no way curbed by the social conventions of the time. Every part of the huge house (except the room set aside for Turner to paint in when he was there) was open to all, and there was a convivial atmosphere of ease and spaciousness. This was

an ideal setting for Turner, and he felt completely at ease. There was agreeable company when he wanted it, but he could always escape to his painting room or to his favourite pastime of fishing, in the lake. In these surroundings his art gained a new dimension, for it is at Petworth that he produced his greatest works as a painter of figures and interiors. The Turner Bequest includes a group of some hundred body-colour drawings on blue paper of scenes in the house, the church and the park. Similar in technique and character to some of the unengraved 'Rivers of France' drawings, these are mostly studies of light and colour. The sombre form of a wooded slope in the park seen in evening light is rapidly scratched onto the paper (Plate 129); the luminous grandeur of one of the state rooms with sun light streaming in through the windows is recorded with detail yet also with economy (Plate 130). Many of the interiors are peopled, as in *The Artist and his Admirers* (Plate 135), in which the figures are boldly set against the bright light of the window, and *Playing Billiards* (Plate 131), where the figures and the table are diffused in the smoky atmosphere of the room. The scale of the rooms at Petworth was certainly important for Turner. They were large enough for him to be able to get away from the subjects he was depicting, though there are also some drawings in which the figures are seen quite close to.

From these small and attractive visions of light, colour and form Turner moved on to a series of large canvases based on Petworth interiors. With reds and yellows predominating these are much less positive than the drawings, and achieve a still greater subtlety of light, tone and form. In the modern idiom these could be described as 'mood' paintings, and their special quality is that they do not impose their mood but provide material for the viewer to create his own interpretations in accordance with his state of mind. *Music Party, Petworth* (Plate 137) could be considered gay with its reds and the gleaming light in the centre, or serious with the dark dress of the pianist and the shadows in foreground and background. In *Interior at Petworth* (Plate 134), which is generally considered the masterpiece of this series, the forms have become even less definite. This distillation of light is skilfully achieved with a limited range of colours, for when the eye looks directly into light, colours and shapes become dissolved. In such private paintings Turner left all conventions of style and technique behind him. In the history of art he is breaking new ground here, and the term 'Impressionist' has often, but mistakenly, been applied to these canvases, which certainly seem to foreshadow the interiors of Vuillard and Bonnard of some seventy years later. Much has been made of Turner's role in the development of Impressionism, but more research is needed before this can be properly assessed.

Except for the 1810 view of the house (Plate 62), which was shown at the Royal Academy, Turner never used a Petworth subject directly for an exhibited or engraved

work. However, in 1831, when he again showed seven works at the Academy, he made indirect use of his deep study of the interior of Petworth in two subject pictures, painted on small panels. In the first, an historical scene of the time of the Gunpowder Plot depicting *Lord Percy under Attainder*, the richly furnished room is reminiscent of Petworth, and one of the three women in the room is actually based on a Van Dyck portrait which hangs there. The second, *Watteau Study by Fresnoy's Rules* (Plate 136), brings to mind several of the Petworth drawings, though there is no direct connection with any one of them. This was one of Turner's most didactic works, and it can be argued that he was more successful as an instructor with paint than he was in his lectures with words. Even in the latter, the numerous specially executed illustrative drawings played a vital role. The primary lesson of the *Watteau Study* was in the use of white, as indicated by the quotation from Fresnoy's *Art of Painting* printed in the catalogue:

'White, when it shines with unstained lustre clear, May bear an object back or bring it near.'

This was the period when Constable was being attacked by several critics for the use of white on the surface of his paintings, which he claimed gave them a quality of 'dewy freshness'. It may be that with the *Watteau Study* Turner was coming to the defence of Constable; too little is known about the relationship between the two artists for this to be more than a very tentative surmise.

Turner's admiration and respect for the paintings of Watteau—feelings which we know that Constable shared—had already been shown in earlier works (see Plate 120), but it is generally thought that in these the influence was an indirect one which came through the work of Thomas Stothard (1755–1834), a senior fellow-Academician who specialised in figure subjects in the style of Watteau. Stothard was also a successful illustrator and he had worked with Turner on the illustrations of Samuel Rogers's *Italy*, published in 1830. However, in Turner's painting of Watteau at work two of his canvases then in London are shown—*La Lorgneuse*, at the time in Samuel Rogers's collection, and (in reverse) *Les Plaisirs du Bal*, which was, as it still is, one of the chief treasures of the Dulwich Gallery.

Much can be learnt from the *Watteau Study* about Turner's sources, methods and aims, but the critics of the day were not impressed; one described the two figure paintings as 'caprices more wild and ridiculous than any other man out of Bedlam would indulge in'. On the other hand the same critics fully approved of another of Turner's exhibits that year, *Life-boat and Manby Apparatus going off to a stranded Vessel making Signal (blue lights) of Distress* (Plate 138). The setting for this dramatic shore scene is Yarmouth, where G. W. Manby, the inventor of the life-saving apparatus depicted here, was barrack-master. In 1831 he was elected F.R.S. for his services to life-saving, and thus the

subject chosen by Turner was a topical one. All the details of the rescue operation are faithfully shown for the discerning eye, though the topographical features of the composition are not very precise. It is ironical that in later years—the painting forms part of the Sheepshanks Collection at the Victoria and Albert Museum—the topographical location, which had not been mentioned in his title by Turner, was remembered, while the rescue operation specifically referred to by the artist was forgotten. The use of such topical 'news items', quite common in his later exhibits, is comparable with his adaptation of specific personal experiences, as, for instance, in the *Hannibal* of 1812. Turner was fully conscious of the necessity for his exhibited works to have a recognisable subject, as demanded by the taste of the day. This was the great period of narrative painting in England, and to some extent Turner felt bound to follow the fashion of the time, though the technique and style of most of his exhibited paintings became increasingly individual.

In the summer of 1831 Turner set off somewhat reluctantly for Scotland to gather more material for a new illustrated edition of Sir Walter Scott's poems. The tour took some two months, and Turner filled twelve small sketch-books with pencil drawings. He thus made far more sketches than had been his wont on recent tours—he had filled only eight sketch-books on his much longer continental journey of 1828–9. His travels were extensive, ranging from Abbotsford to Elgin, and including Edinburgh and Glasgow, but the varied scenery that he saw did not seem to make a marked impression on him, for he made little use of these sketches in his finished work. Fifteen of the drawings which were engraved as illustrations for Scott's *Poetical Works* were exhibited in London by Messrs Moon, Boys and Graves in 1832 and 1833, and were considered at the time to be among Turner's finest achievements in watercolour.

One of Turner's six paintings at the 1832 Academy exhibition was a Scottish subject, based upon an experience at the close of his tour. He took a steamer from Tobermory to visit Staffa and Iona, but, as he himself wrote some years later 'a strong wind and head sea prevented us making Staffa until too late to go on to Iona. After scrambling over the rocks on the lee side of the island, some got into Fingal's Cave, others would not. It is not very pleasant or safe when the wave rolls right in. One hour was given to meet on the rock we landed on.' Turner certainly visited the cave, for one of his illustrations for Scott's *Lord of the Isles* is drawn from inside the cave, looking out through the entrance at the setting sun. It was then decided that the weather was too bad to proceed to Iona; 'the sun getting towards the horizon, burst through the rain cloud, angry, and for wind; and so it proved, for we were driven for shelter into Loch Ulver, and did not get back to Tobermoray before midnight'. *Staffa, Fingal's Cave* (Plate 139), seems to encapsulate this episode, but when exhibited in 1832 its title was accompanied in the

catalogue by four lines from Scott's *Lord of the Isles*. Turner's own surprisingly graphic description of the event was not written until some years later, in a letter to Mr. Lenox of New York, who bought the painting on the advice of C. R. Leslie in 1845. It was the first of Turner's paintings to go to America, where there is now a considerable number of major works in public and private collections, though the *Staffa* is back in Britain.

For three consecutive years Turner did not travel abroad; the theory that he paid his second visit to Venice in 1832 has not been proved correct. A reason for that suggestion was that in the following year Turner showed the first two of a long line of Venetian subjects among his annual exhibits at the Academy. One of these was the *Bridge of Sighs, Ducal Palace and Custom-house, Venice: Canaletti painting* (Plate 140), which Turner referred to as a 'scrap' when it was purchased by Mr. Vernon, who was collecting British paintings for presentation to the National Gallery. There is no doubt that Turner could have based such a composition on the sketches and memories gathered on his visit to Venice some thirteen years earlier, but what is surprising is that this small and detailed panel is the first of Turner's paintings of which it was reported that he painted it almost entirely when already on the walls of the Academy, in the brief space of two days. That report was dismissed as 'absurd' by Finberg, but has been more sympathetically received by today's scholars, one of whom has also suggested that in showing Canaletto painting in the left foreground on a canvas already within a heavy gilt frame, Turner was demonstrating his own conviction that the frame is a vital factor in the total effect of a painting. The presence of the somewhat ludicrous figure of Canaletto may well have been meant as a gesture of respect for his greatest predecessor in the painting of Venice, which, if the conclusions formulated as a result of the most recent research into Turner's visits to that city are correct, he himself re-visited in the summer of 1833.

In each of the next two years he exhibited straight-forward topographical views of the city, which were followed in 1836 and 1837 by large compositions of Shakespearean subjects with Venice as their setting, somewhat surprisingly in the former case, where the subject was Juliet. Turner showed no Venetian paintings in the next two years, but from 1840 until 1846 there were two or more Venetian subjects among his exhibits every year. While there is still some doubt that he visited Venice in 1833, it is certain that he was there for about three weeks in 1840. Venice, the city of water, was an obvious source of inspiration for Turner. As Ruskin wrote in one of his most perceptive passages about the artist; 'At Venice he found freedom of space, brilliancy of light, variety of colour, massive simplicity of general form, and to Venice we owe many of the motives in which his highest powers of colour have been displayed.' Venice stands with Farnley and Petworth as one of the vital formative influences in Turner's

art, but while he declined to make public the latter two, his Venetian impressions were an essential element of the public image of the ageing Turner. This was the time when Venice, with its Byronic connections, was steadily gaining popularity with British travellers and artists. Some of the most daring canvases that Turner exhibited in his final years were of Venetian subjects; as we shall see, there was also a private element in Turner's Venetian work, the scintillating watercolours executed on the spot during his final visit.

Soon after his return to England from a tour in France and Germany in 1834 Turner visited Petworth, from which he came back to London in time to witness the burning of the Houses of Parliament during the night of 16 October. On hearing of the fire he rushed out to record the scene from both sides of the river. He made nine rapid water-colour sketches on the spot that night (one is reproduced as Plate 132). These nine drawings were contained in a single sketch-book which was not used again, and which forms part of the Turner Bequest in the British Museum. In the following year (1835) he exhibited two oil paintings of the scene, both now in museums in America. The earlier version (Plate 141) was shown at the British Institution, and we have a vivid record, from the pen of the painter E. V. Rippingille, of how Turner completed this canvas on Varnishing Day. 'The picture when sent in was a mere dab of several colours, and "without form and void", like chaos before the Creation. The managers knew that a picture would be sent there, and would not have hesitated, knowing to whom it belonged, to have received and hung up a bare canvas, than which this was but little better. Such a magician, performing his incantations in public, was an object of interest and attraction. Etty was working at his side and every now and then a word and a quiet laugh emanated and passed between the two great painters. Little Etty stepped back every now and then to look at the effect of his picture, lolling his head on one side and half closing his eyes, and sometimes speaking to some one near him, after the approved manner of painters: but not so Turner; for the three hours I was there—and I understood it had been the same since he began in the morning—he never ceased to work, or even once looked or turned from the wall on which his picture hung. All lookers-on were amused by the figure Turner exhibited in himself, and the process he was pursuing with his picture. A small box of colours, a few very small brushes, and a vial or two were at his feet, very inconveniently placed; but his short figure, stooping, enabled him to reach what he wanted very readily. Leaning forward and sideways over to the right, the left hand metal button of his blue coat rose six inches higher than the right, and his head buried in his shoulders and held down, presented an aspect curious to all beholders, who whispered their remarks to each other, and quietly laughed to themselves. In one part of the mysterious proceedings Turner, who worked

almost entirely with his palette knife, was observed to be rolling and spreading a lump of half-transparent stuff over his picture, the size of a finger in length and thickness. As Callcott was looking on I ventured to say to him, "What is that he is plastering his picture with?" to which inquiry it was replied, "I should be sorry to be the man to ask him." . . . Presently the work was finished: Turner gathered his tools together, put them into and shut up the box, and then, with his face still turned to the wall, and at the same distance from it, went sideling off, without speaking a word to anybody, and when he came to the staircase, in the centre of the room, hurried down as fast as he could. All looked with a half-wondering smile, and Maclise, who stood near, remarked, "There, that's masterly, he does not stop to look at his work; he *knows* it is done, and he is off".'

This well-known description of Turner at work provides a valuable insight into the unorthodox techniques which he used in his later years. These idiosyncratic methods were based on his mastery of the traditional rules of painting which he had painstakingly achieved during the first thirty or forty years of his working life. During these same years he had also constantly developed his skill in the use of watercolours and body-colours, and, as has already been suggested, it was partially through the experience he had gained in these more fluid mediums that he was now able to revolutionise his methods in oils. Many of the details of how he worked during these later years are still a matter of conjecture. One unfortunate consequence of the unorthodoxy of his technique is that it has proved extremely difficult to preserve, clean and restore many of his late canvases.

Understandably the painting of *The Burning of the Houses of Lords and Commons* caused great interest, and on the whole its reception by the critics was favourable; 'Turner's picture transcends its neighbours as the sun eclipses the moon and stars', wrote the critic of the *Spectator*. 'The burst of light', he continued, 'in the body of the flame, and the flood of fiery radiance that forms a luminous atmosphere around all the objects near, cannot be surpassed for truth.' As this perceptive critic had realised, the event was far more than an emotional and historic occasion for Turner; it provided him with just that vital combination of vivid light and colour effects which were the central element of his painting. Turner produced another painting of the fire, seen this time from a more distant point on the Surrey side of the Thames, for the 1835 R.A. exhibition (Plate 133). This canvas also shows signs of having been rapidly painted, but there is no record of its having been completed on the walls of the gallery.

Another of Turner's 1835 R.A. exhibits, *Keelmen hauling in Coals by Night* (Plate 143), demonstrates his continued interest in the painterly possibilities of flames and smoke reflected in water. In this moonlit scene the flames add an element of foreboding to the

ghostly appearance of the ships. That foreboding seems to be realised in the awesome *A Fire at Sea* (Plate 144), a painting which has been considered to be unfinished and which was certainly not exhibited. This composition must have been based on an event experienced by Turner, and in a sketch-book dated by Finberg to 1834 there is a small group of watercolour studies of a ship on fire. In *A Fire at Sea* Turner combines the impact of this experience with his deep existing knowledge of the sea and the sky, and uses all in a great swirl of paint that is almost as alive and dramatic as the moment he is portraying.

Water and the sea in particular continued as a focal centre of interest throughout Turner's life. In the 1830s and 1840s he painted many large and effective studies of waves and of stormy seas. Although it is tempting to think that some of these realistic canvases, such as *Waves breaking on a lee Shore* and *Breakers on a flat Beach* (Plates 145,170), were painted in the open, this is unlikely. However, in these studies Turner shows his complete liberation from the traditional concepts of oil painting. They were essentially 'private' pictures, not meant for exhibition or sale, though Turner may occasionally have used such a canvas as the basis of one of his 'public' compositions. The majority of these sea studies remained in his studio and are in the Turner Bequest, but a few are in other collections, including the lovely *Seascape: Folkestone* belonging to Lord Clark. It has been suggested that these may originally have been given to Mrs. Booth, and sold by her after Turner's death. Turner had lodged with Mrs. Booth at Margate, and later established her in a house at Chelsea where he spent most of his final years. While at Margate Turner certainly spent much time observing the sea, and what is probably his last sketch-book includes drawings of the town.

In 1837 the Royal Academy exhibition was held for the first time in its new galleries in the recently completed National Gallery building in Trafalgar Square. The exhibition was opened by William IV, and the Duchess of Kent and her daughter were in the audience. A few weeks later the King was dead and the Duchess's daughter succeeded as Queen Victoria; the Victorian Age had begun.

Turner was on the Hanging Committee of the 1837 exhibition, to which he contributed four paintings, two of which are now in America. *Scene—a Street in Venice*, in the Huntington Gallery, is a crowded view down the Grand Canal supposedly illustrating an episode in Shakespeare's *Merchant of Venice*. It is one of Turner's most gaudy paintings, and shows none of the subtlety which most of his Venetian canvases display. Its effect is in complete contrast with the dramatic *Snowstorm in the Valley of Aosta*, now in Chicago, in which the swirling storm is reminiscent of *Hannibal Crossing the Alps* (Plate 57) of some twenty-five years earlier. The inspiration for the Aosta composition certainly stems from Turner's visit to Switzerland in 1836, when he was accompanied by his new

patron and friend, Mr. H. A. J. Munro of Novar, but as that visit took place during the summer the artist could not have experienced such a storm on this occasion. The other two paintings in the 1837 exhibition also present a contrast, that of the serene calm of the *Apollo and Daphne* with the turbulent splendour of *The Parting of Hero and Leander* (Plate 142). Predictably Turner presents these two classical subjects in classical style, and both originated in his mind long before they were exhibited—indeed a drawing for the *Hero and Leander* is to be found in a sketch-book used some thirty years earlier. In many ways these works are backward-looking, though in their technique, especially in the complex light effects of the *Hero and Leander*, they display Turner's mature mastery.

He probably showed such compositions in an endeavour to combat the violent criticisms of many of his later paintings, which certainly riled him though they did little to affect his stature as an artist. Indeed it was in 1837 that he was represented for the first time at one of the 'Old Master' exhibitions at the British Institution. The painting shown was 'The Bridgewater Sea Piece', which had been exhibited at the Royal Academy in 1801. In this context it is interesting to note that the two 'classical' exhibits of 1837 remained unsold, while the *Snowstorm in the Valley of Aosta* was bought by Mr. Munro and the Venetian scene by John Ruskin's father. Turner was finding patronage among the rising number of middle-class collectors, and it is significant that the leading figure among his former aristocratic patrons, Lord Egremont, died in November 1837. Lord Egremont's death was a sad blow to Turner, who did not again find such a friendly haven as Petworth, and before that Farnley, had been for him. He himself was ill at the end of the year, and this may have persuaded him finally to resign as Professor of Perspective at the Royal Academy—he had given his last lectures in 1828.

The advent of John Ruskin in his life was perhaps more significant for Turner's posthumous reputation than it was for the artist during his lifetime. The young author had first made the acquaintance of Turner's work when he was given a copy of the fine 1830 edition of Samuel Rogers's *Italy* illustrated with Turner's vignettes. His 'love of Turner' developed rapidly, and in 1836, when he was only seventeen, he drafted a lengthy reply to the violent criticism of Turner's Royal Academy exhibits of that year published in the October issue of *Blackwood's Edinburgh Magazine* (see Appendix). Though approved of by Turner, the letter was not submitted for publication; it has been printed since and amply proves Ruskin's precocious understanding of his idol's work, of which he then knew only the more recent, or engravings. Defending Turner's use of colour, he wrote 'He can produce instantaneous effect by a roll of his brush, and, with a few dashes of mingled colour, will express the most complicated subject: the means employed appear more astonishingly inadequate to the effect produced than in any other master. . . . Turner thinks and feels in colour; he cannot help doing so. Nature

has given him a peculiar eye, and a wildly beautiful imagination, and he must obey its dictates.' In 1837 Ruskin was given his first Turner drawing by his father, and this was soon followed by the acquisition of *Scene—a Street in Venice*.

Ruskin met Turner for the first time three years later. The relationship between the artist and his young critic never became a close one, but during the last years of his life Turner was a fairly frequent visitor at the Ruskin home in Denmark Hill, and he was one of the regular participants at John Ruskin's birthday dinner each February 8th. When Turner died in 1851 Ruskin should have been one of his executors, though in the end he refused to act because of the dispute over the artist's will. Turner became increasingly a recluse during the final decade of his life, and under these circumstances it is surprising that the precocious author became as intimate with the ageing Royal Academician as he did. It is also surprising that in his writings Ruskin makes little of his friendship with the artist; from them we gain a definite impression of worship from afar. At one stage Ruskin was planning to write a biography of Turner, but after Thornbury's publication he abandoned the idea. It is a remarkable and unfortunate fact that even today Turner still lacks a really satisfactory biography—no writer or fellow-artist has succeeded in doing for Turner what C. R. Leslie achieved so brilliantly in his *Memoirs of the Life of John Constable*. Much of Turner's life, especially the later years, is still shrouded in mystery. Modern research is beginning to fill some of the gaps; but there is little sign that one of the greatest needs, the provision of a full and reliable catalogue of the thousands of drawings in the Turner Bequest, will be supplied in the foreseeable future.

By the later 1830s Turner's work specifically for the engravers had almost ceased, as the demand for small books illustrated with fine engravings was ending. However, the fashion for large plates after individual paintings and drawings was gaining momentum once again, and, from 1838 until his death, some twenty such plates after works by Turner were published and proved popular. It is possible that Turner had such publication specifically in mind for a pair of canvases which he exhibited in 1838: *Modern Italy— the Pifferari* (Plate 154) and *Ancient Italy—Ovid banished from Rome*. Painted with overall freedom and luminosity both compositions also contain a wealth of figurative detail on a tiny scale. The *pifferari* (pipers) of *Modern Italy* are two insignificant figures in the left foreground, but their inclusion accords with the kind of genre subject that had become popular in the 1830s, partially through the influence of Wilkie. Indeed it is possible that in his *Pifferari* Turner was tilting at Wilkie's painting of that title, which he had exhibited in 1829, having already sold it to George IV. The Wilkie is a small figure painting and one of the few, rather disappointing, products of his visit to Italy in the mid-1820s. There are several accounts of Turner's jealousy of Wilkie, though other

'legends' record their warm friendship. Wilkie was frequently patronised by Royalty, and he was knighted in 1836. Turner only once received Royal patronage and was never knighted. There can be little doubt that he resented this, and it must have been a particularly cruel blow to him when the Honours announced soon after Queen Victoria's accession included a landscape painter, but not, of course, himself. The chosen artist was Augustus Wall Callcott, R.A., a successful but relatively minor painter who was a follower of Turner; they remained the best of friends.

It cannot really have come to Turner as a surprise that he himself was not selected, for he never made any pretence at being other than an eccentric, and only rarely made any allowances for the manners and fashions of his time. His character ranged from the gruff and harsh to the sympathetic and charitable, and he was never one to hide his true feelings. Ruskin, after their first meeting in 1840, described Turner a 'a somewhat eccentric, keen-mannered, matter-of-fact, Englishminded-gentleman: good-natured evidently, bad-tempered evidently, hating humbug of all sorts, shrewd, perhaps a little selfish, highly intellectual, the powers of his mind not brought out with any delight in their manifestation, or intention of display, but flashing out occasionally in a word or a look.' As Ruskin also wrote, Turner was generally considered to be 'coarse, boorish, unintellectual, vulgar', and he must have agreed wholeheartedly with the artist, George Jones, who wrote to him a few years after Turner's death, 'I am extremely solicitous about Turner, I thought so well of him as an artist and a man; his unpropitiating manner is more remembered by the world than his affectionate kindness to his friends.' As we see from the remarkable portrayal of the shabby and unshaven old man holding a tea-cup at a reception (Plate 5) Turner in his last years was far from being an impressive figure. Eugène Delacroix remembered him as looking like 'an English farmer with his rough black coat and heavy boots, and his cold, hard expression'.

Neither Turner's personal eccentricities nor the apparent eccentricities of his recent art had a fundamental effect on his position as *the* British painter of the day. This was shown by the immediate success and popularity of one of his 1839 Academy exhibits, *The Fighting 'Téméraire'* (Plates 146, 152). The critics were unanimous in their praise, though in *Blackwood's Magazine* that praise was presented with a touch of sarcasm; 'Here is genius . . . a work of great effect and feeling, worthy of Turner when he was Turner!' To modern eyes this ever popular canvas is an outstanding example of Turner's depiction of colour and light; to the public and critics of early Victorian England *The Fighting 'Téméraire' tugged to her last Berth to be broken up*, to give the painting its full title, was attractive largely because of its content. This was a subject picture, a painting with a story which provided a reminder of the country's glorious past. The great warship of 98 guns had been launched at Chatham in 1798 and played a distinguished

role at the Battle of Trafalgar in 1805; Turner's portrayal of the last voyage of the heroic vessel evoked nostalgic feelings of patriotism. All this was brilliantly summed up by the young William Makepiece Thackeray, then a struggling young artist and art critic writing under the pseudonym of Michael Angelo Titmarsh, Esq., in *Fraser's Magazine*. Introducing it as 'as grand a painting as ever figured on the walls of any academy, or came from the easel of any painter', he continued, 'The old Téméraire is dragged to her last home by a little, spiteful, diabolical steamer. A mighty red sun, amidst a host of flaring clouds, sinks to rest on one side of the picture, and illumines a river that seems interminable, and a countless navy that fades away into such a wonderful distance as never was painted before. The little demon of a steamer is belching out a volume . . . of foul, lurid, red-hot, malignant smoke, paddling furiously and lashing up the water round about it; while behind it (a cold grey moon looking down on it), slow, sad, and majestic, follows the brave old ship, with death, as it were, written on her. . . . It is absurd, you will say . . . for Titmarsh, or any other Briton, to grow so politically enthusiastic about a four-foot canvas, representing a ship, a steamer, a river, and a sunset. But herein surely lies the power of the great artist. He makes you see and think a great deal more than the objects before you.' Thackeray ends his passage by predicting that 'when the art of translating colours into music or poetry shall be discovered, [*The Fighting 'Téméraire'*] will be found to be a magnificent national ode or piece of music'. No other painting by Turner ever aroused such widespread enthusiasm; Turner referred to it as 'my darling' and consistently refused to sell it.

Turner's three additional 1839 exhibits included another pair, *Ancient Rome* (Plate 153) and *Modern Rome*. Somewhat theatrical in character, these classical compositions are reminiscent of the crowded canvases of John Martin, who had begun exhibiting regularly at the Royal Academy in 1837. There must again be some suspicion that Turner was displaying his own ability to equal or outdo a potential rival who was gaining popularity. In contrast to such artificial works *The Ponte delle Torri, Spoleto* (Plate 155) represents Turner's more personal art at this period. Based on sketches made during the Italian tour of 1819, this large and delicate painting belongs to that category of 'unfinished' works which Turner on occasion submitted to the exhibitions and then 'completed' during the varnishing days. Fortunately a considerable number of such paintings remained in Turner's studio and in recent years they have been exhibited as an important part of the Turner Bequest. The essential element of *The Ponte delle Torri* is the diffused and misty glow of the Umbrian sunrise; in *Venice, the Piazzetta with the Ceremony of the Doge marrying the Sea* (Plate 156) Turner penetrates the secret of the deep and hot light of Venice in the bold blues of the sky and water. That Venice can also experience cloud and mist is seen in *Festive Lagoon Scene, Venice* (Plate 147).

It was when Turner succeeded in retaining these personal elements in his public pictures that he achieved his outstanding later masterpieces. *The Fighting 'Téméraire'* was one; another was the almost equally famous *Slave Ship* (Plate 148), exhibited in 1840. On that occasion its full title was *'Slavers throwing overboard the Dead and Dying—Typhon coming on'*, and the title was accompanied in the catalogue by seven lines from *The Fallacies of Hope*, of which the last two read 'Hope, Hope, fallacious Hope! Where is thy market now?'. The source for much of the gruesome detail can be found in some graphic lines in James Thomson's *Summer* which Turner had probably had in mind for years. It has been suggested that the immediate factor which moved Turner to attempt this subject was the re-publication in 1839 of T. Clarkson's *History of the Abolition of the Slave Trade* in which was told the dreadful story of the slave ship *Zong*, whose master, when an epidemic broke out among his cargo, threw the sick slaves overboard, as insurance could be claimed for those lost at sea but not for those who died from disease. Here again we have ample evidence of how carefully Turner assembled the material for many of his exhibited paintings. Yet there was, of course, the more important overriding element of Turner's own experience and observation, in this case brilliantly summed up by John Ruskin in a famous passage from the first volume of *Modern Painters*, which was published anonymously in 1843. 'I believe,' he wrote, 'if I were reduced to rest Turner's immortality upon any single work, I should choose this. Its daring conception, ideal in the highest sense of the word, is based on the purest truth, and wrought out with the concentrated knowledge of a life: its colour is absolutely perfect, not one false or morbid hue in any part or line, and so modulated that every square inch of canvas is a perfect composition; its drawing as accurate as fearless; the ship buoyant, bending, and full of motion; its tones as true as they are wonderful; and the whole picture dedicated to the most sublime of subjects and impressions . . . the power, majesty, and deathfulness of the open, deep, illimitable sea.'

This moving passage is typical of Ruskin's prose at its best. But it is more than just a piece of fine writing; it shows Ruskin's deep feeling for an understanding of the art of Turner, and we should remember that these lines were written before their author owned the painting concerned; he was given the *Slave Ship* by his father in 1844. The first and second (1846) of the five volumes of *Modern Painters* are a monumental defence of the later work of Turner, and, until quite recently, much of the subsequent thinking and feeling about Turner has been strongly influenced by these youthful writings of Ruskin. Great enthusiasm and sincerity lie at the heart of *Modern Painters*, making its outspoken and often violent criticism tolerable. Yet when he wrote these confident passages Ruskin's knowledge and experience of painting—even of that of Turner—was relatively limited. This defect was more than made good by Ruskin's instinctive understanding of

his hero's work, though Turner is reported to have said at one time that Ruskin 'discovered in his pictures things which he himself did not know were there'. Ruskin's authorship of *Modern Painters* became public knowledge in 1849, when his *The Seven Lamps of Architecture* was published as 'by John Ruskin, author of *Modern Painters*'. His reputation as the leading art critic of the day was immediately established. There is no doubt that Turner did benefit from the advocacy of this brilliant young man, who was at that time himself building up an unrivalled collection of Turner's drawings.

Turner showed as many as seven paintings at the Royal Academy of 1840. Two of these were of Venetian views, of which one, *Venice, from the Canale della Giudecca, Chiesa di S. Maria della Salute, &c.* (Plate 157), was bought by John Sheepshanks. Another of the 1840 exhibits, the lovely and intimate *Neapolitan Fisher Girls surprised bathing by Moonlight*, was acquired by Robert Vernon, though he sold it two years later at Christie's where it fetched only 55 guineas. The same collector purchased one of the two Venetian subjects shown in 1842, *The Dogano, San Giorgio, Citella, from the Steps of the Europa* (Plate 158), which was one of four works by Turner in the collection of British paintings which he presented to the National Gallery in 1847. The second of the 1842 Venetian subjects, the *Campo Santo, Venice* (Plate 159), was bought for 150 guineas by another of the 'new' collectors, Mr. Elhanan Bicknell, who assembled ten paintings as well as watercolours by Turner at his house in Herne Hill. He bought six of these direct from the artist in 1844, when he paid 1000 guineas for the *Palestrina* of 1828 (Plate 122).

Royal patronage, however, continued to elude Turner, who now renewed his efforts to achieve it. Queen Victoria had married Prince Albert in 1840, and his interest in art was well known. During his tour in Germany that year Turner visited Coburg, the Prince's birthplace. In the following year he exhibited *Schloss Rosenau, seat of H.R.H. Prince Albert of Coburg, near Coburg, Germany* (Plate 160), but, despite its sweet romantic manner, this did not enter the Royal Collection. Turner probably had similar hopes for *Heidelberg Castle in the Olden Time* (Plate 161), which dates from about this time though it was not exhibited. In its free technique this large canvas is once again reminiscent of Turner's use of watercolours, as comparison with the fluent drawing of Heidelberg (Plate 149) shows. It may well have been the way that *Schloss Rosenau* was painted that offended Victoria and Albert, whose taste in paintings at this time was for the precise and meticulous work of artists such as the Nazarenes or Landseer. Nor were the critics at all enthusiastic for the thick and solid paint of *Schloss Rosenau*, of which *The Times* wrote that 'it resembles nothing in nature but eggs and spinach. The lake is a composition in which salad oil abounds and the art of cookery is more predominant than the art of painting'. Again it was the Venetian subjects, of which there were three, that were best received at the 1841 exhibition, as were the two shown in 1842 (Plates 158, 159).

Little is known of how Turner himself reacted to the violent criticism so often thrown at his work. However, there is some evidence about this in the case of another of his 1842 exhibits, the dramatic marine composition, *Snowstorm—Steamboat off a Harbour's Mouth making signals in shallow Water, and going by the Lead. The Author was in this Storm on the Night the Ariel left Harwich* (Plate 173). On the day that one critic declared it 'a mass of soapsuds and whitewash' Turner was dining with the Ruskins. After dinner John Ruskin heard him 'muttering low to himself at intervals, "Soapsuds and whitewash!" again and again, and again. At last I went to him, asking, "why he minded what they said?" Then he burst out—"Soapsuds and whitewash! What would they have? I wonder what they think the sea's like? I wish they had been in it".' On the other hand we know from Turner's friend the Rev. W. Kingsley that when he told the artist that his mother admired the *Snowstorm*, Turner replied that he had only painted it because he 'wished to show what such a scene was like; I got the sailors to lash me to the mast to observe it; I was lashed for four hours, and I did not expect to escape, but I felt bound to record it if I did. But no one had any business to like it.'

Turner was then in his mid-sixties; several of his fellow-members of the Royal Academy had died in these years, including in 1841 his close friends Sir David Wilkie (also at times a competitor) and Sir Francis Chantrey, who were both younger men. Apart from the President, Sir Martin Archer Shee, Turner was the most senior Academician. For forty years he had been at the centre of the artistic world of London, and had been one of its chief ornaments. But a penalty of such early and continuous success was inevitably increasing loneliness and isolation. Something of this can be sensed in another of his 1842 exhibits, *Peace—Burial at Sea* (Plate 174), which commemorated the death of Wilkie at sea on the return voyage from the Middle East; but this dark and sombre composition seems to mourn more than the passing of one man—like *The Fighting 'Téméraire'* it symbolises the end of an era.

However unorthodox in technique, the 1842 exhibits still retained recognisable subject matter, but in the following year Turner showed a pair of compositions that were almost abstract. These were *Shade and Darkness—the Evening of the Deluge* (Plate 151) and *Light and Colour (Goethe's Theory)—the Morning after the Deluge—Moses writing the Book of Genesis* (Plate 150). Perspicaciously described by one critic of the day as 'two riddles that none but himself [Turner] can read', these pendant circular compositions have received considerable attention as evidence of Turner's thinking on theories of light and colour. The first English translation, by Turner's friend and fellow-artist Charles Eastlake, of Goethe's celebrated *Theory of Colours (Farbenlehre)* had been published in 1840. Though that publication may have revived Turner's interest, it seems probable that he had already been familiar with Goethe's thinking for many

years, and these two puzzling canvases confirm the belief that Turner was not a man to be moved or influenced by particular theories. He was something of a scavenger, garnering material from every conceivable source, and re-using it in his individual way. *Shade and Darkness* and *Light and Colour* are prime examples of that individuality.

In the final decade of his life Turner continued to work prolifically in watercolour, and, as in earlier years, he made progress most consistently in that medium. During his last visit to Venice he used a roll sketch-book with relatively large sheets of white paper to make rapid on-the-spot watercolour studies, such as the magical views of the *Grand Canal* (Plate 162) and the *Riva degli Schiavoni* (Plate 163) reproduced here. In the Turner Bequest there are large groups of late Venetian drawings in watercolour and body-colours, some of them on grey and brown paper, which have yet to be firmly dated. It seems probable that the majority of these belong to the 1840 visit. In several instances one of these drawings was used by Turner as the basis of an exhibited Venetian oil painting, as in the case of the translucent *St. Benedetto, looking towards Fusina* (Plate 164), which was shown in 1843. There is a similar connection not previously recognised, between the drawing of the *Riva degli Schiavoni* reproduced here and the painting *Venice Quay, Ducal Palace* exhibited in 1844 (Plate 165). In these late drawings and paintings of Venice there is little to distinguish between Turner's technique in watercolour or in oils.

The full significance of Turner's later work in watercolour has yet to be elucidated. The quantity of drawings in the Turner Bequest makes this a daunting task, and when compiling his *Inventory*, A. J. Finberg listed hundreds of such drawings under the general heading of "Miscellaneous". The sketch-book study of *Ehrenbreitenstein* (Plate 167) is included in this category, as are other studies of this great rock fortress on the Rhine opposite Coblenz. It was one of the places which Turner visited several times on his travels and to which he devoted a number of drawings recording different effects of light and weather. In the present drawing, which is sometimes called the 'pink' Ehrenbreitenstein, the glowing sunset light is depicted in a variety of techniques, ranging from the use of a wet brush to that of his fingers and the tip of his brush handle. The last was also used to achieve some of the evocative and yet simple effects of the famous watercolour *Dawn after the Wreck* (Plate 171). Here the addition of the miserable dog shivering on the beach, adds to the poignancy of the whole. This drawing belonged to Turner's friend, the Rev. W. Kingsley, and it is possible that the dog was added as an afterthought to make this a more 'finished' subject rather than just an on-the-spot study, such as *River with Distant Castle* (Plate 166).

Turner's four final visits abroad, in the summers of 1841 to 1844, all took him to Switzerland; on these it was the lakes as much as the mountains that gave him material

for many watercolour sketches. On his return to England in 1842 Turner approached his dealer, Mr. Griffith of Norwood, with fifteen Swiss sketches from which he proposed to make ten finished drawings (of which he had already completed four) to sell at 100 guineas each. Griffith had considerable difficulty in selling these watercolours, but finally disposed of them at 80 guineas each to Mr. Munro of Novar, Mr. Bicknell and to John Ruskin, who has left a detailed account of this whole transaction. Ruskin considered these drawings as outstanding, especially *The Splügen Pass* (Plate 168), which Turner himself thought the finest of the group. This sombre composition executed largely in yellows, browns and greys, and with only small 'scratches' of colour, achieves a magnificent depth and breadth. There is something of the same feeling of infinity in *The 'Blue Rigi'* (Plate 169), in which the mountain on the Lake of Lucerne is seen 'floating' in the misty morning light. At Lucerne Turner stayed at *The Swan* inn, from the windows of which he could observe the constant changes in the tones, colours and surfaces of the lake and the mountain beyond it. Some of his rapid blot-like studies of these changes are in the 'Lucerne Sketch-Book' in the Turner Bequest, and there are many others among the miscellaneous late drawings. Six of the ten 1842 Swiss watercolours were of Lucerne and Rigi.

Turner again approached Griffith in 1843 with sketches for ten more Swiss watercolours on the same terms as in the previous year. On this occasion the dealer was only able to secure commissions for five finished drawings, of which two went to Ruskin and three to H. A. J. Munro of Novar. One of these three was probably another Lucerne subject, the *Lucerne by Moonlight* (Plate 180), which now forms part of the R. W. Lloyd Bequest in the British Museum, where it can be studied together with the original sketch (Plate 179). The haunting atmosphere of the sketch is somewhat lost in the firmer technique of the finished drawing, and to modern eyes some of the finished late Swiss watercolours are not as effective as the spontaneous studies on which they were based. Ruskin, on the other hand, considered the 1842 and 1843 watercolours to be among Turner's greatest achievements, and wrote movingly about them on numerous occasions. Turner executed another group of eight Swiss drawings for sale in 1845, and, as is proved by the recently discovered 1846 watermark on the *Lake of Geneva* (Plate 172), continued to do so in the following years. In the *Lake of Geneva* watercolours and bodycolour are used in a variety of techniques, including painstaking stippling; but much of the effect relies on leaving the white paper totally exposed, and this is how the distant snow-capped mountains are represented. This drawing proves beyond doubt that Turner remained the greatest watercolour artist of the day even in his closing years, though he himself never exhibited watercolours after 1830. He was not influenced by current fashions in his watercolours, except in his early years. Cotman, Cox, Varley

and De Wint were among the numerous outstanding artists in this medium during the second half of Turner's life, but there is no sign of influence on Turner by any of them. On the other hand there was a considerable number of lesser watercolour artists who produced work in Turner's manner in the 1830s and '40s and later.

As a painter in oils Turner attracted fewer followers, though there were numerous efforts to produce fake Turners in the years immediately before and after the artist's death. It was largely the topographical works that attracted the attention of these artists, and no painter set out to rival or emulate such masterpieces as *The Fighting 'Téméraire'* or *Rain, Steam, and Speed* (Plate 175). The latter was one of seven paintings exhibited in 1844, its full title being *Rain, Steam, and Speed—The Great Western Railway*. It was another of Turner's symbolic works, painted at the height of the Railway Mania and recording with immense drama the effect that the 'omnipresent fiery monsters' must have had on the placid English countryside. Thackeray again wrote a perceptive description of this canvas, which closed by stating that 'the world has never seen anything like this picture'. This was entirely true, but there was no artist in Britain able to follow Turner's daring lead, though thirty years later some of the French Impressionists, particularly Monet, produced great paintings of railway trains and their surroundings. Once again Turner used a personal experience, described in several later apocryphal reports, as the basis of his composition. He completed the painting on the Academy varnishing days when he was watched by the nine-year-old G. D. Leslie, who himself became an R.A. many years later and who recalled: 'He used rather short brushes, a very messy palette, and, standing very close up to the canvas, appeared to paint with his eyes and his nose as well as his hand' (see Plate 4).

1845 was an active year for Turner, who celebrated his seventieth birthday that April. Owing to the illness of the President of the Royal Academy, Sir Martin Archer Shee, Turner acted as Deputy-President for a considerable period. Yet he still had the time and energy to prepare work for the annual summer exhibitions, showing six paintings at the R.A. in this and the following year. In addition he sent *The Opening of the Wallhalla* (originally shown at the Academy in 1843) as his contribution—by invitation—to the Congress of European Art in Munich in 1845. The painting was not well received by the Germans, and Turner had the additional annoyance of finding when it was returned that it was damaged.

Two of the Academy exhibits in 1845 were concerned with a new theme, the hazards and challenges of whale-fishing (see Plate 176). In the catalogue both paintings were simply entitled *Whalers*, but the titles were accompanied by specific references to Thomas Beale's *Natural History of the Sperm Whale*, which had been published in 1839. Turner was inspired by this book for his final great series, for he showed two whaling

subjects again the following year. In that year he also showed one of his rare Biblical works, *The Angel standing in the Sun* (Plate 181), in which the all-powerful forces of sunlight are portrayed as the basis of the Apocalyptic catastrophe. In these late exhibits, Turner's principal subject was light, but in such works as *The Angel standing in the Sun* there is also a variety of symbolic content, which allows for an equal variety of interpretation. Ruskin dismissed these works as the product of a mind that was senile and unbalanced; others have seen them as indicative of overwhelming pessimism and gloom. There is little positive evidence concerning Turner's state of mind and way of life in his closing years, although the picture that has been built up is one of increasing eccentricity and withdrawal.

Turner lived in a cottage on the river at Chelsea, but he retained his gallery in Queen Ann Street until his death. As well as the painting by George Jones (Plate 6), we have several vivid descriptions of this during these years, including one written after a visit in May, 1846, by the authoress Miss Elizabeth Rigby, who was to marry the artist Sir Charles Eastlake a few years later. 'The door was opened', wrote Miss Rigby, 'by a hag of a woman, for whom one hardly knew what to feel most, terror or pity—a hideous woman is such a mistake. She showed us into a dining-room, which had penury and meanness written on every wall and article of furniture. Then up into the gallery; a fine room—indeed, one of the best in London, but in a dilapidated state; his pictures the same. The great *Rise of Carthage* all mildewed and flaking off; another with all the elements in an uproar, of which I incautiously said: "The End of the World, Mr. Turner?" "No, ma'am: *Hannibal crossing the Alps*." His *Battle of Trafalgar* excellent, the disposition of the figures unstudied apparently. Then he uncovered a few matchless creatures, fresh and dewy, like pearls just set—the mere colours grateful to the eye without reference to the subjects. The *Téméraire* a grand sunset effect. The old gentleman was great fun.'

Among the 'matchless creatures, fresh and dewy, like pearls just set' may have been such canvases as *Norham Castle, Sunrise* (Plate 177). It is impossible to date this and similar studies accurately, but it is certain that they are the work of Turner's old age, though, as the comparative illustrations (Plates 184–90) show, the *Norham Castle* is based on a life-long sequence of depictions of this subject. We see him here in the calmest of moods, his eye thrilled by the beauty of the sunrise which he had witnessed so often, for he was an early riser, his brush evoking it with a wonderful combination of colour and form and a full understanding of the problems of light involved. From such late masterpieces we can assume that Turner the artist was still very much alive.

As we have seen, he had already achieved the status of an 'Old Master', and Turner himself was definitely aware of the remarkable reputation which he enjoyed. In an early

Will he bequeathed two works to the newly formed National Gallery, to hang in perpetuity beside two paintings by Claude. In a later Will he devised an ambitious scheme for the formation of a Turner Gallery, and for the creation of a home for indigent artists, to which he assigned the bulk of his fortune, amounting to some £140,000. This Will was successfully disputed by distant relatives, who, though this was entirely contrary to Turner's wishes, received the money, while the contents of the artist's studio—some 300 paintings and some 19,000 drawings and watercolours— passed to the Nation, represented by the National Gallery. The housing and exhibiting of this vast collection was for many years a matter of controversy and there is still considerable room for improvement. A selection of the paintings is on view at the National Gallery, while a larger series is shown in a number of special galleries at the Tate Gallery. The drawings are kept permanently in the Print Room of the British Museum, though a selection is shown at the Tate Gallery. Thus thanks to his own forethought, England possesses a uniquely representative collection of the work of its greatest painter; what is surprising is that despite this, there are still such lacunae in our knowledge of Turner's life and work.

Having shown nothing in 1848 and only two early works in 1849, including *The Wreck Buoy* (Plate 183) after considerable alterations, Turner made a special effort for the exhibition of 1850, for which he painted four ambitious compositions, all of subjects taken from the story of Dido and Aeneas, and each accompanied by a 'quotation' from the *Fallacies of Hope*. These were the last paintings exhibited by Turner at the Royal Academy, and, though they are not among his greatest work, they are a remarkable achievement for a man of his age, combining his usual freedom of technique with grandeur of composition. *The Visit to the Tomb* (Plate 182) features a vivid evening sky with the sun setting in the centre of the picture, and was accompanied by the line, 'The sun went down in wrath at such deceit'. Another late sunset painting, *Sun setting over a Lake* (Plate 178), reminds us of the spectacular development of Turner's art from the proficient topographical watercolours of his teens to the fluent and courageous visions of light and colour of his seventies. This canvas brings to mind the description of Turner's last moments in his home at Chelsea as recorded by W. Bartlett, the 'Surgeon Dentist and Cupper', who attended him in his final illness: 'it was very dull and gloomy, but just before 9 a.m. the sun burst forth and shone directly on him with that brilliancy which he loved to gaze on and transfer the likeness to his paintings. He died without a groan.'

Biographical Outline

1775	23 April. Joseph Mallord William Turner born at 21 Maiden Lane, Covent Garden, London, the eldest son of a barber.
1787	First signed and dated drawings.
1789	Probable date of earliest sketch-book from nature. Admitted student at the Royal Academy Schools, where he studied for four years. Also studying under Thomas Malton during this period.
1790	First exhibit, a watercolour, at the Royal Academy.
1791	First sketching tour, at Bristol, Bath, Malmesbury, etc.
1792	First visit to Wales.
1793	Awarded the 'Greater Silver Pallet' for landscape drawing by the Society of Arts.
1794	Publication of the first engraving after one of his drawings. Probably first year in which he spent the winter evenings copying drawings for Dr. Monro, often together with Thomas Girtin.
1795	Shows eight watercolours at the Royal Academy.
1796	Exhibits his first oil painting at the Royal Academy.
1797	First visit to the Lake District.
1799	Elected an Associate of the Royal Academy. Takes lodgings in Harley Street.
1802	12 February. Elected a full member of the Royal Academy. First journey abroad, to France and Switzerland.
1804	Death of Turner's mother. First exhibition at his own gallery in Harley Street.
1806	Takes a house on the river at Hammersmith.
1807	First part of the *Liber Studiorum* published. Elected Professor of Perspective at the Royal Academy.
1810	First recorded visit to Walter Fawkes at Farnley Hall in Yorkshire, where he was a frequent visitor until 1824.
1811	Delivers first lectures as Professor of Perspective. Starts building house at Twickenham. Alterations to his Gallery; the entrance is moved to Queen Ann Street West.
1815	Turner's R.A. exhibits violently criticised by Sir George Beaumont.
1817	Tour of the Netherlands and the Rhine Valley.
1819	Highly successful exhibitions of his works at the London homes of two of his patrons, Sir John Leicester and Walter Fawkes. In August sets out on first visit to Italy.
1820	Returns from Italy in February.
1821	Major alterations in house and gallery at Queen Ann Street West (formerly Harley Street) completed. Visit to France.
1822	Series of watercolours made for engravings exhibited in London by the publisher W. B. Cooke. Further exhibitions in 1823 and 1824. Visits Edinburgh, going by sea up the East coast.
1823	Commissioned to paint the *Battle of Trafalgar* for St. James's Palace. Sketches on the south-east coast.
1825	Tour of Holland, the Rhine and Belgium. Death of Walter Fawkes.
1826	Visits the Meuse, the Moselle, Brittany, and the Loire.
1827	Stays on Isle of Wight as guest of John Nash, the architect. Probable beginning of regular visits to Petworth, as guest of Lord Egremont.
1828	Last lectures as Professor of Perspective. Second visit to Italy; exhibited three oils in Rome.
1829	Visit to France. Death of Turner's father, who had long been living with him.
1832	Exhibition of engraved watercolours at Messrs. Moon, Boys and Graves, London; also in 1833 and 1834.
1833	First Venetian subjects exhibited at the Royal Academy. Visit to Paris and Italy, including, probably, Venice.
1834	Visit to France and Germany.
1835	Visit to Italy.
1836	Visit to France and Switzerland.
1837	Represented in British Institution's 'Old Masters' Exhibition. Death of Lord Egremont. Resigns as Professor of Perspective.
c.1839	Takes a cottage on the river at Chelsea.
1840	Visit to Italy, including Venice.
1841	Visits Switzerland, and again in 1842, 1843 and 1844.
1843	Anonymous publication of first volume of Ruskin's *Modern Painters*.
1845	Represented at the Congress of European Art in Munich. Acts as Deputy-President of the Royal Academy during the President's illness; continues with these duties in 1846. Two short visits to French coast, his last journeys abroad.
1848	Painting hung in the National Gallery to represent the Vernon Gift. No exhibits at Royal Academy.
1849	Two early works shown in the British Institution's 'Old Masters' Exhibition.
1850	Last exhibits (four oils) at the Royal Academy.
1851	19 December. Dies at his home in Chelsea; is buried in St. Paul's Cathedral on 30 December.

Contemporary Reviews and Comments

In what may be termed the view department Mr. Turner steps before his brethren with gigantic strides; he looks at nature with a penetrating and discriminating eye, and arranges her representations with exquisite taste, aided by a powerful genius. He has in our opinion more of that sublime faculty which we denominate genius than any other of the pictorial claimants; and could be another Claude or Vandevelde if he thought it expedient; but it is necessary for the dignity of the British School that he should be the father and founder of his own manner.
Morning Post, 1802.

We hasten, while we have yet room in this, to congratulate the country in having to boast of work which will carry down to posterity the date of the present time and cause it to be named with honour by those who are yet unborn. Contemporary criticism seems puny, and almost irreverent when applied to productions whose flourishing existence, when criticism is hushed and critics are no more, is secured by the eternal laws that regulate the moral nature of man. Wilkie's *Distraining for Rent* (118), and Turner's *Crossing the Brook* and *Dido building Carthage* are of this high class, and one almost shrinks from discussing in a newspaper paragraph achievements that raise the achievers to that small but noble group whose name is not so much of to-day as of all time.
William Hazlitt, in *The Champion*, 1815.

Sir George Beaumont called & sat a considerable time. He had just come from the Exhibition at the Royal Academy. He had again attentively considered Turner's picture of '*Dido* building Carthage'—so much cried up by Artists & newspapers. He wished to satisfy Himself that He was not mistaken in the judgment He had formed upon it:– He felt convinced that He was right in that opinion, and that the picture is painted in a false taste, not true to nature; the colouring discordant, out of harmony, resembling those French Painters who attempted imitations of Claude Lorrain, but substituted for His purity & just harmony, violent mannered oppositions of Brown and hot colours to cold tints, blues & greys: that several parts of Turner's picture were pleasingly treated but as a *whole* it was of the above character.
Of His picture 'Crossing the Brook' He sd. it appeared to Him *weak* and like the work of an Old

man, one who no longer saw or felt colour properly; it was all of *pea-green* insipidity.—These are my sentiments said He, & I have as good a right & it is as proper that I shd. express them as I have to give my opinion of a poetical or any other production.
The Farington Diary, 5 June, 1815. Reproduced by gracious permission of Her Majesty the Queen. James Greig edition, vol. VIII, 1928, p. 5.

To J. M. W. TURNER, ESQ., R.A., P.P.
My dear Sir, The unbought and spontaneous expression of the public opinion respecting my Collection of Water Colour Drawings, decidedly points out to whom this little catalogue should be inscribed.

To you, therefore, I dedicate it, first as an act of duty, and secondly as an Offering of Friendship; for, be assured, I can never look at it without intensely feeling the delight I have experienced during the greater part of my life from the exertion of your talent, and the pleasure of your society.

That you may year after year reap an accession of fame and fortune is the anxious wish of your sincere friend,
WALTER FAWKES
Dedication of the Catalogue printed after the Exhibition of the Fawkes Collection in London in 1819.

Having touched every natural key in the scale of art, Mr. Turner is determined to become attractive by the violence of his powers: yet, amidst all this glitter and gaud of colours, it is impossible to shut our eyes to the wonderful skill, and to the lightness and brilliancy which he has effected: so that had the subject been a fairy scene, we should have regarded it with admiration, nor, as now, lamented that it was anything but natural.
The Literary Gazette, 1826.

I have fortunately met with a good-tempered, funny, little, elderly gentleman, who will probably be my travelling companion throughout the journey. He is continually popping his head out of window to sketch whatever strikes his fancy, and became quite angry because the conductor would not wait for him whilst he took a sunrise view of Macerata. 'Damn the fellow!' says he. 'He has no feeling.' He speaks but a few words of Italian, about as much of French, which two languages he jumbles together most amusingly. His good

temper, however, carries him through all his troubles. I am sure you would love him for his indefatigability in his favourite pursuit. From his conversation he is evidently *near kin to*, if not *absolutely*, an artist. Probably you may know something of him. The name on his trunk is, J. W. or J. M. W. Turner!

Letter from Thomas Uwins (quoting an anonymous source) to Joseph Severn, dated Naples, 3 February 1829 (Mrs. Uwins, *A Memoir of Thomas Uwins, R.A.*, 1858, Vol. II, p. 240).

This celebrated artist stands unrivalled; a perfect master of his art. In his innumerable works he has produced almost every effect of light and shade of which the face of landscape is susceptible. His pictures are full of truth and poetry, and he seizes with a masterly hand the most sublime features of nature. There is so much genius and knowledge of art in his pictures, that his engravings from them have become works of reference to many of his contemporaries. Mr. Turner may be said to have founded a new school of landscape painting; a school superior for its brilliance and originality to any other in the world.

The Gallery of Modern British Artists, 1834.

Turner reminds us of the story of the man that sold his shadow, and that he might not appear singular, will not let anything in the world have a shadow to show for love or money. But the worst of it is, there is so great a submission to Turner's admitted genius, that his practice amounts to a persuasion to hosts of imitators to reject shadows, find them where they will. They would let in light into Erebus, and make 'darkness' much beyond the 'visible' point. Turner has been great, and now when in his vagaries he chooses to be great no longer, he is like the cunning creature, that having lost his tail, persuaded every animal that had one, that it was a useless appendage. He has robbed the sun of his birthright to cast shadows. Whenever Nature shall dispense with them too, and shall make trees like brooms, and this green earth to alternate between brimstone and white, set off with brightest blues that no longer shall keep their distance; when cows shall be made of white paper and milk-white figures represent pastoral, and when human eyes shall be happily gifted with a kaleidoscope power to patternize all confusion, and shall become ophthalmia proof, then will Turner be a greater painter than ever the world yet saw, or than ever the world, constituted as it is at present, wishes to see. It is grievous to see genius, that it might outstrip all others, fly off into mere eccentricities, where it ought to stand alone, because none to follow it.

Blackwood's Edinburgh Magazine, October, 1836.

Not only in truth to nature, but in all other points, Turner is the greatest landscape painter who has ever lived. But his superiority is, in matters of feeling, one of kind, not of degree. Superiority of degree implies a superseding of others; superiority of kind implies only sustaining a more important, but not more necessary, part than others. If *truth* were all that we required from art, all other painters might cast aside their brushes in despair, for all that they have done he has done more fully and accurately; but when we pass to the higher requirements of art, beauty and character, their contributions are all equally necessary and desirable, because different, and however inferior in position or rank, are still perfect of their kind; their inferiority is only that of the lark to the nightingale, or of the violet to the rose.

John Ruskin, *Modern Painters*, Vol. I, 1843.

Whatever hesitation might have been felt by the mass of those who gazed on the later efforts of his brush in believing that he was entitled to the highest rank in his profession, none of his brethren seems to have any doubt of his decided excellence, and the best of them all have ever readily admitted his superiority in poetry, feeling, fancy, and genius. Long ere his death he had the felicity of knowing that his name and his works were regarded with that reverential respect and estimation which is given to other artists by posterity alone, and his earlier productions have been placed among the classical ornaments of our choicest collections and galleries for many years. Even those who could only sneer and smile at the erratic blaze of his colour . . . lingered minute after minute before the last incomprehensible 'Turner' that gleamed on the walls of the Academy, and the first name sought for upon the catalogue by the critic, artist, and amateur . . . was his also.

The Times, 31 December, 1851.

Turner's conversation, his lectures, and his advice were at all times enigmatical, not from want

of knowledge, but from want of verbal power. Rare advice it was, if you could unriddle it, but so mysteriously given or expressed that it was hard to comprehend—conveyed sometimes in a few indistinct words, in a wave of the hand, a poke in the side, pointing at the same time to some part of a student's drawing, but saying nothing more than a 'Humph!' or 'What's that for?'. Yet the fault hinted at, the thing to be altered was there, if you could but find it out; and if, after a deep puzzle, you did succeed in comprehending his meaning, he would congratulate you when he came round again, and would give you some further hint; if not, he would leave you with another disdainful growl, or perhaps seizing your porte-crayon, or with his broad thumb, make you at once sensible of your fault. . . . The schools were usually better attended during his visitorships than during those of most other members, from which it may be inferred that the students appreciated his teaching. . . .

His lectures on perspective, after he was elected to the professorship, were, from his naturally enigmatical and ambiguous style of delivery, almost unintelligible. Half of each lecture was addressed to the attendant behind him, who was constantly busied, under his muttered directions, in selecting from a huge portfolio drawings and diagrams to illustrate his teaching; many of these were truly beautiful, speaking intelligibly enough to the eye, if his language did not to the ear. As illustrations of aërial perspective and the perspective of colour, many of his rarest drawings were at these lectures placed before the students in all the glory of their first unfaded freshness. A rare treat to our eyes they were. Thomas Stothard, the librarian to the Royal Academy, who was nearly deaf for some years before his death, was a constant attendant at Turner's lectures. A brother member, who judged of them rather from the known dryness of the subject, and the certainty of what Turner's delivery would be, than from any attendance on his part, asked the librarian why he was so constant. 'Sir,' said he, 'there is much to *see* at Turner's lectures—much that I delight in seeing, though I cannot hear him.' . . .

In person Turner had little of the outward appearance that we love to attribute to the possessors of genius. In the last twenty years of his life, during which we knew him well, his short figure had become corpulent—his face, perhaps from continual exposure to the air, was unusually red, and a little inclined to blotches. His dark eye was bright and restless—his nose, aquiline. He generally wore what is called a black dress-coat, which would have been the better for brushing—the sleeves were mostly too long, coming down over his fat and not over-clean hands. He wore his hat while painting on the varnishing days—or otherwise a large wrapper over his head, while on the warmest days he generally had another wrapper or comforter round his throat—though occasionally he would unloose it and allow the two ends to dangle down in front and pick up a little of the colour from his ample palette. This, together with his ruddy face, his rollicking eye, and his continuous, although, except to himself, unintelligible jokes, gave him the appearance of one of that now wholly extinct race—a long-stage coachman.
Samuel and Richard Redgrave, *A Century of British Painters*, 1866.

The Plates

WITHIN THE LIMITATIONS posed by matters of design and production the plates are arranged in a chronological sequence. Each caption includes a date; if this is preceded by '*c.*' this indicates that it is an approximate date, usually based on comparative or stylistic criteria; if by 'R.A.' or 'B.I.' this means that the work was exhibited at the Royal Academy or British Institution in that year.

In all measurements height precedes width. In no case is the reproduction of a work an enlargement; in a few cases drawings are reproduced actual size, and this is indicated in the caption.

For drawings in the Turner Bequest, deposited in the British Museum, the relevant *Inventory* references are given at the end of the captions.

(Plates 1 to 7 will be found in the text)

8. *(opposite) Transept of Tintern Abbey, Monmouthshire.* R.A. 1795. Watercolour over pencil, with pen and ink; $14 \times 10\frac{1}{4}$ in. (355×260 mm.) Oxford, Ashmolean Museum.

9. *The Pantheon, the Morning after the Fire.* 1792.
 Watercolour;
 $15\frac{1}{2} \times 20\frac{1}{2}$ in. (394×520 mm.)
 London, British Museum (IX A).

10. *Buttermere Lake, with Part of Cromack Water, Cumberland, a Shower*. R.A. 1798.
Oil on canvas;
35 × 47 in. (889 × 1,193 mm.)
London, Tate Gallery.

11. *Calais Pier, with French Poissards
 preparing for Sea: an English Packet
 arriving.* R.A. 1803.
 Oil on canvas;
 $67\frac{3}{4} \times 94\frac{1}{2}$ in. $(1,720 \times 2,400$ mm.)
 London, National Gallery.

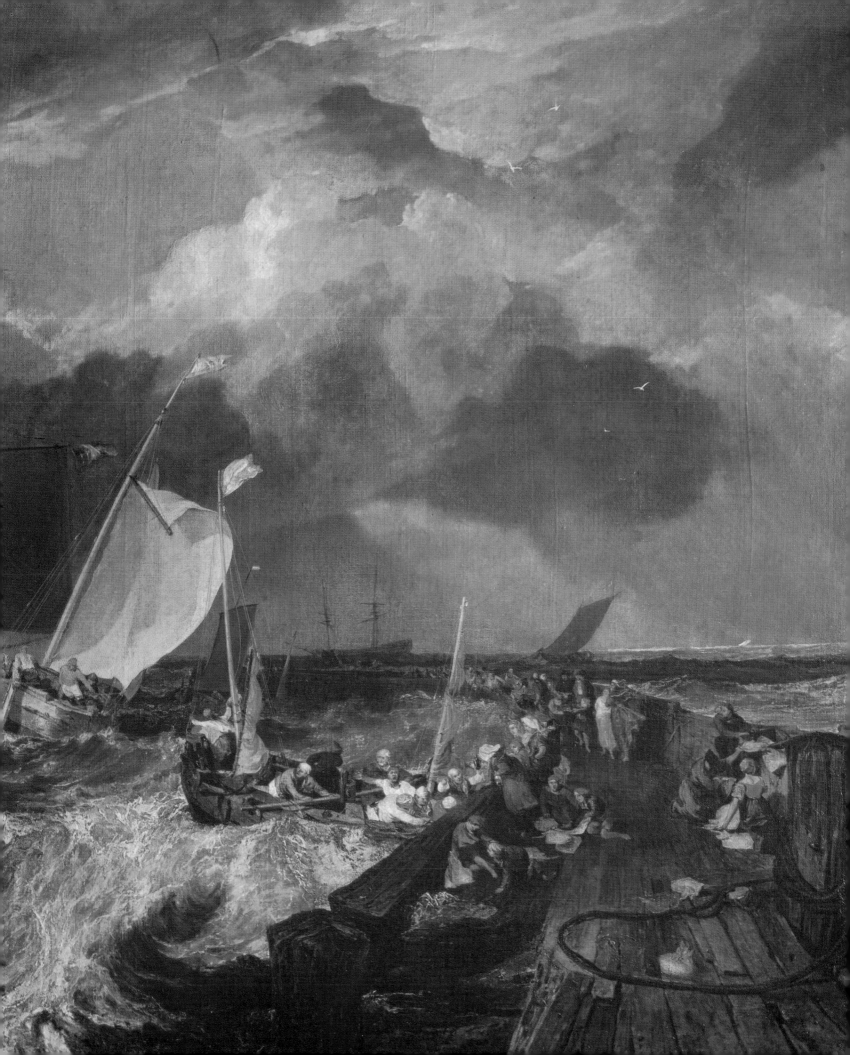

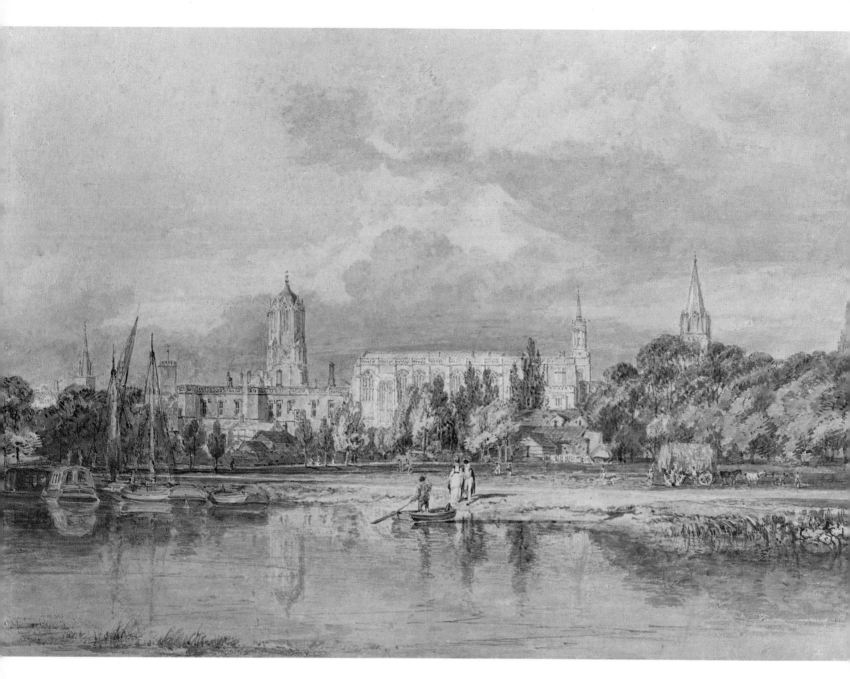

12. *South View of Christ Church, &c. from the Meadows.* 1799.
Watercolour, with some pen and black ink, over pencil;
$12\frac{3}{8} \times 17\frac{3}{4}$ in. (315 × 451 mm.)
Oxford, Ashmolean Museum.

13. Paul Sandby, R.A.,
 Windsor Castle; The Hundred Steps. c. 1790–5.
 Gouache;
 17¼ × 23 in. (439 × 585 mm.)
 Windsor, The Royal Collection, Windsor Castle
 (reproduced by gracious permission of Her
 Majesty the Queen).

14. *Chepstow Castle.* 1794.
 Watercolour;
 8 × 11¾ in. (203 × 297 mm.)
 London, Courtauld Institute of Art, University of
 London.

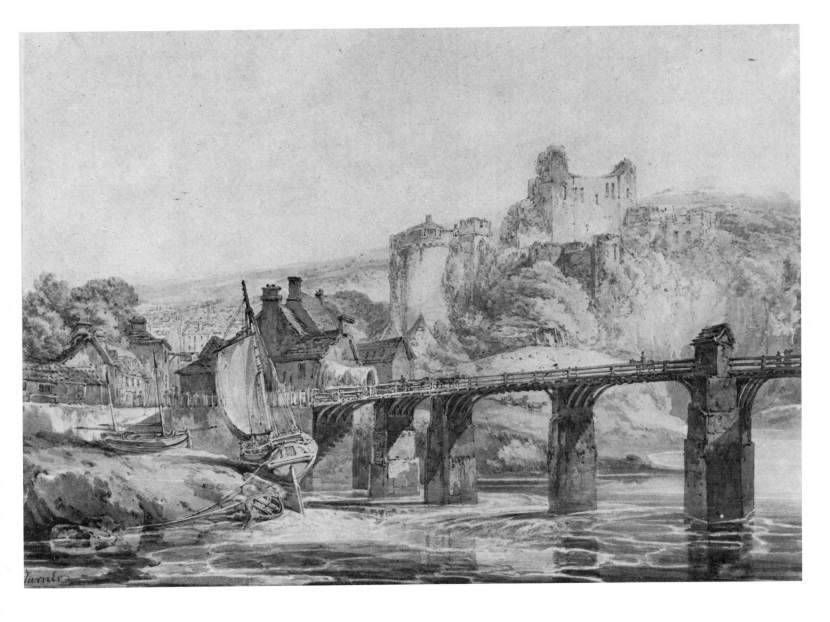

15. Thomas Girtin,
Kirkstall Abbey, Yorkshire—Evening. c. 1800.
Watercolour;
$12 \times 20\frac{1}{8}$ in. (305×510 mm.)
London, Victoria and Albert Museum.

16. *Convents near Capo di Monte. c.* 1794.
Pencil with blue and grey washes;
7 × 16⅜ in. (178 × 416 mm.)
Manchester, Whitworth Art Gallery, University of Manchester.

17. *'Nunwell and Brading from Bembridge Mill'*. 1795.
 Pencil and watercolour;
 8 × 10⅜ in. (203 × 263 mm.)
 London, British Museum (XXIV 49).

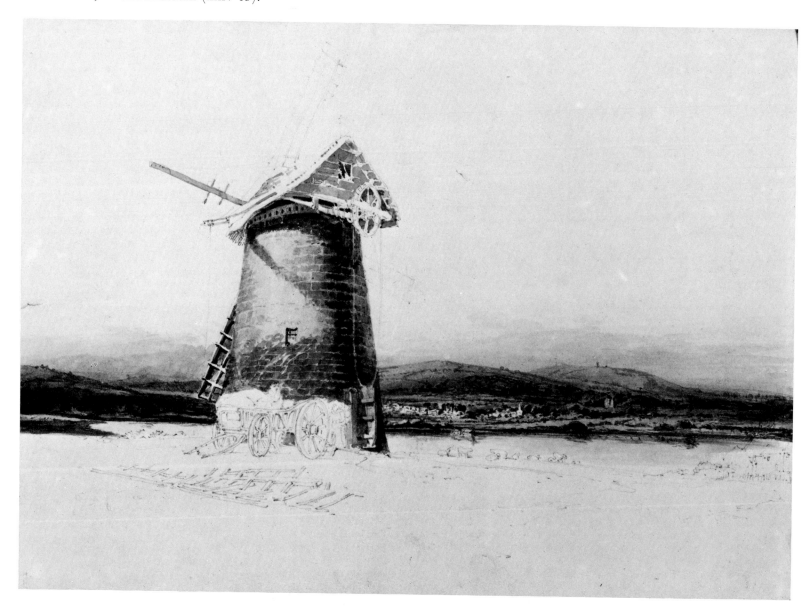

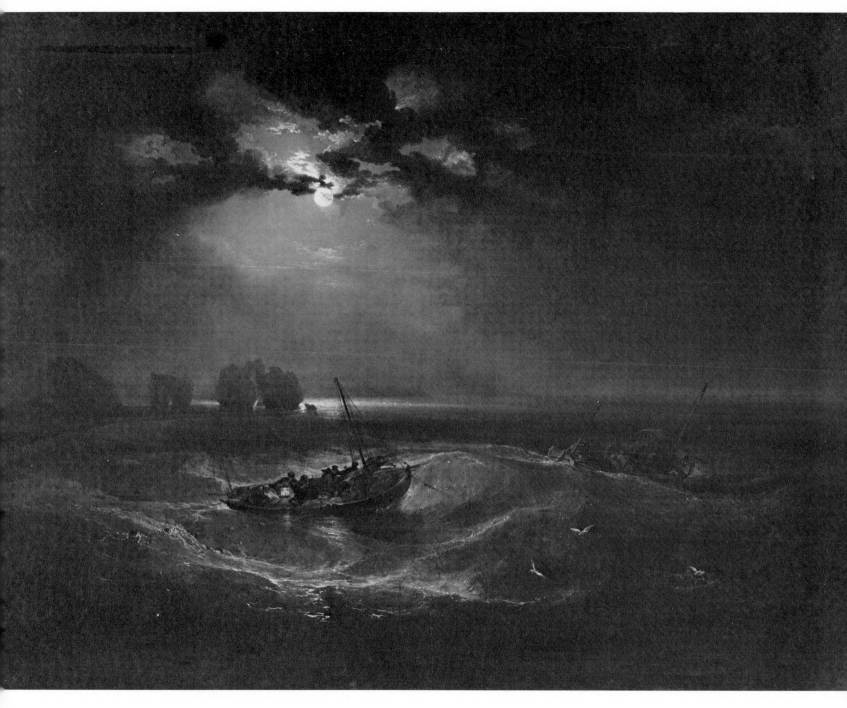

18. *Fishermen at Sea off the Needles*. R.A. 1796.
Oil on canvas;
36 × 48⅛ in. (915 × 1,222 mm.)
London, Tate Gallery.

19. *Transept of Ewenny Priory, Glamorganshire*. R.A. 1797.
Watercolour;
$15\frac{1}{2} \times 22$ in. (394×559 mm.)
Cardiff, National Museum of Wales.

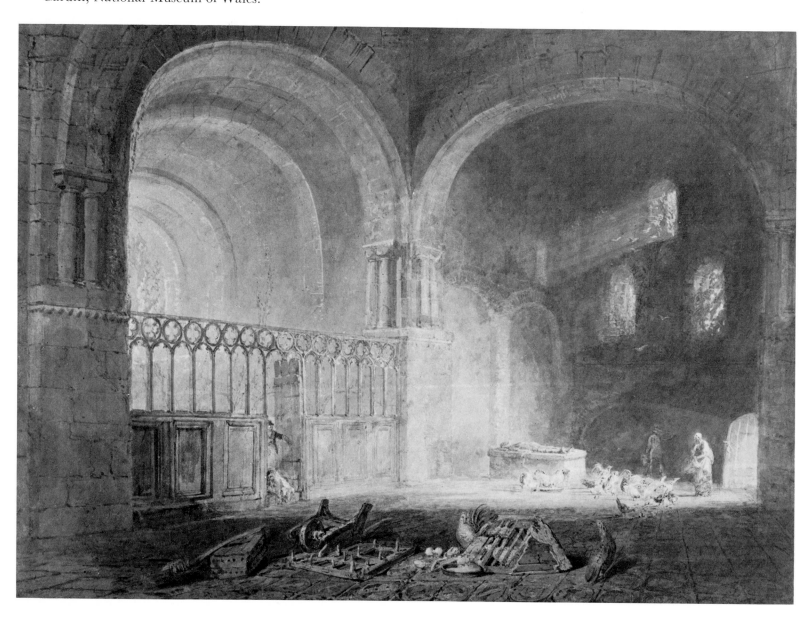

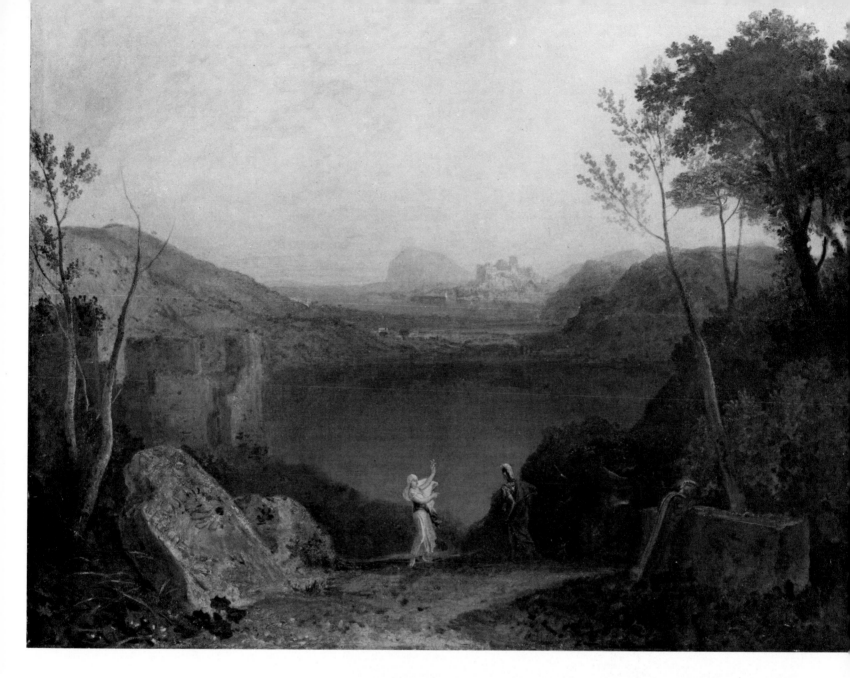

20. *Aeneas and the Sibyl, Lake Avernus. c.* 1798.
Oil on canvas;
$30\frac{1}{8} \times 38\frac{3}{4}$ in. (765×985 mm.)
London, Tate Gallery.

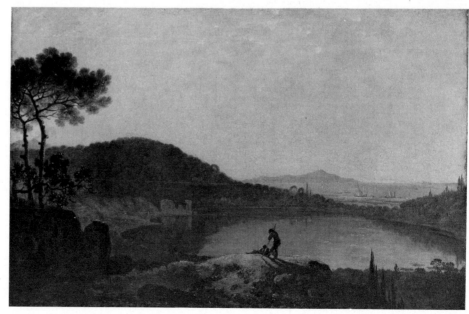

21. Richard Wilson, R.A.,
Lake Avernus and the Island of Ischia. c. 1752–7.
Oil on canvas; $18\frac{1}{2} \times 28\frac{1}{2}$ in. (470×725 mm.)
London, Tate Gallery.

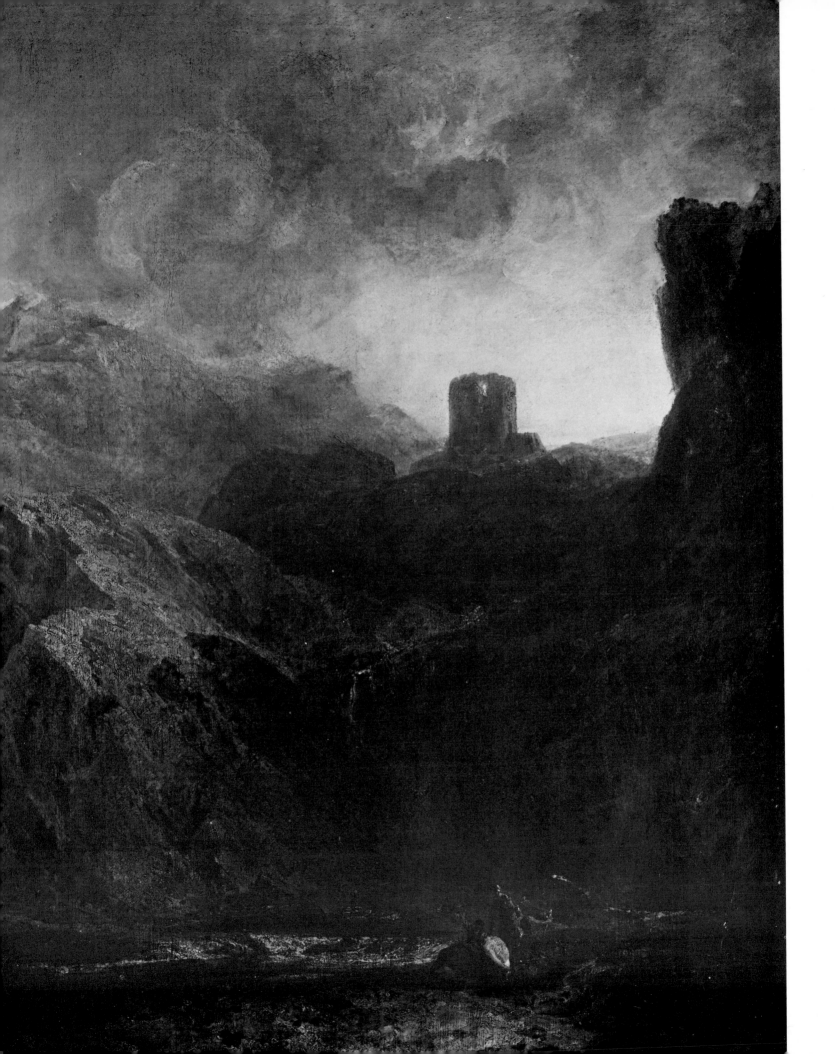

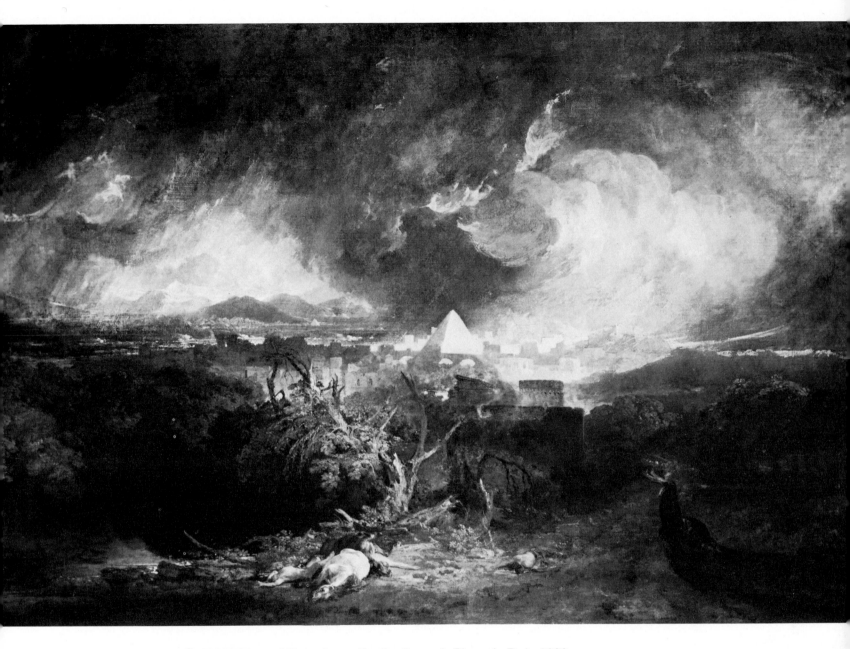

23. *The Fifth Plague of Egypt* (actually the Seventh Plague). R.A. 1800.
Oil on canvas;
49 × 72 in. (1,245 × 1,830 mm.)
Indianapolis Museum of Art, Gift in memory of Evan F. Lilly.

22. *(opposite) Dolbadern Castle, North Wales.* R.A. 1800.
Oil on canvas;
47 × 35½ in. (1,193 × 902 mm.)
London, Royal Academy of Arts.

24. *The Fall of the Clyde, Lanarkshire: Noon.* R.A. 1802.
 Watercolour;
 $29\frac{3}{8} \times 41\frac{5}{8}$ in. (745 × 1,058 mm.)
 Liverpool, Walker Art Gallery.

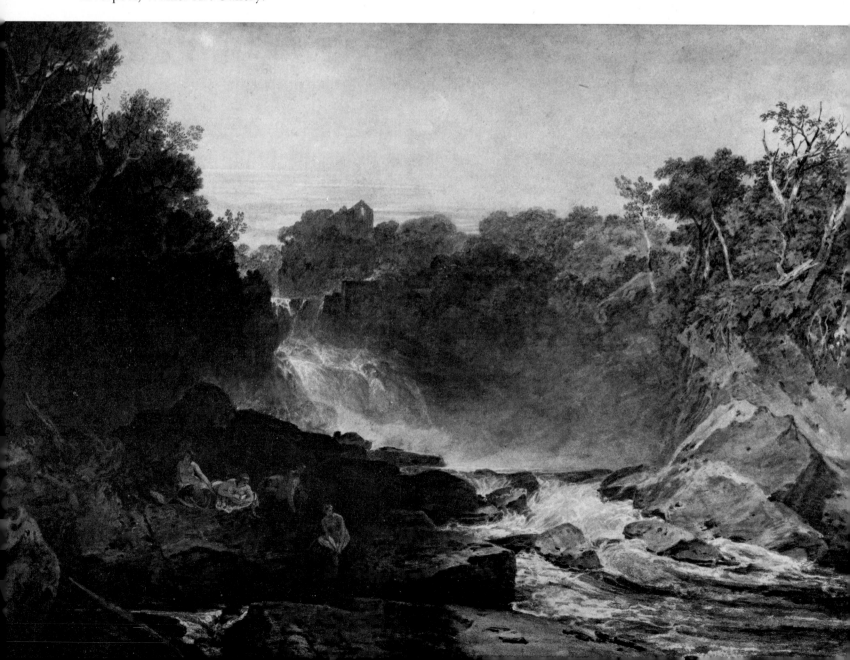

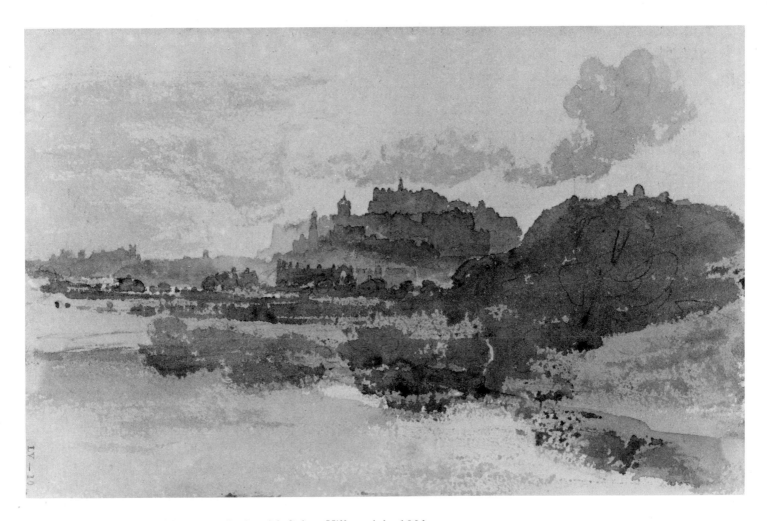

25. *Edinburgh from St. Margaret's Loch, with Calton Hill on right.* 1801.
Watercolour over pencil;
$5 \times 7\frac{3}{4}$ in. (128 × 197 mm.) Actual size.
London, British Museum (LV 10).

27. *Sun rising through Vapour: Fishermen cleaning and selling Fish.*
 R.A. 1807.
 Oil on canvas;
 53 × 70½ in. (1,345 × 1,790 mm.)
 London, National Gallery.

26. *Study for 'Calm'* (Sun rising through Vapour). *c.* 1805.
 Black and white chalk on grey paper;
 10¾ × 17⅛ in. (272 × 435 mm.)
 London, British Museum (LXXXI 40).

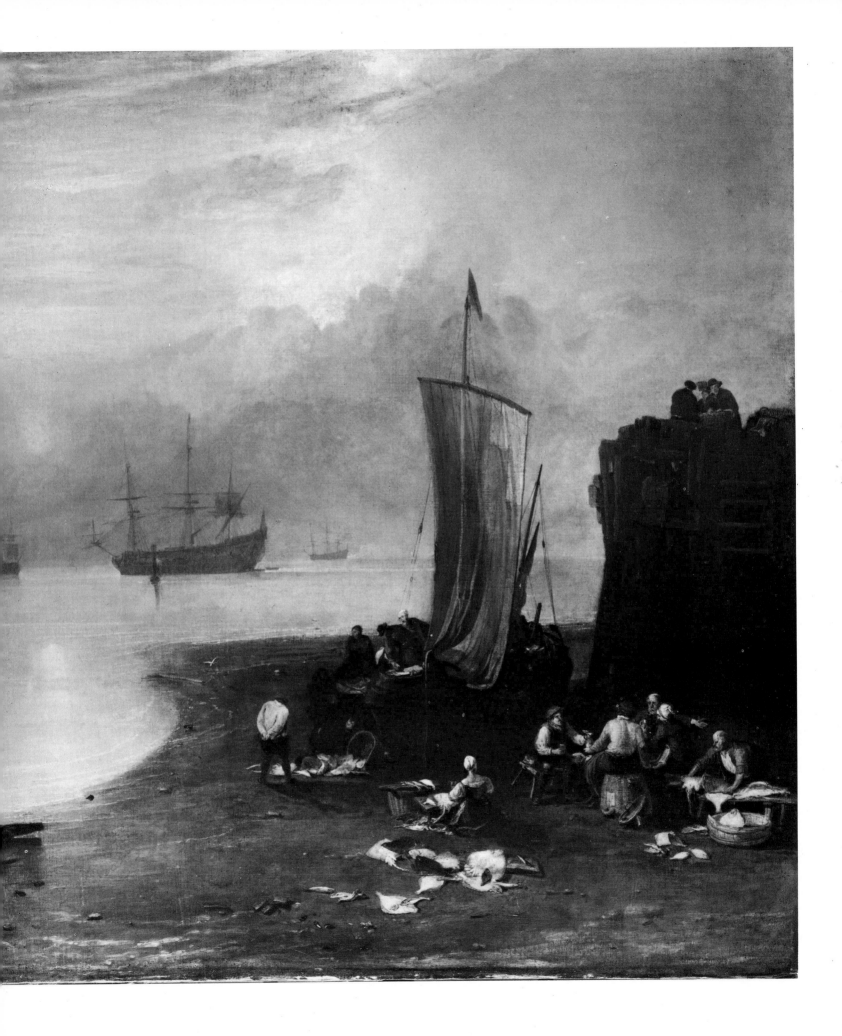

28. *Pembroke Castle, South Wales: Thunder Storm approaching.* R.A. 1801.
 Watercolour;
 $26\frac{1}{2} \times 41$ in. $(673 \times 1,041$ mm.)
 Toronto, University of Toronto.

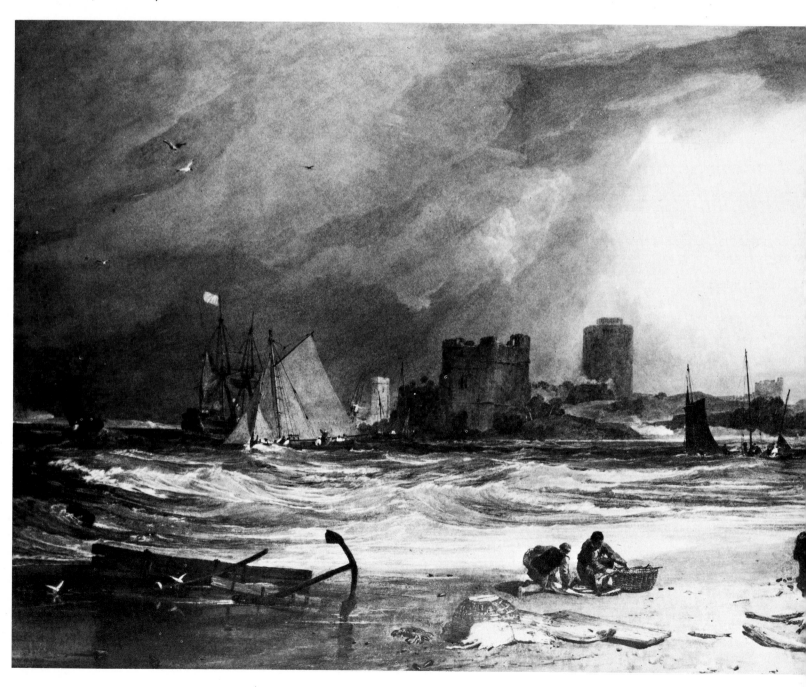

29. *Fishermen launching a Boat in heavy Sea. c.* 1800–2.
Pen and ink and wash, on grey prepared paper;
$4\frac{1}{2} \times 7\frac{1}{8}$ in. (115 × 181 mm.) Actual size.
London, British Museum (LXVIII 3).

30. Willem van de Velde the Younger,
Vessels close-hauled. c. 1670.
Oil on canvas;
$12\frac{7}{8} \times 15\frac{7}{8}$ (327 × 403 mm.)
London, National Gallery.

31. *Fishermen upon a Lee-shore, in squally Weather.* R.A. 1802.
Oil on canvas;
36 × 48 in. (915 × 1,220 mm.)
London, the Iveagh Bequest, Kenwood.

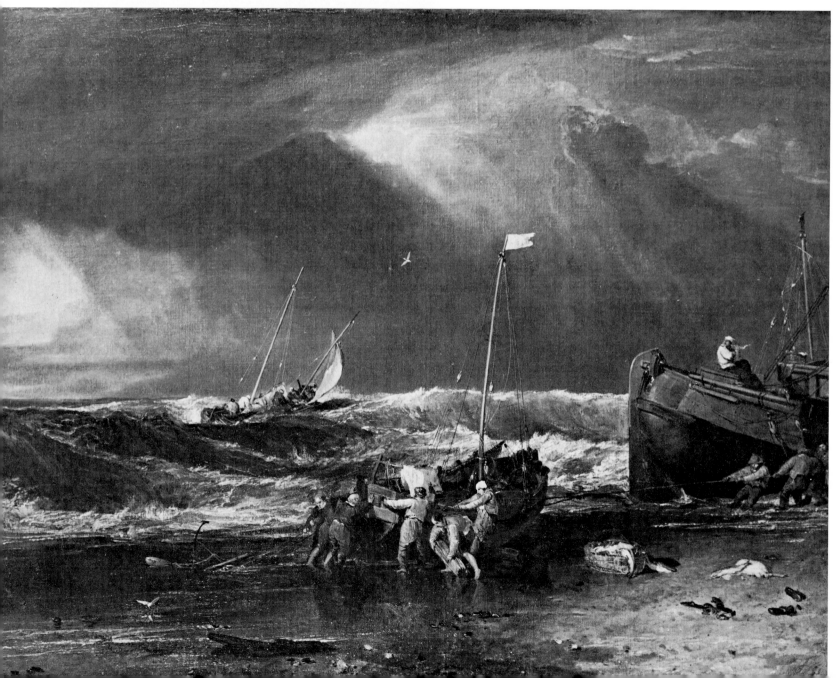

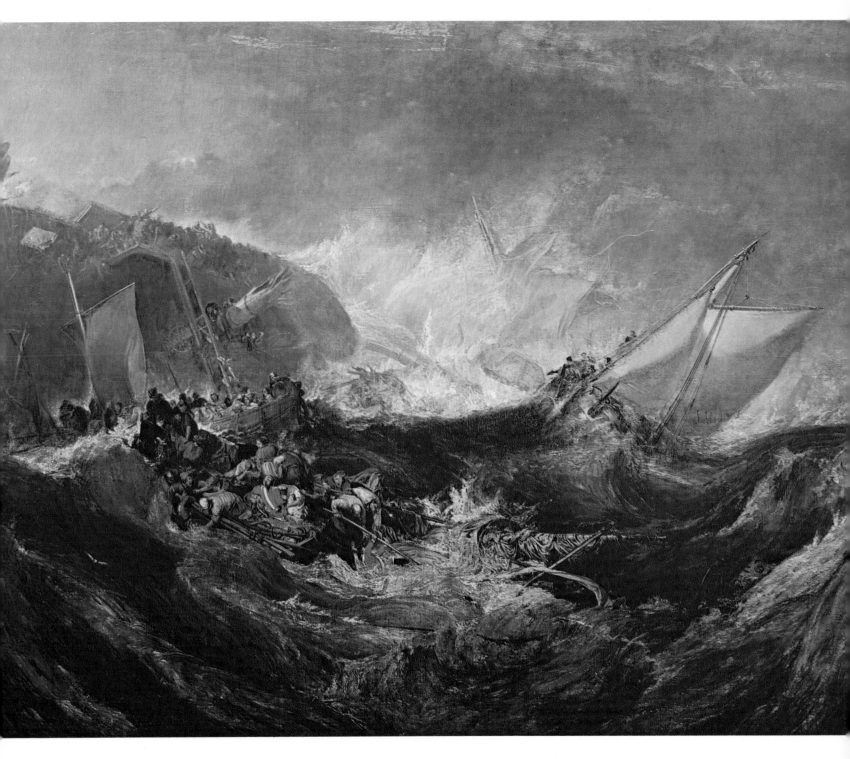

32. *The Wreck of a Transport Ship. c.* 1807.
Oil on canvas;
$68\frac{1}{8} \times 95$ in. $(1,730 \times 2,410$ mm.)
Lisbon, Calouste Gulbenkian Foundation. Detail.

33. *The Thames near Walton Bridges. c.* 1807.
 Oil on panel;
 $14\frac{5}{8} \times 29$ in. (372 × 737 mm.)
 London, Tate Gallery.

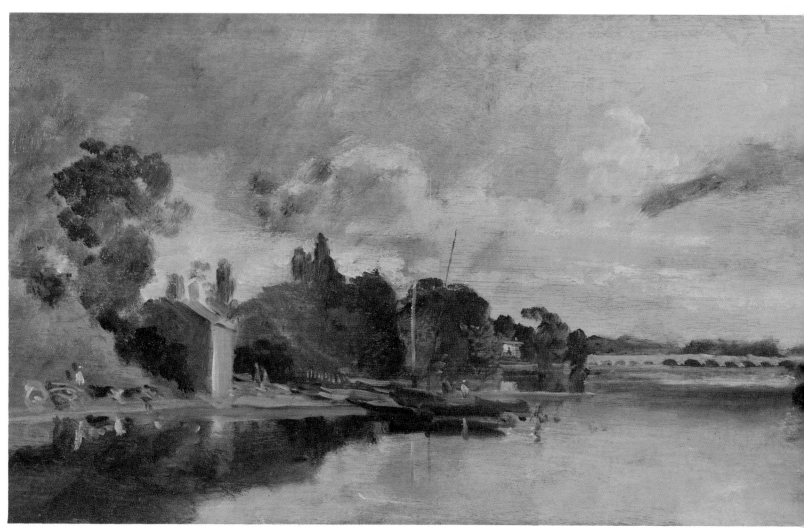

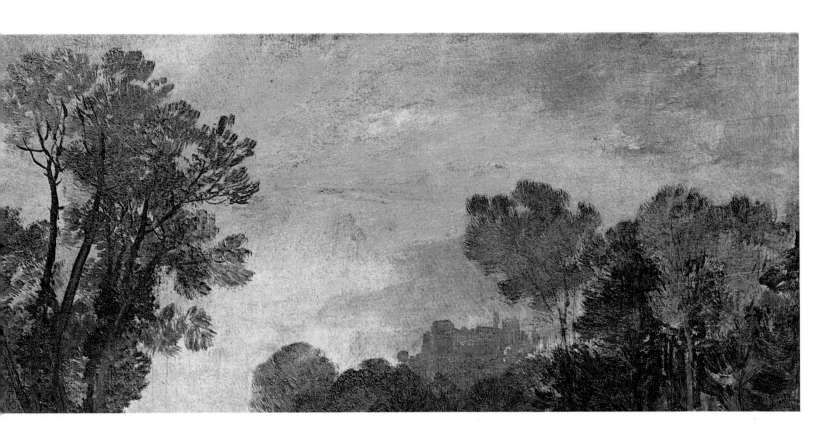

34. *Tree Tops and Sky, Guildford Castle, Evening. c.* 1807.
Oil on panel;
$10\frac{7}{8} \times 29$ in. $(276 \times 737$ mm.)
London, Tate Gallery.

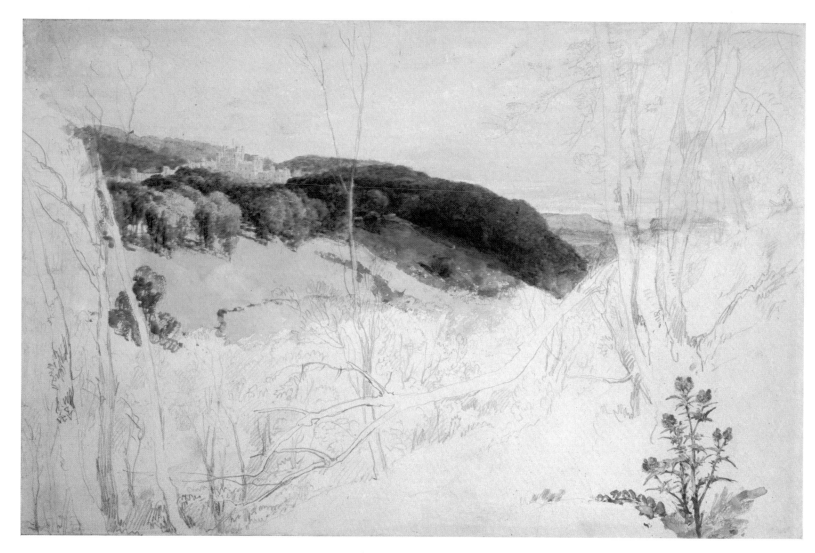

35. *Distant View of Lowther Castle (Park Scene)*. 1809.
Watercolour and pencil;
8⅞ × 13⅞ in. (224 × 352 mm.)
Oxford, Ashmolean Museum (Ruskin School Collection).

36. *(opposite) The Old Devil's
Bridge, St. Gothard*. 1802.
Watercolour and body-
colour on grey prepared
paper;
18⅝ × 12⅜ in. (473 × 314
mm.)
London, British Museum
(LXXV 34).

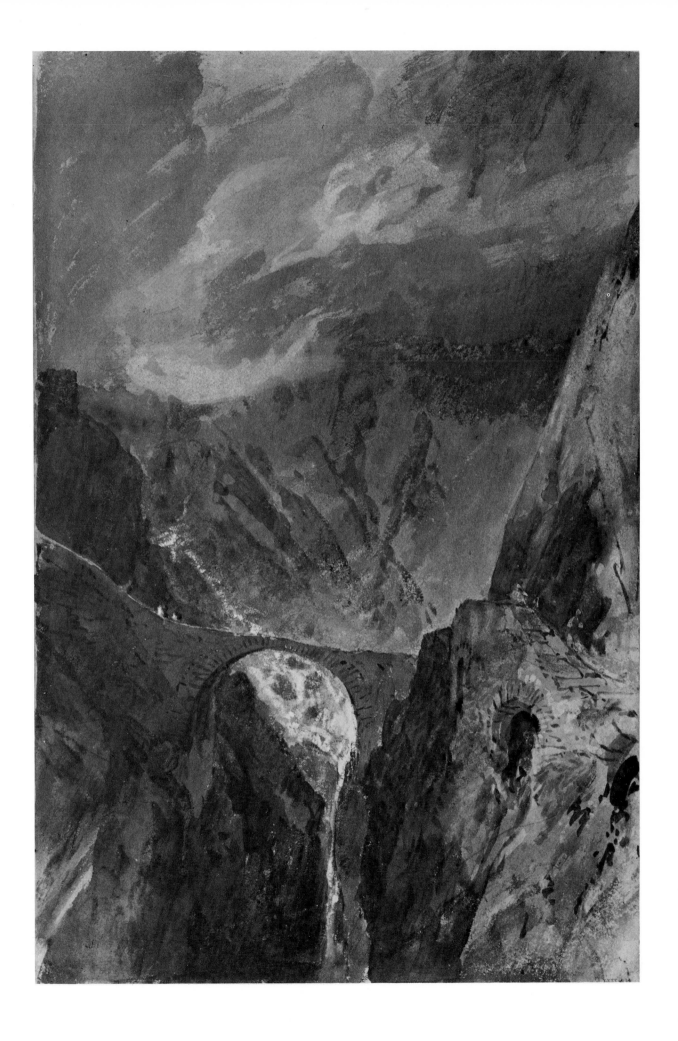

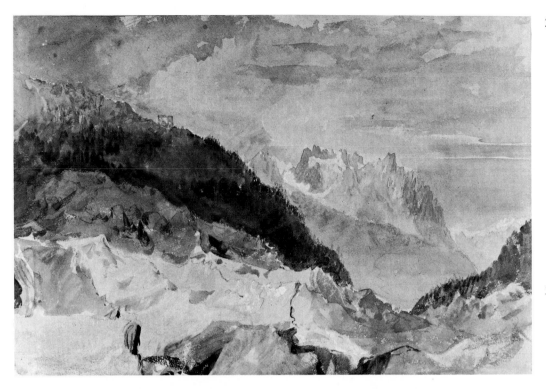

37. *The Mer de Glace, Chamonix*. 1802.
 Watercolour and body-colour on grey
 prepared paper.
 $12\frac{3}{8} \times 18\frac{5}{8}$ in. (314 × 473 mm.)
 London, British Museum (LXXV 22).

38. *The Mer de Glace and Source of the
 Arveyron, Chamonix*. R.A. 1803.
 Watercolour;
 27 × 40 in. (685 × 1,015 mm.)
 New Haven, Yale Center for British
 Art, Paul Mellon Collection.

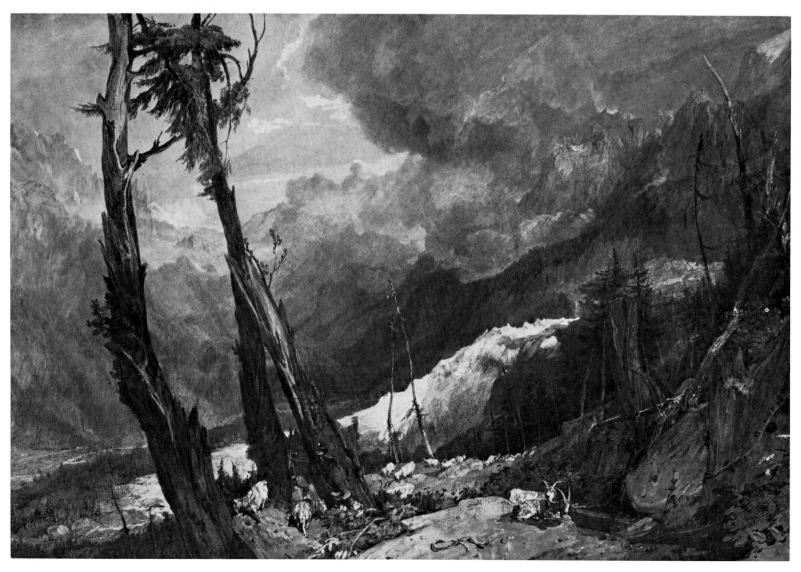

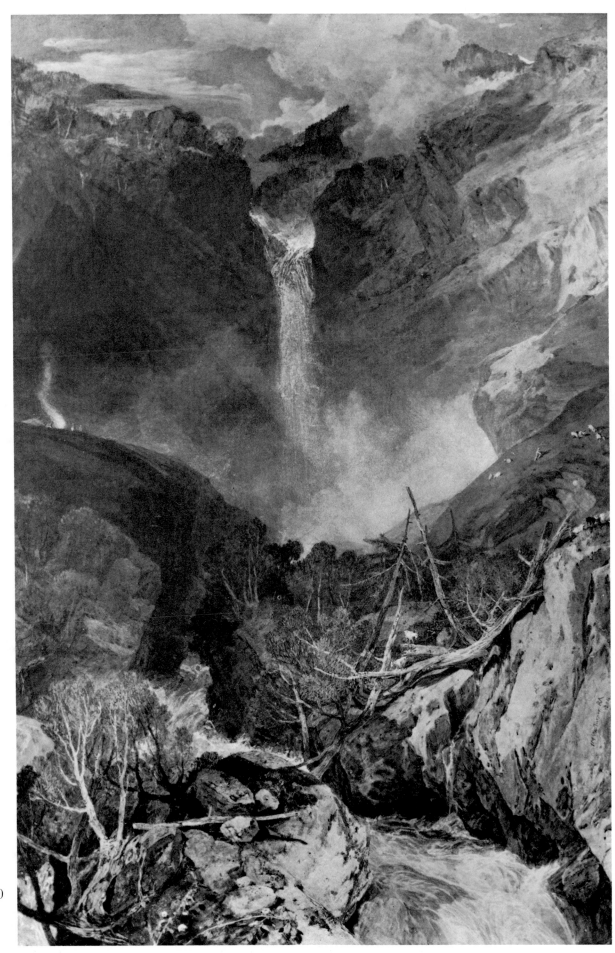

39. *The great Falls of the Reichenbach.* 1804.
Watercolour;
$39\frac{5}{8} \times 26\frac{3}{4}$ in. $(1{,}007 \times 680$ mm.)
Bedford, Cecil Higgins Museum.

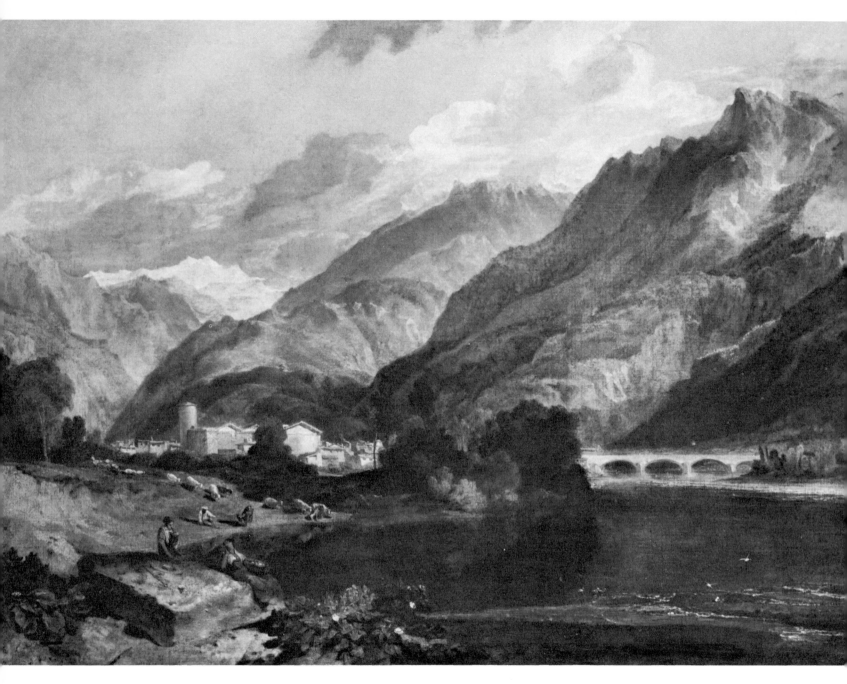

40. *Bonneville, Savoy, with Mont Blanc.* R.A. 1803.
 Oil on canvas;
 36 × 48 in. (915 × 1,220 mm.)
 Private Collection.

41. *(opposite) The Festival upon the Opening of the Vintage at Macon.* R.A. 1803.
 Oil on canvas;
 57 × 92 in. (1,448 × 2,338 mm.)
 Sheffield, Graves Art Gallery.

42. *(opposite)* Claude Lorrain, *Landscape with Jacob and Laban.* 1654/5.
 Oil on canvas;
 56½ × 99 in. (1,435 × 2,515 mm.)
 Petworth House, Sussex.

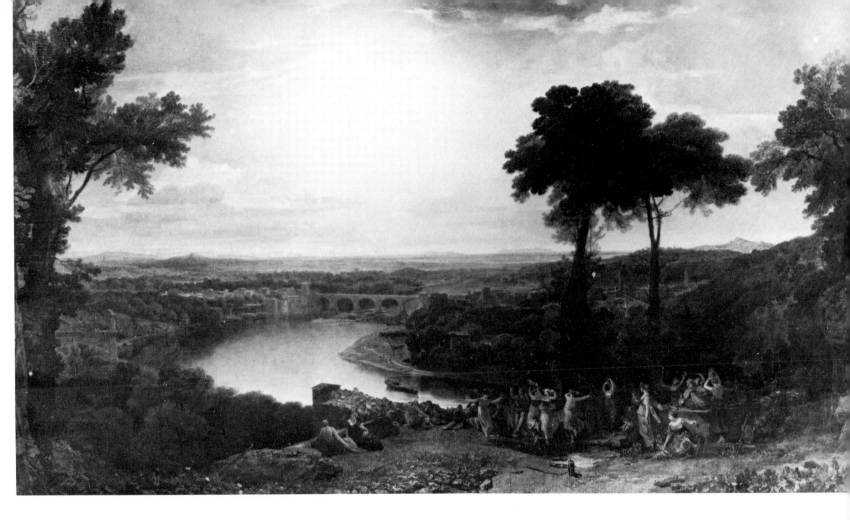

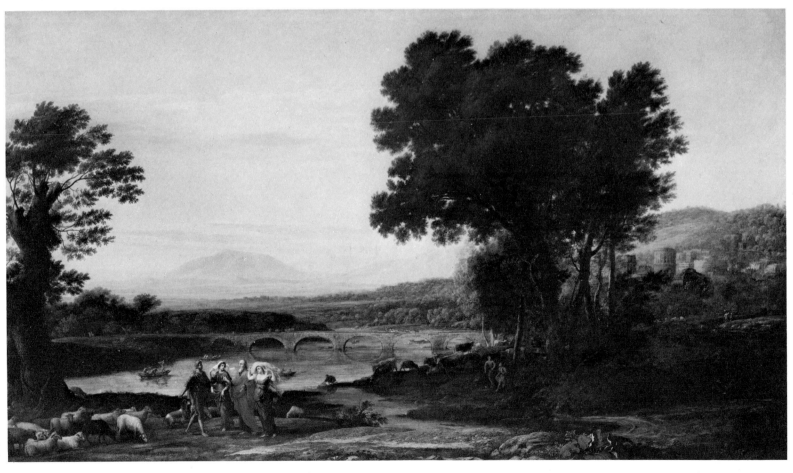

43. *Holy Family*. R.A. 1803.
 Oil on canvas;
 40 × 56 in. (1,016 × 1,422 mm.)
 London, Tate Gallery.

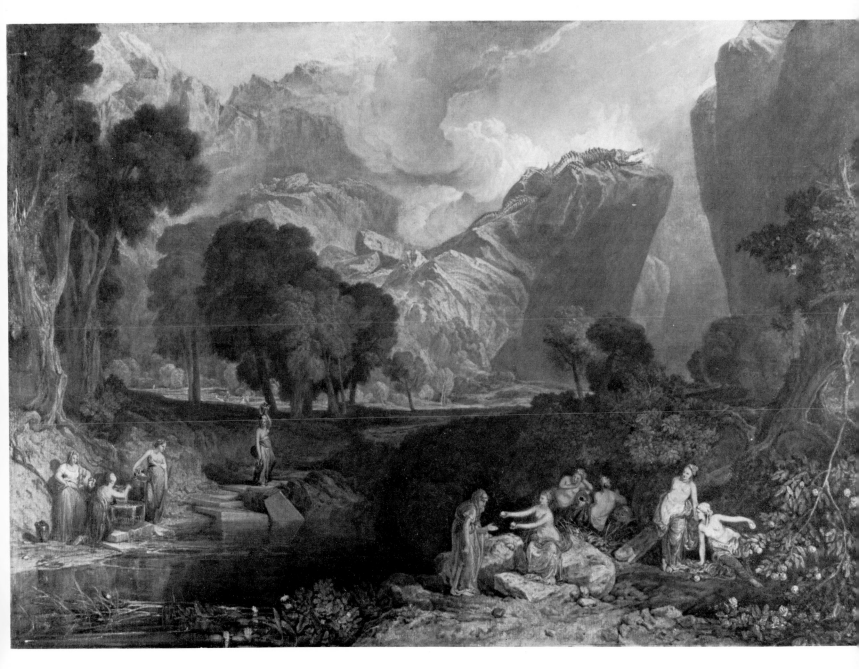

44. *The Goddess of Discord choosing the Apple of Contention in the Garden of the Hesperides.* B.I. 1806.
Oil on canvas;
61½ × 86 in. (1,552 × 2,184 mm.)
London, Tate Gallery.

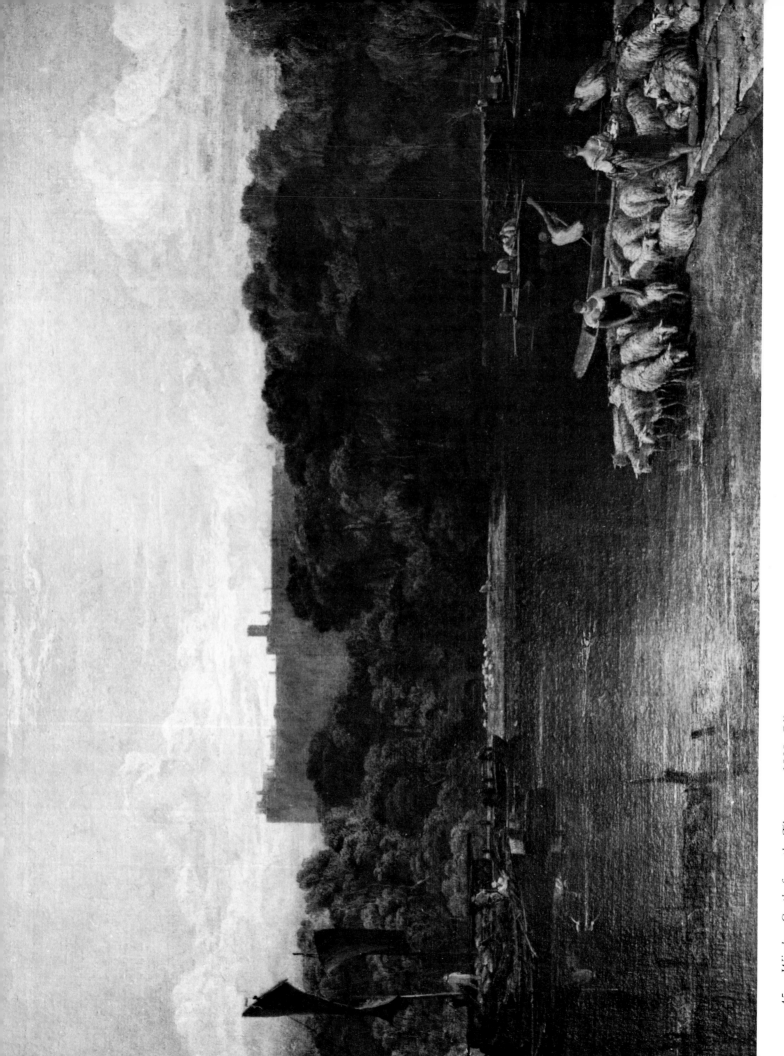

45. *Windsor Castle from the Thames. c.* 1805. Oil on canvas; 35 × 47 in. (890 × 1,194 mm.) Petworth House, Sussex.

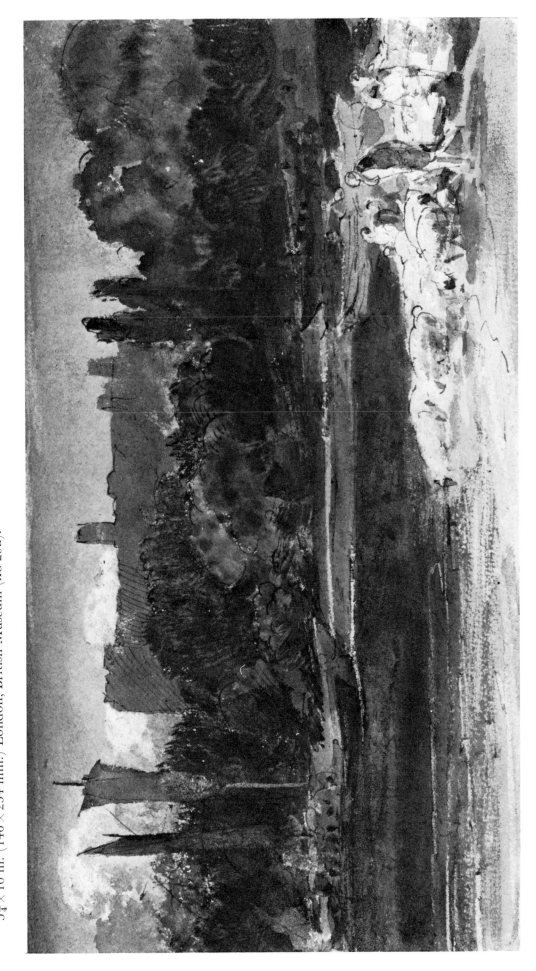

46. *Study for 'Windsor Castle from the Thames'. c.* 1805. Watercolour and pen and ink on grey prepared paper; 5¾ × 10 in. (146 × 254 mm.) London, British Museum (xc 29a).

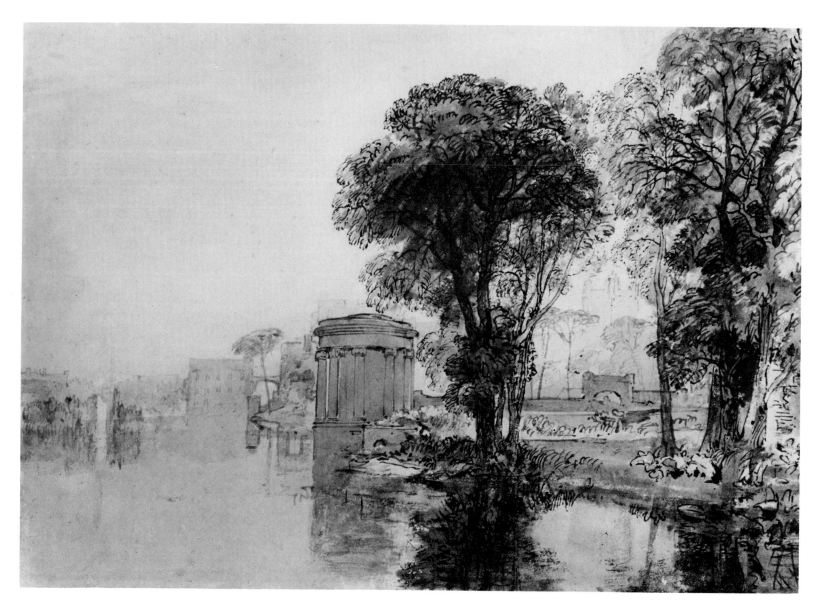

47. *Isleworth. c.* 1815.
Pen and ink and wash;
$8\frac{7}{16} \times 11\frac{1}{2}$ in. (215 × 292 mm.)
London, British Museum (CXVIII I).

48. *(opposite) Isleworth c.* 1819.
Etching;
$8\frac{3}{16} \times 11\frac{1}{2}$ in. (208 × 292 mm.)
London, British Museum.

49. *(opposite) Isleworth.* 1819.
Mezzotint engraving by H. Dawe;
$8\frac{3}{16} \times 11\frac{7}{16}$ in. (208 × 290 mm.)
London, Victoria and Albert Museum.

50. *Scene on the Thames. c.* 1806–7. Watercolour over pencil;
$10\frac{1}{8} \times 14\frac{3}{8}$ in. (256 × 370 mm.) London, British Museum (xcv 46).

51. *Chevening Park, Kent. c.* 1806–7. Oil over pencil on paper; $10\frac{7}{8} \times 14\frac{7}{8}$ in. (276 × 378 mm.) London, British Museum (XCV (a) B).

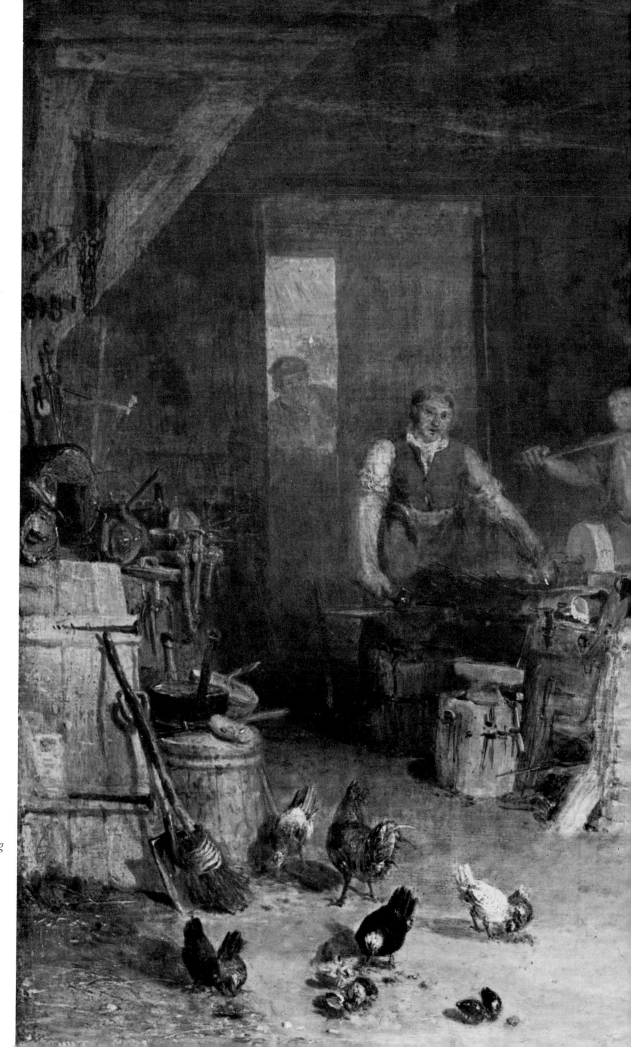

52. *A country Blacksmith disputing upon the Price of Iron, and the Price charged to the Butcher for shoeing his Pony.*
R.A. 1807.
Oil on canvas;
$21\frac{5}{8} \times 30\frac{5}{8}$ in. $(550 \times 779$ mm.)
London, Tate Gallery.

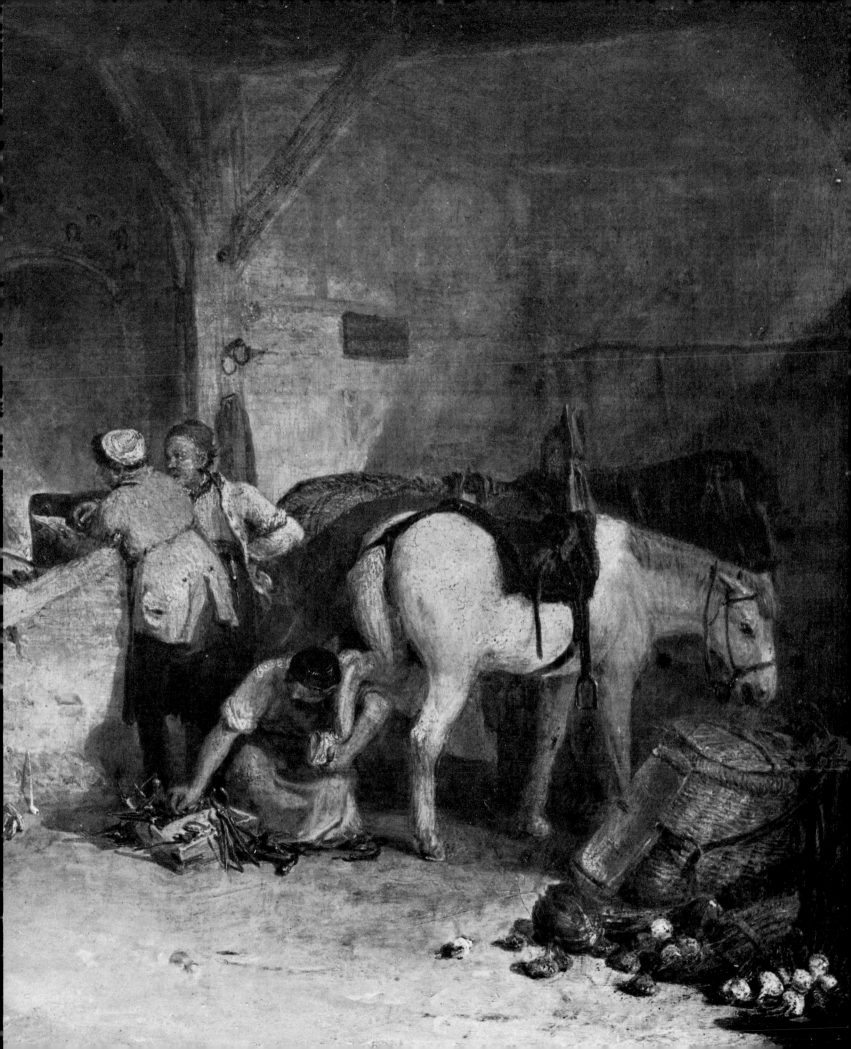

53. *Willows beside a Stream. c.* 1807.
 Oil on canvas;
 $33\frac{7}{8} \times 45\frac{3}{4}$ in. (860 × 1,165 mm.)
 London, Tate Gallery.

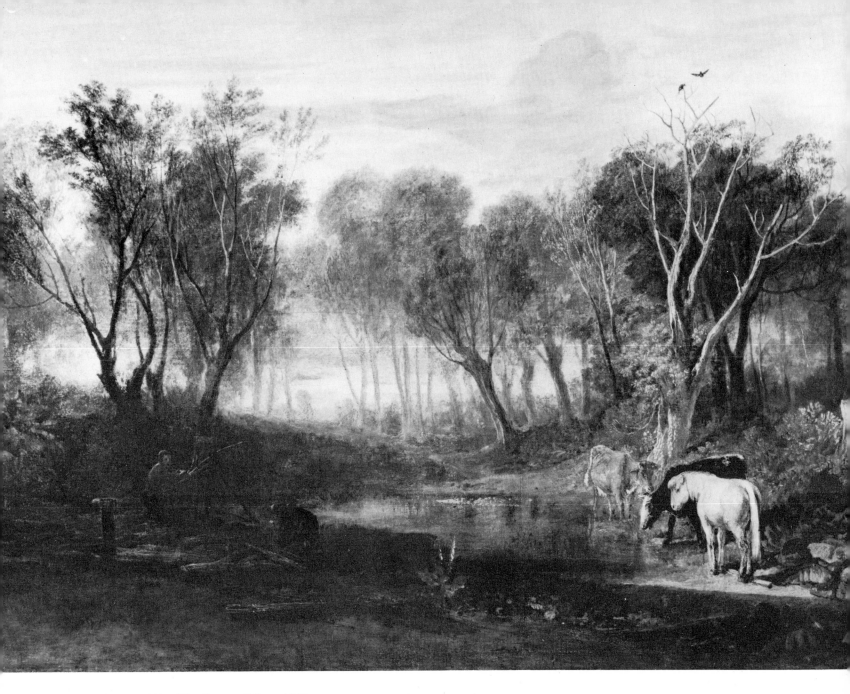

54. *The Forest of Bere*. 1808.
 Oil on canvas;
 35 × 47 in. (890 × 1,194 mm.)
 Petworth House, Sussex.

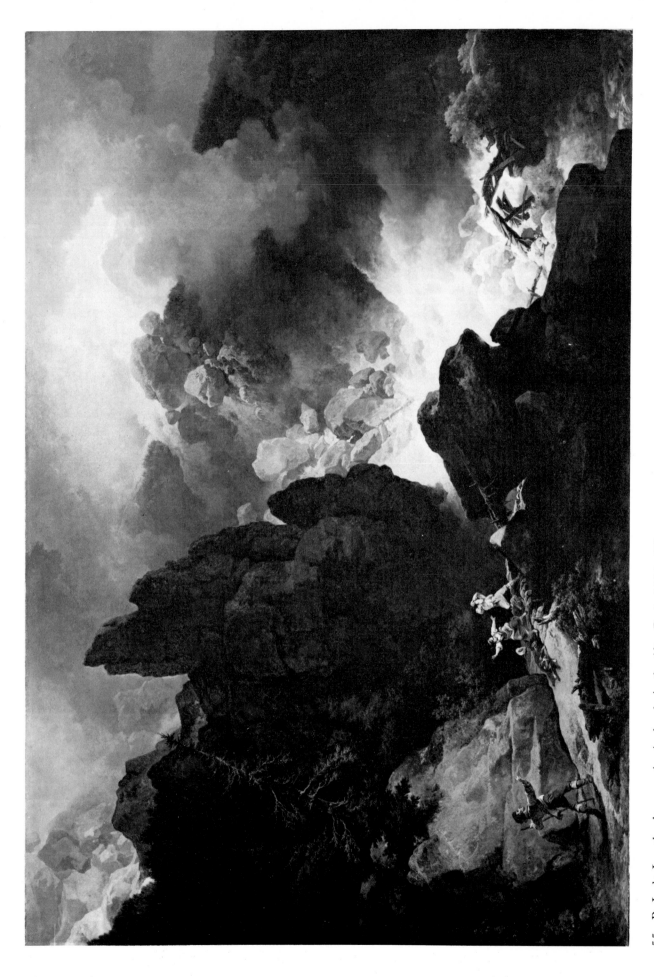

55. P. J. de Loutherbourg, *An Avalanche in the Alps*. R.A. 1804. Oil on canvas; 43¼ × 63 in. (1,099 × 1,600 mm.) London, Tate Gallery.

56. *The Fall of an Avalanche in the Grisons.* Exhibited 1810. Oil on canvas; 35½ × 47¼ in. (902 × 1,200 mm.) London, Tate Gallery.

57. *Snowstorm: Hannibal and his Army crossing the Alps.* R.A. 1812. Oil on canvas; 57 × 93 in. (1,448 × 2,362 mm.) London, Tate Gallery.

58. *Frosty Morning*. R.A. 1813. Oil on canvas;
44¾ × 68¾ in. (1,137 × 1,746 mm.) London, Tate Gallery.

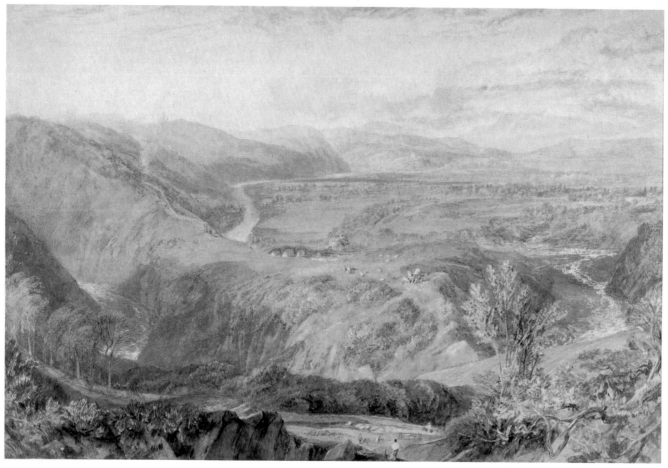

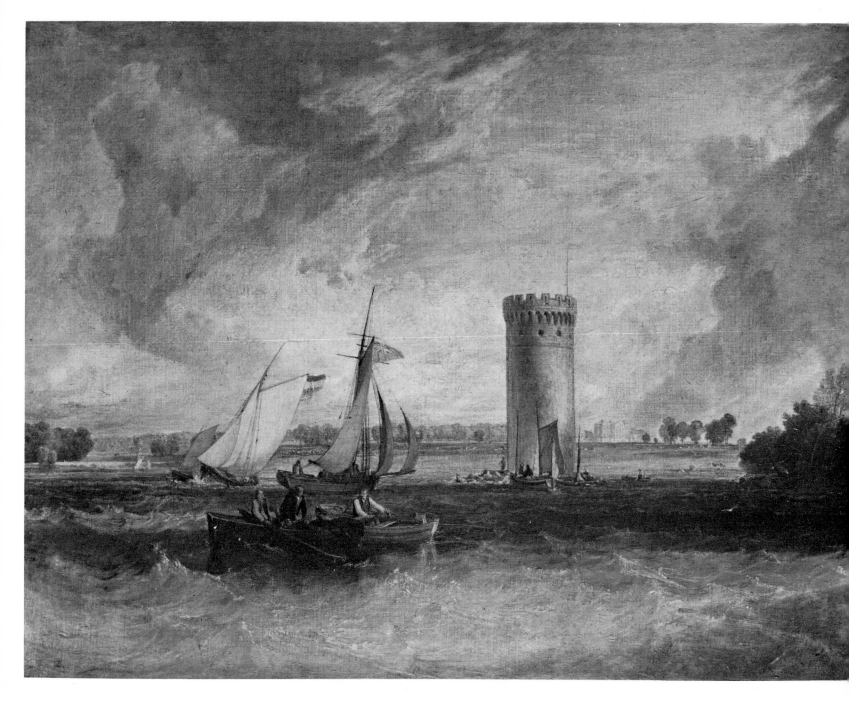

61. *Tabley, the Seat of Sir J. F. Leicester, Bart.: Windy Day.* R.A. 1809.
Oil on canvas;
36 × 47½ in. (915 × 1,206 mm.)
University of Manchester (on long loan to the Whitworth
Art Gallery, Manchester).

59. *(opposite) Falmouth Harbour.* 1813.
Oil on paper prepared with a grey-brown ground;
6⅛ × 9 1/16 in. (155 × 230 mm.)
London, British Museum (CXXX C).

60. *(opposite) The Crook of Lune.* 1816–18.
Watercolour and pen and ink;
11 × 16⅜ in. (280 × 417 mm.)
London, Courtauld Institute of Art, University of London.

62. *Petworth, Sussex, the Seat of the Earl of Egremont: Dewy Morning.* R.A. 1810. Oil on canvas; 35½ × 47½ in. (902 × 1,206 mm.) Petworth House, Sussex.

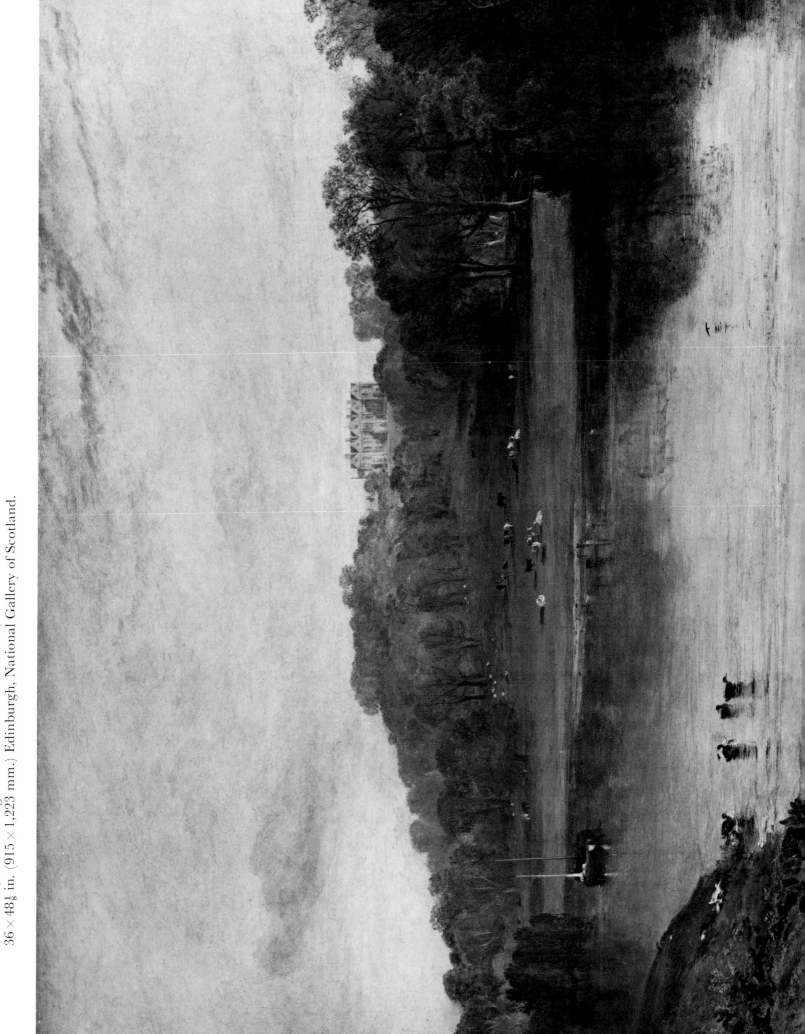

63. *Somer Hill, near Tunbridge.* R.A. 1811. Oil on canvas;
36 × 48⅛ in. (915 × 1,223 mm.) Edinburgh, National Gallery of Scotland.

64. Aelbert Cuyp,
Landscape near Nijmegen.
Oil on canvas;
$44\frac{1}{2} \times 69\frac{1}{2}$ in. (1,130 × 1,765 mm.)
Petworth House, Sussex.

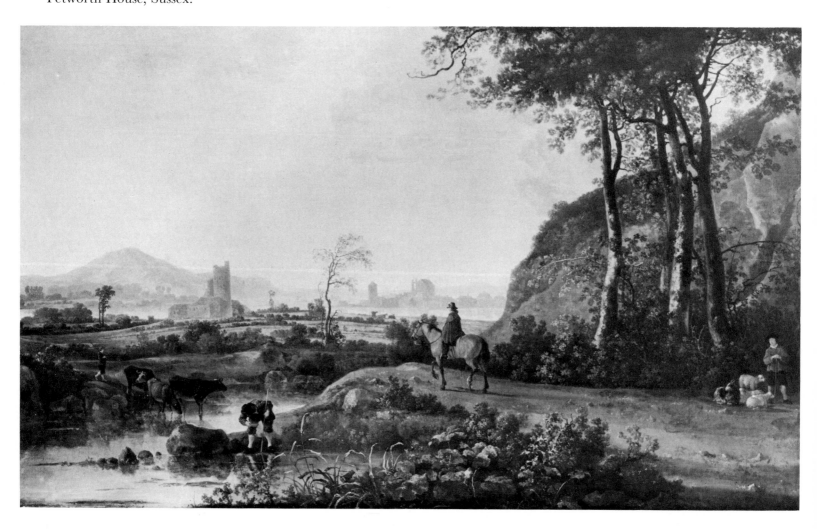

65. *Dorchester Mead, Oxfordshire.* 1810.
Oil on canvas;
40 × 51¼ in. (1,016 × 1,302 mm.)
London, Tate Gallery.

66. *Whalley Bridge and Abbey, Lancashire: Dyers washing and drying Cloth.* R.A. 1811. Oil on canvas; $24\frac{1}{8} \times 36\frac{3}{8}$ in. (612 × 925 mm.) Lockinge, Berkshire, Christopher Loyd.

67. *Sunshine on the Tamar*. *c.* 1813. Watercolour; $8\frac{1}{2} \times 14\frac{1}{2}$ in. $(217 \times 367$ mm.) Oxford, Ashmolean Museum (Ruskin School Collection).

68. *The Junction of the Greta and Tees at Rokeby.* 1816–18. Watercolour over pencil; $11\frac{3}{8} \times 16\frac{1}{4}$ in. (290 × 414 mm.) Oxford, Ashmolean Museum (Ruskin School Collection).

69. *Leeds*. 1816. Watercolour; $11\frac{1}{2} \times 16\frac{3}{4}$ in. (292 × 425 mm.)
New Haven, Yale Center for British Art, Paul Mellon Collection.

70. *Valley of the Wharfe from Caley Park. c.* 1815.
13 × 17½ in. (330 × 440 mm.) Farnley Hall, Yorkshire, G. N. Le G. Horton-Fawkes.

72. *Appulia in Search of Appulus*. B.I. 1814. Oil on canvas;
57 × 93 in. (1,448 × 2,362 mm.) London, Tate Gallery.

71. *Roslin Castle, Hawthornden*. 1818–20. Watercolour and body-colour; $6\frac{7}{8} \times 10\frac{1}{2}$ in. (175 × 267 mm.)
Indianapolis Museum of Art; Gift in Memory of Dr. and Mrs. Hugo Pantzer by their Children.

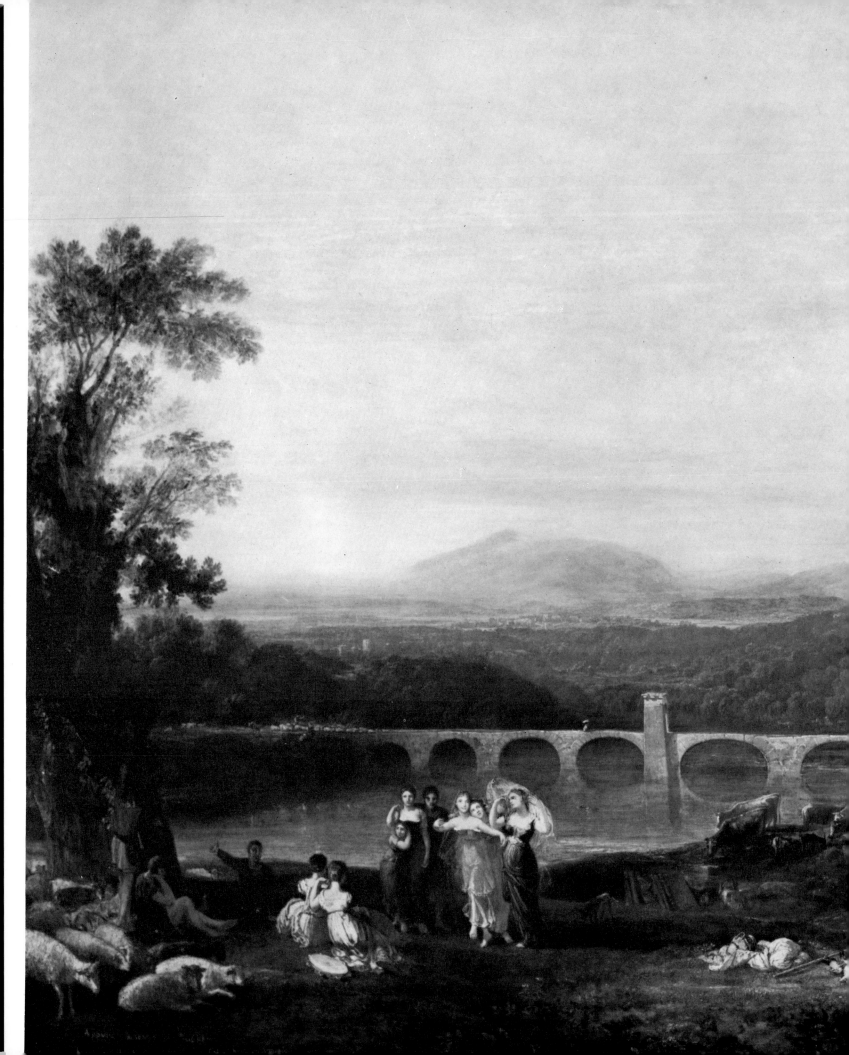

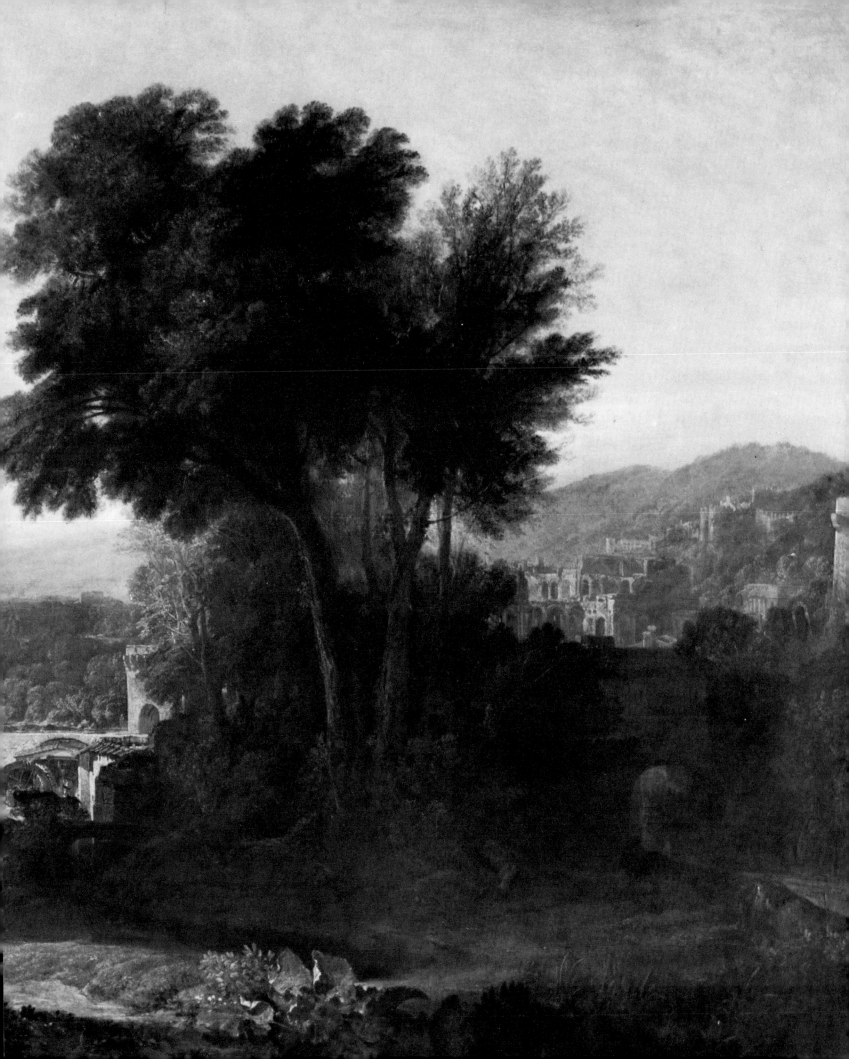

73. *Marksburg.* 1817. Watercolour; $7\frac{7}{8} \times 12\frac{1}{2}$ in. (200×318 mm.)
Indianapolis Museum of Art; Gift in Memory of Dr. and Mrs. Hugo O. Pantzer by their Children.

74. *St. Goarshausen and Katz Castle.* 1817. Watercolour, slightly heightened with white; 7⅝ × 12 in. (193 × 304 mm.) London, Courtauld Institute of Art, University of London.

75. *A Frontispiece (at Farnley Hall)*. 1815.
 Watercolour over pencil, with pen and ink;
 $7 \times 9\frac{1}{2}$ in. (178×242 mm.)
 Oxford, Ashmolean Museum (Ruskin School Collection).

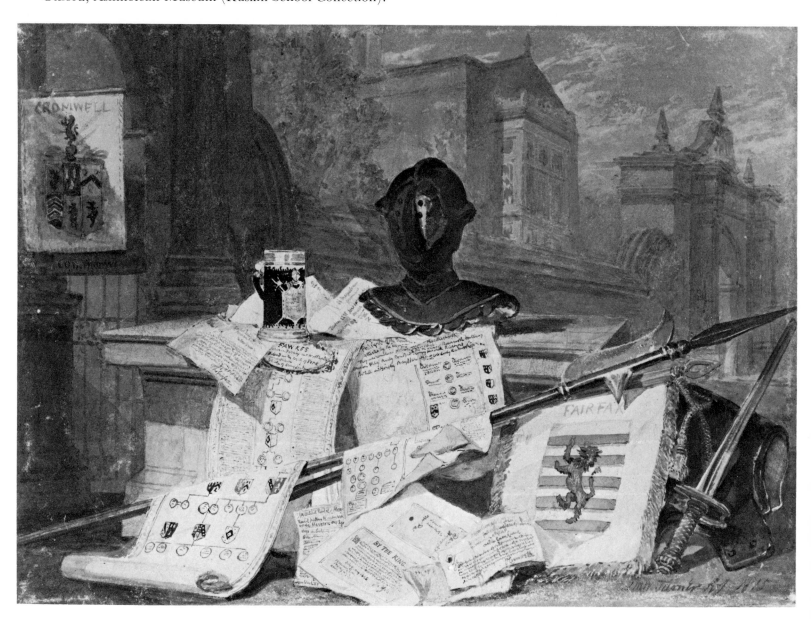

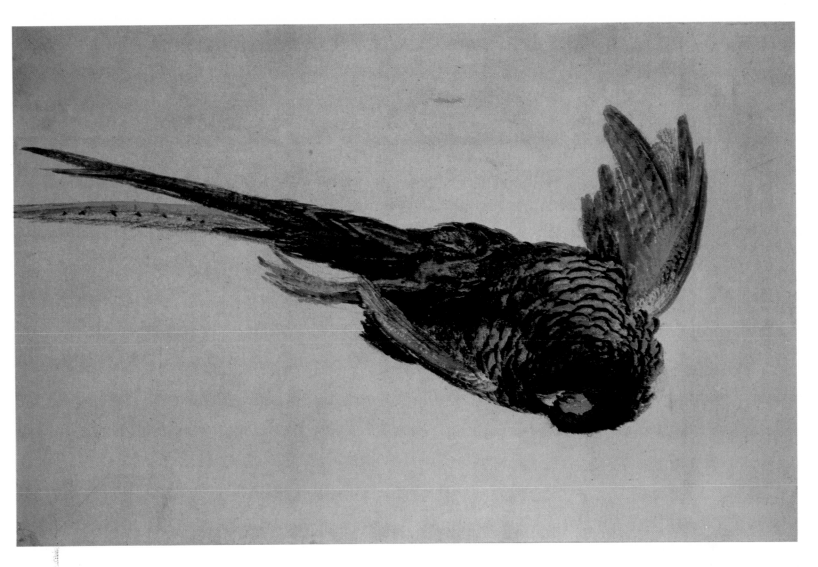

76. *Sketch of a Pheasant. c.* 1815.
Watercolour; $8\frac{3}{4} \times 13\frac{5}{8}$ in. (223×345 mm.)
Oxford, Ashmolean Museum (Ruskin School Collection).

77. *(overleaf) Dido building Carthage; or the Rise of the Carthaginian Empire.* R.A. 1815.
Oil on canvas;
$61\frac{1}{4} \times 91\frac{1}{4}$ in. ($1,555 \times 2,230$ mm.)
London, National Gallery.

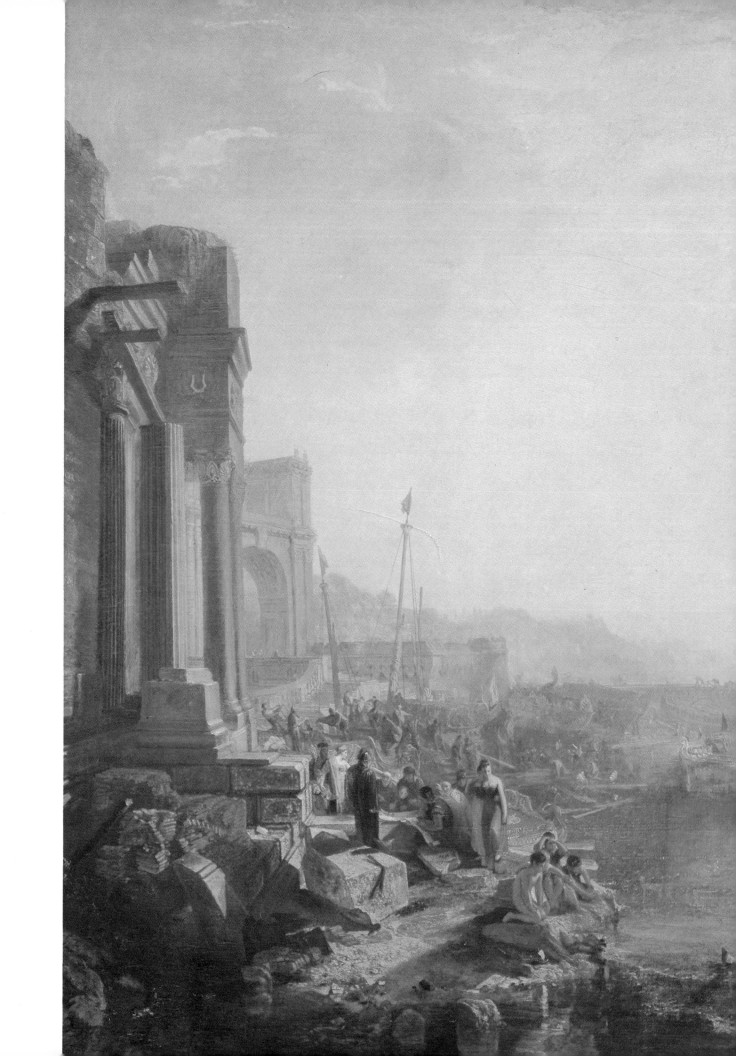

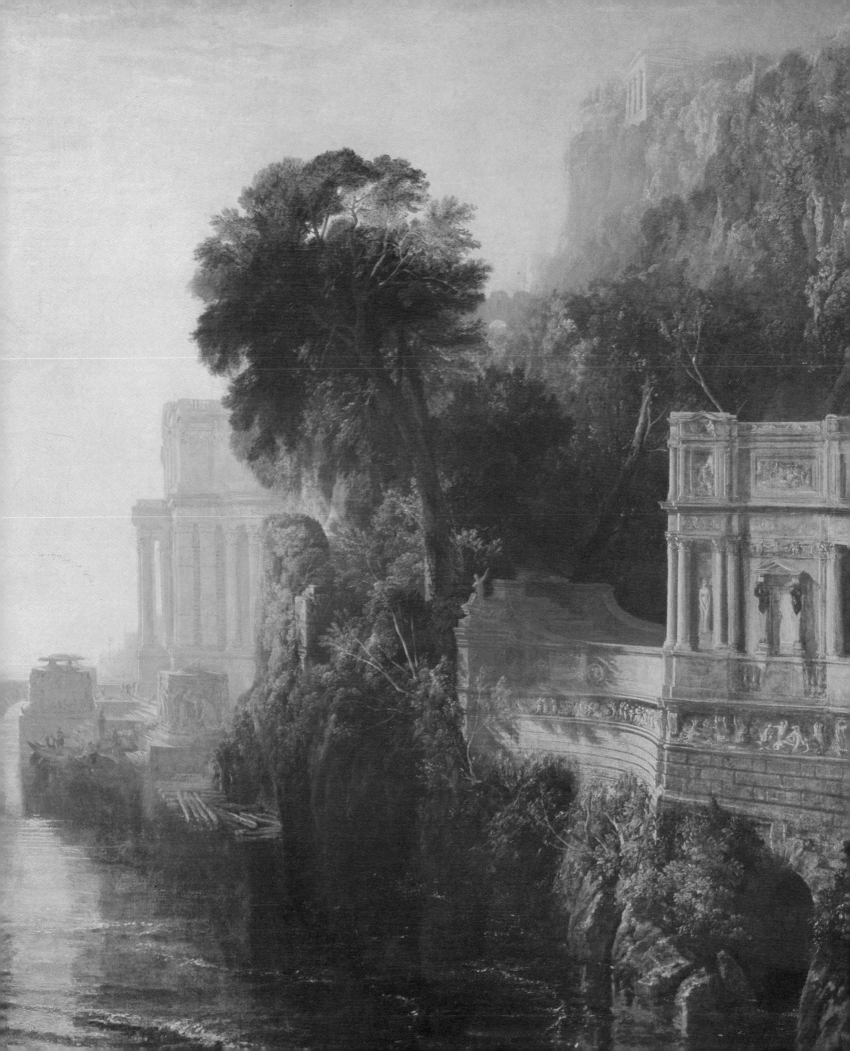

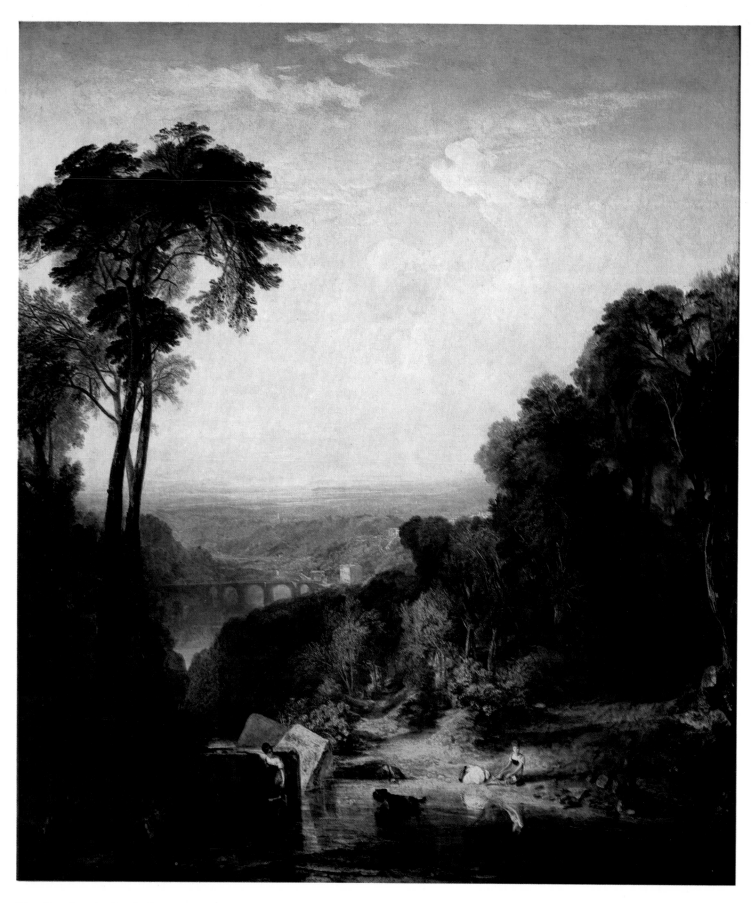

78. *Crossing the Brook*. R.A. 1815. Oil on canvas;
76 × 65 in. (1,930 × 1,651 mm.) London, Tate Gallery.

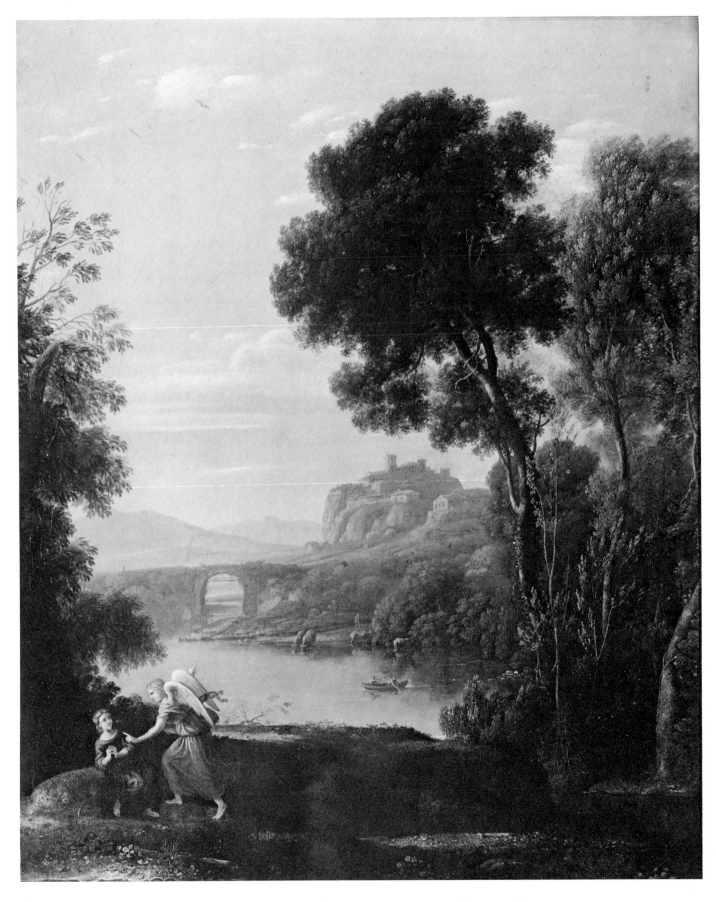

79. Claude Lorrain, *Landscape: Hagar and the Angel*. 1646. Canvas mounted on panel;
 20¾ × 17¼ in. (527 × 438 mm.) London, National Gallery.

80. *A First Rate taking in Stores*. 1818.
Watercolour;
$11\frac{1}{4} \times 15\frac{5}{8}$ in. (286×398 mm.)
Bedford, Cecil Higgins Museum.

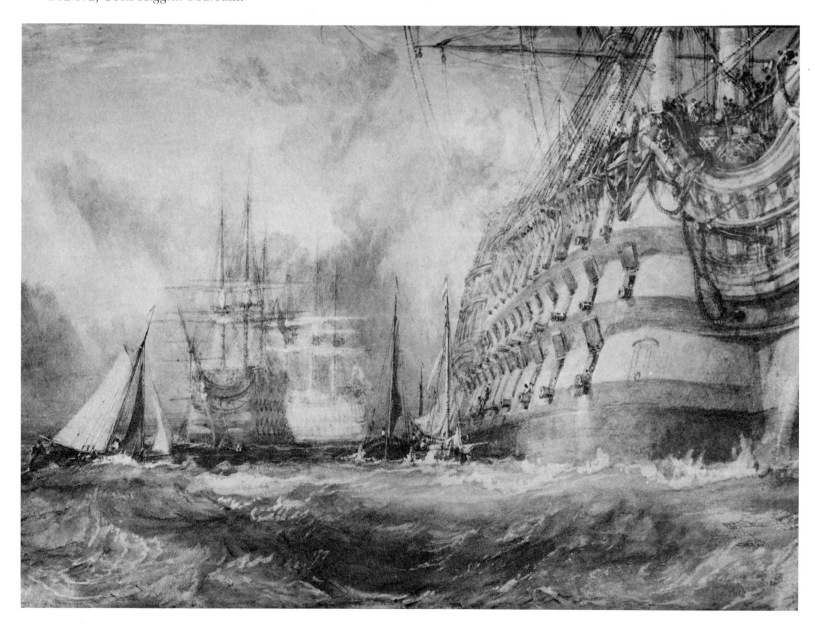

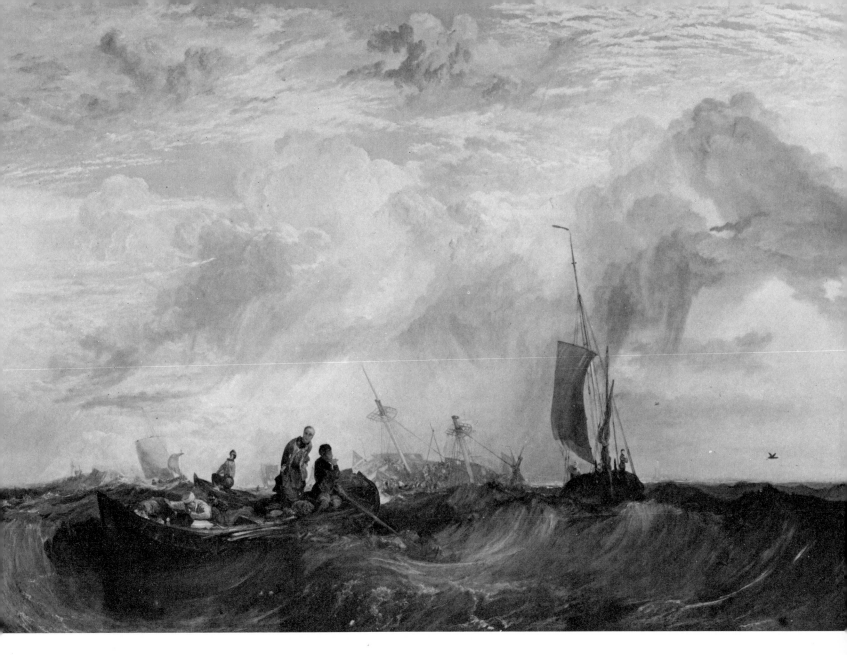

81. *Entrance of the Meuse: Orange-Merchant on the Bar, going to Pieces.* R.A. 1819.
Oil on canvas;
67 × 97½ in. (1,702 × 2,476 mm.)
London, Tate Gallery.

82. *View from Richmond Hill. c.* 1815. Watercolour;
$7\frac{1}{2} \times 10\frac{1}{2}$ in. (190 × 267 mm.) London, British Museum (CXCVII B).

84. *(overleaf) Rome from the Vatican: Raffaelle, accompanied by La Fornarina, preparing his Pictures for the Decoration of the Loggia.* R.A. 1820. Oil on canvas; 69½ × 131 in. (1,765 × 3,332 mm.) London, Tate Gallery.

83. *England: Richmond Hill, on the Prince Regent's Birthday.* R.A. 1819. Oil on canvas; 71¾ × 132 in. (1,823 × 3,352 mm.) London, Tate Gallery.

85. Aelbert Cuyp, *View of Dordrecht*. Oil on canvas; 38½ × 54¼ in. (978 × 1,378 mm.) London, the Iveagh Bequest, Kenwood.

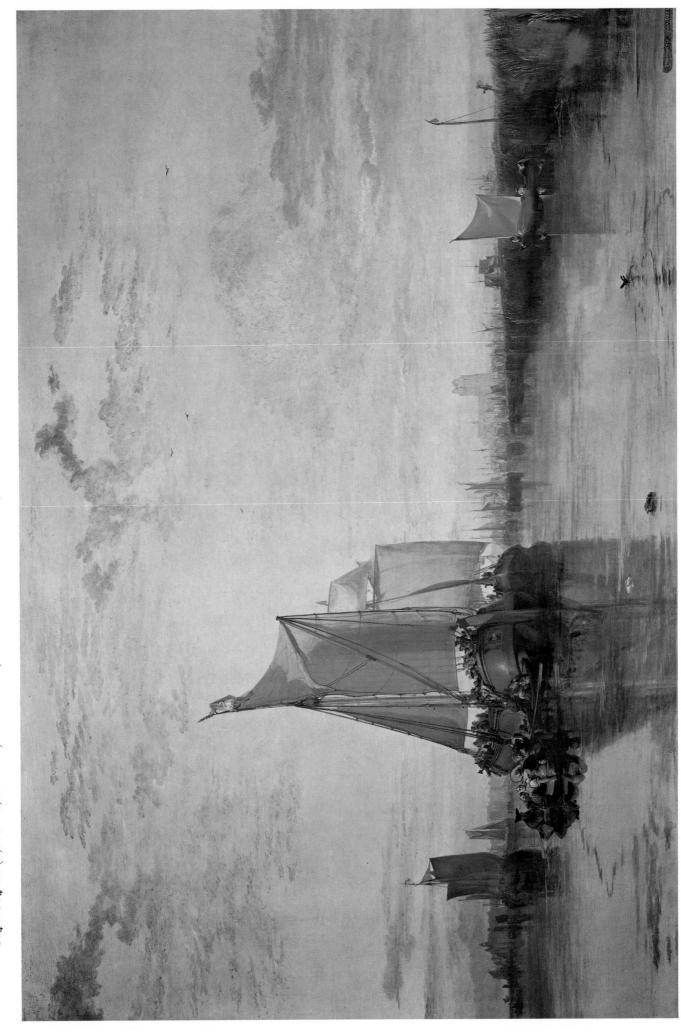

86. *Dort or Dordecht: The Dort Packet-boat from Rotterdam becalmed.* R.A. 1818. Oil on canvas; 61¾ × 93¼ in. (1,570 × 2,370 mm.) New Haven, Yale Center for British Art, Paul Mellon Collection.

87. *Venice: looking east from the Giudecca: Sunrise.* 1819.
Watercolour;
$8\frac{3}{4} \times 11\frac{5}{16}$ in. (222 × 287 mm.)
London, British Museum (CLXXXI 5).

88. *Venice: San Giorgio Maggiore from the Dogana.* 1819.
Watercolour;
$8\frac{13}{16} \times 11\frac{5}{16}$ in. (224 × 287 mm.)
London, British Museum (CLXXXI 4).

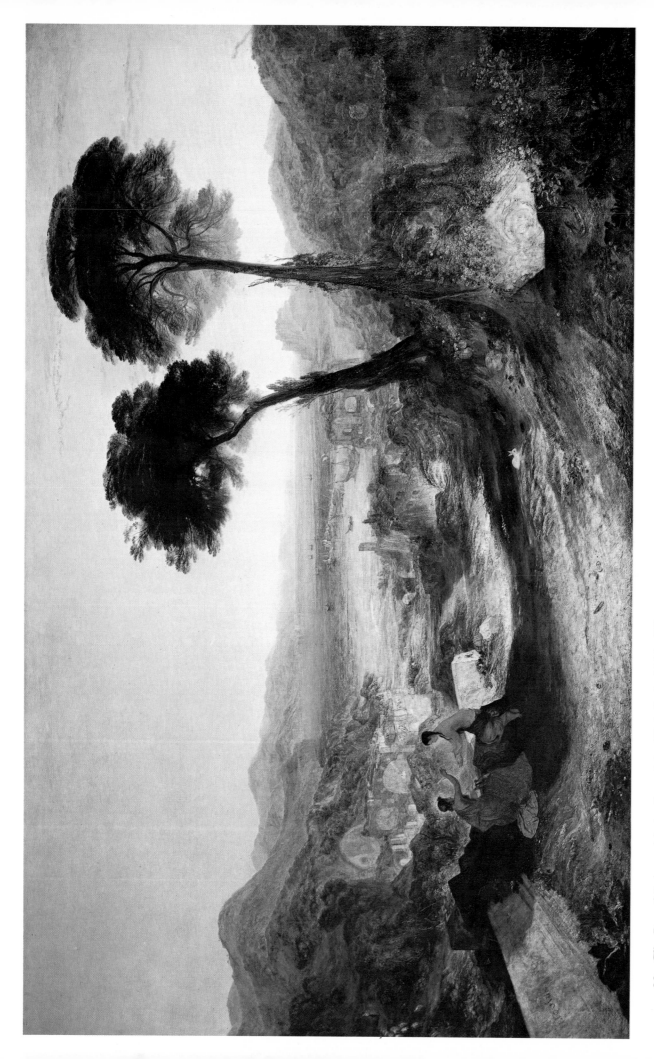

89. *The Bay of Baiae, with Apollo and the Sibyl.* R.A. 1823. Oil on canvas; 57½ × 93½ in. (1,460 × 2,374 mm.) London, Tate Gallery.

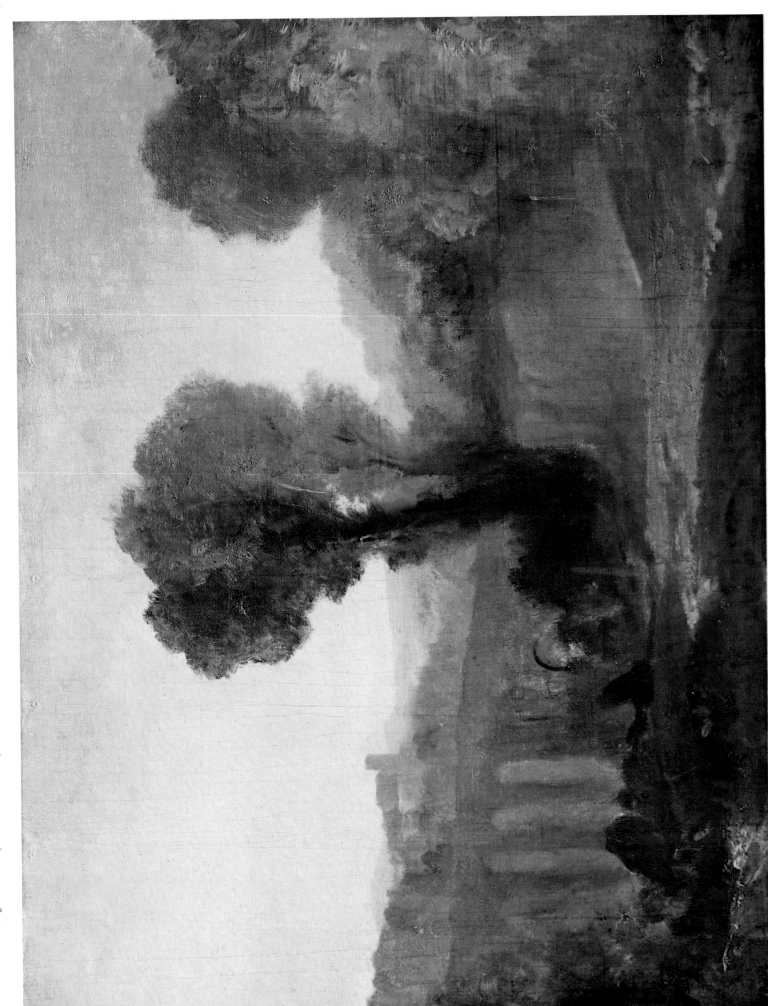

90. *Aricca?, Sunset.* 1828. Oil on canvas;
23½ × 31 in. (597 × 788 mm.) London, Tate Gallery.

91. *Storm Clouds: Sunset. c.* 1825.
 Watercolour;
 $9\frac{1}{2} \times 13\frac{1}{4}$ in. (241 × 336 mm.)
 London, British Museum (CXCVII F).

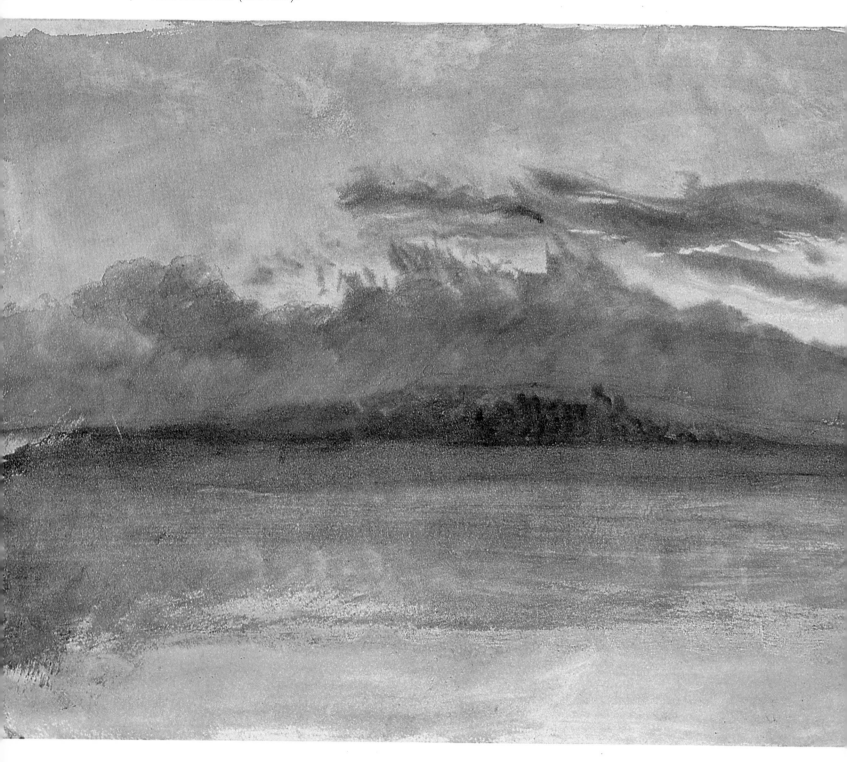

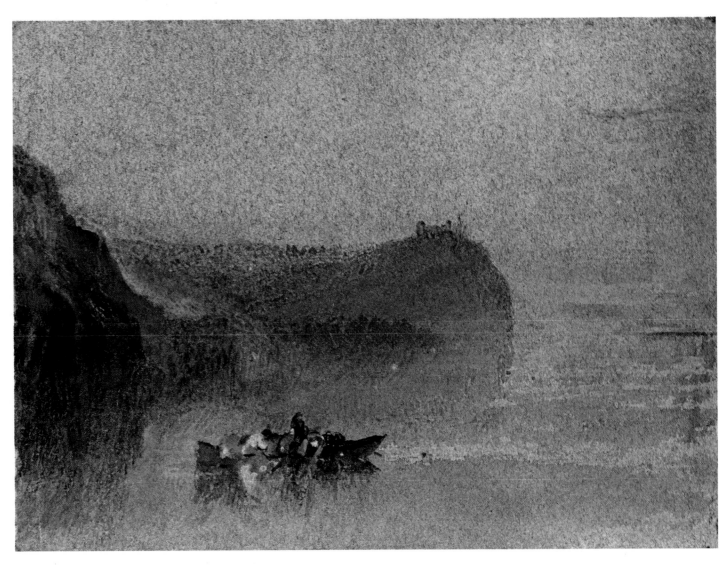

92. *Scene on the Loire. c.* 1826–30.
Body-colour and watercolour on blue-grey paper;
$5\frac{1}{2} \times 7\frac{1}{2}$ in. (140 × 191 mm.)
Oxford, Ashmolean Museum (Ruskin School Collection).

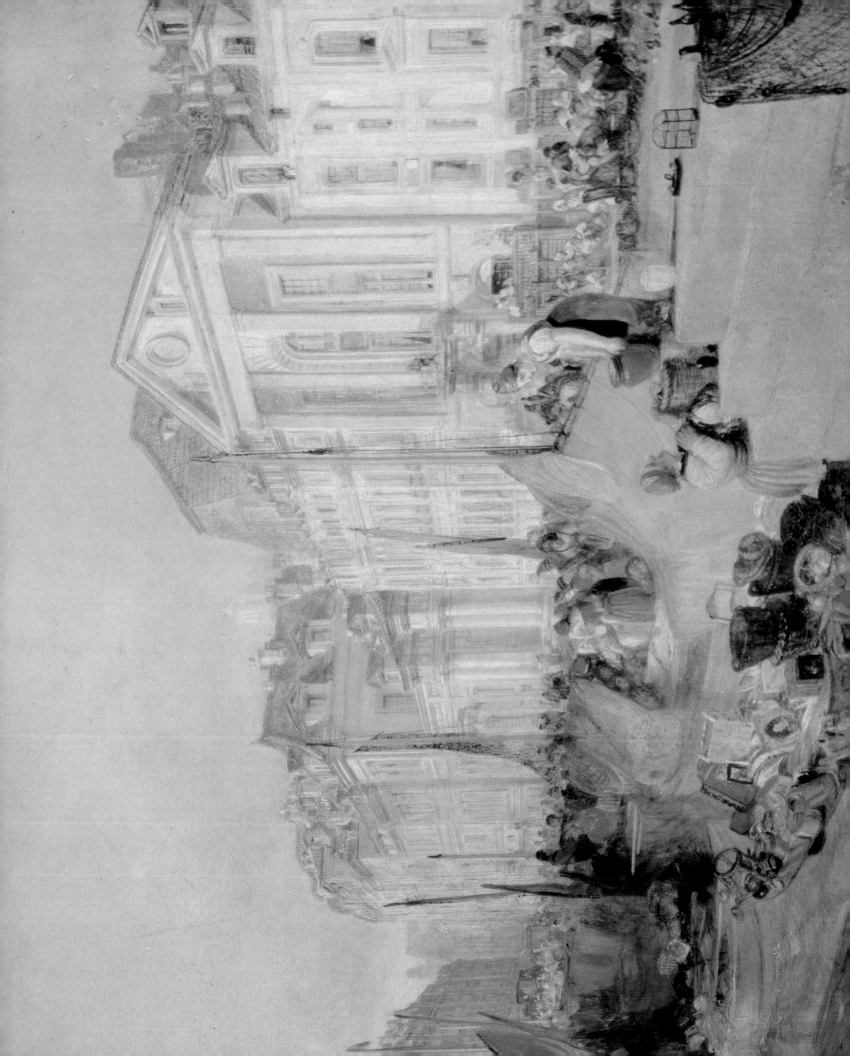

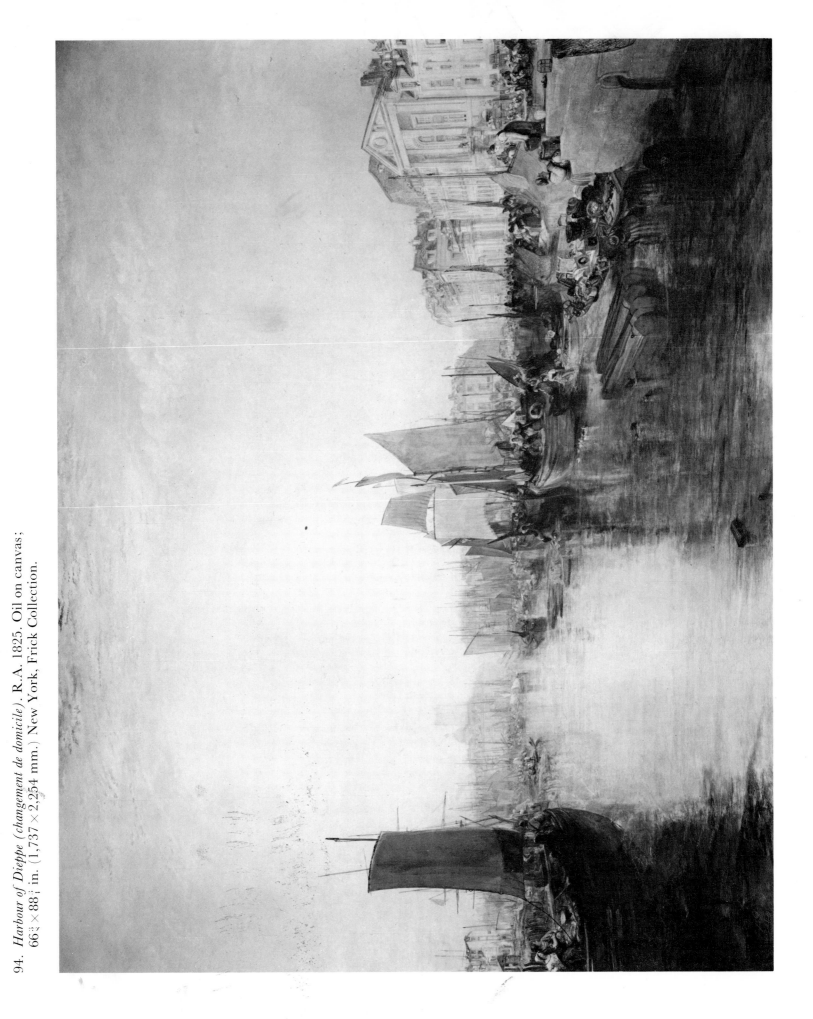

93. *(above)* Detail from *Harbour of Dieppe* (Plate 94).

94. *Harbour of Dieppe (changement de domicile)*. R.A. 1825. Oil on canvas; 66¾ × 88⅞ in. (1,737 × 2,254 mm.) New York, Frick Collection.

95. *Ponte di Rialto, Venice*. 1819. Pencil;
 $4\frac{3}{8} \times 7\frac{7}{16}$ in. (111 × 189 mm.) Actual size. London, British Museum (CLXXV 77a).

96. *Gondolas passing the Barberigo (?) Palace, Venice*. 1819. Pencil;
 $4\frac{3}{8} \times 7\frac{7}{16}$ in. (111 × 189 mm.) Actual size. London, British Museum (CLXXV 38).

97. *Rome, from the Vatican.* 1819. Pencil, pen and ink, heightened with white on grey paper;
 $9\frac{1}{8} \times 14\frac{1}{2}$ in. (231 × 370 mm.) London, British Museum (CLXXXIX 41).

98. *View in Rome with the Basilica of Constantine and the Colosseum.* 1819. Pencil and watercolour on grey paper;
 $9\frac{1}{8} \times 14\frac{1}{2}$ in. (229 × 370 mm.) London, British Museum (CLXXXIX 20).

101. *The Passage of Mont Cenis: Snowstorm.* 1820.
Watercolour;
28 × 40 in. (711 × 1,017 mm.)
Birmingham, City Art Gallery.

99. *(opposite) Naples.* 1819.
Watercolour over pencil;
10 $\frac{1}{16}$ × 16 in. (255 × 406 mm.)
London, British Museum (CLXXXVII 13).

100. *(opposite) Tivoli.* 1819.
Watercolour over pencil;
10 $\frac{1}{16}$ × 16 in. (255 × 406 mm.)
London, British Museum (CLXXXVII 32).

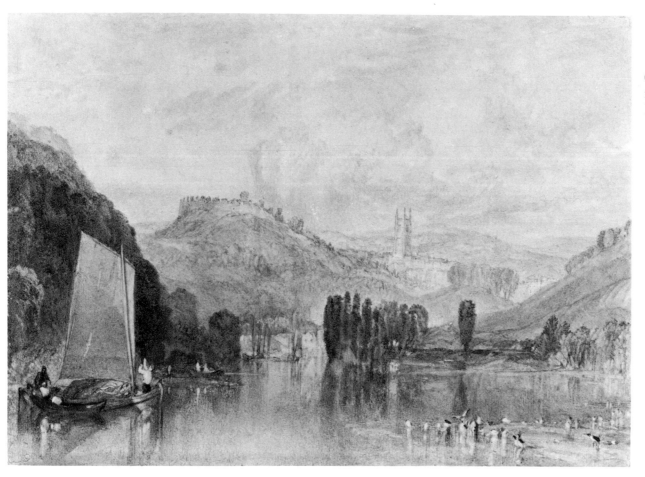

102.

Totnes, on the River Dart.
1824. Watercolour;
$6\frac{3}{8} \times 9\frac{1}{16}$ in. (162×232
mm.) London, British
Museum (CCVIII B).

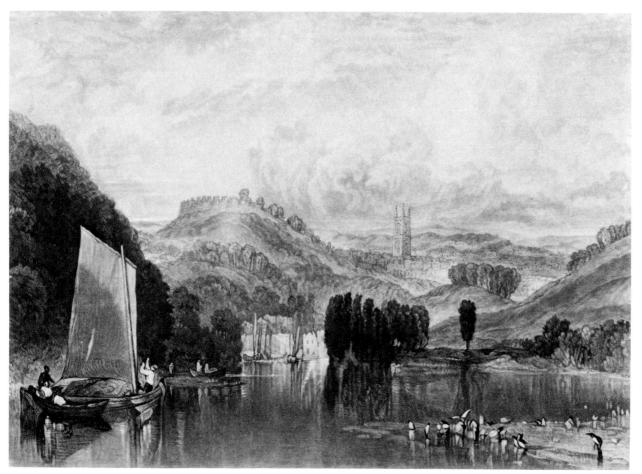

103.

Totnes, on the River Dart.
Mezzotint engraving
by C. Turner; $6\frac{5}{16} \times 9$
in. (160×228 mm.)
London, British
Museum.

04. *Colchester. c.* 1827. Watercolour, slightly heightened with white; $11\frac{1}{8} \times 15\frac{7}{8}$ in. (283×404 mm.) London, Courtauld Institute of Art, University of London.

05. *Richmond Hill and Bridge, Surrey. c.* 1830. Watercolour; $11\frac{1}{2} \times 17$ in. (292×432 mm.) London, British Museum (R. W. Lloyd Bequest).

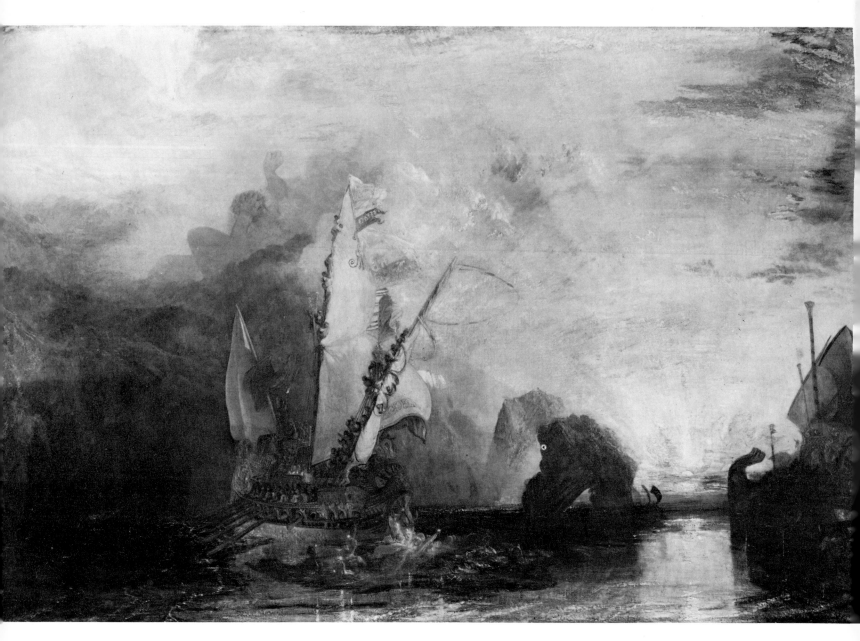

106, 107. *Ulysses deriding Polyphemus*. R.A. 1829.
Oil on canvas;
$52\frac{1}{4} \times 80$ in. $(1,325 \times 2,030$ mm.)
London, National Gallery. Detail on right.

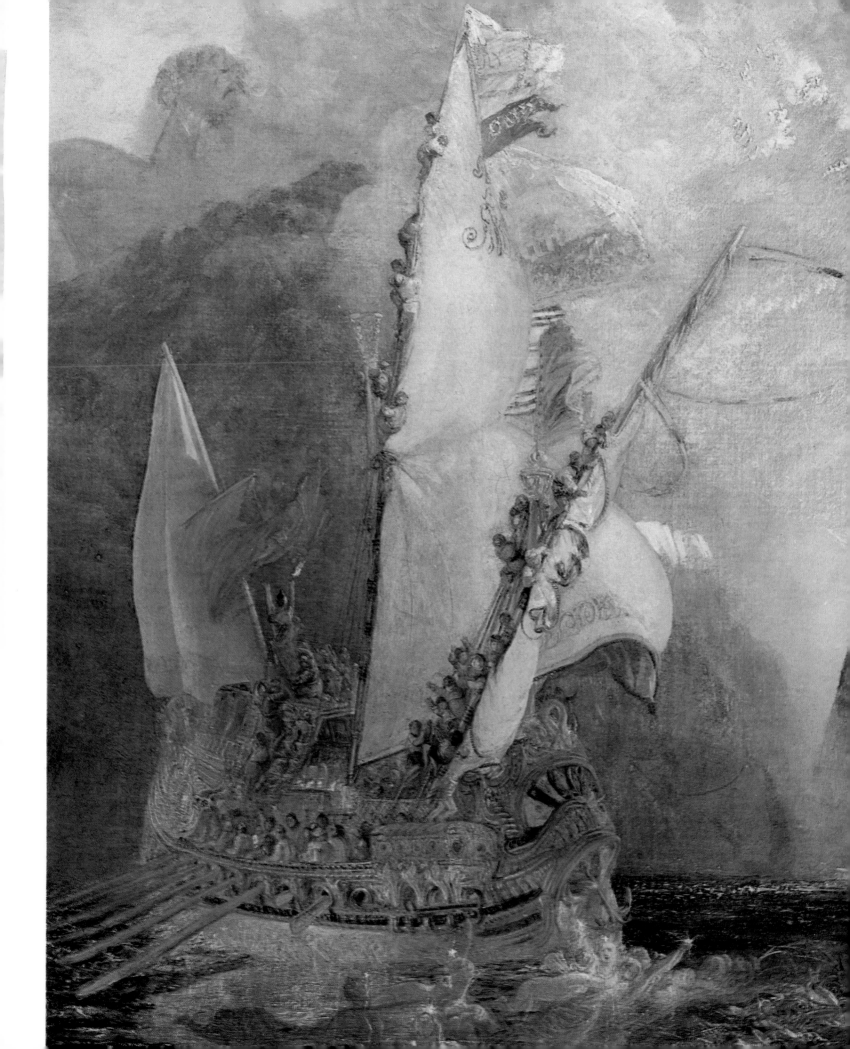

108. *Petworth Park: Tillington Church in the Distance. c.* 1828.
Oil on canvas;
$25\frac{1}{4} \times 58\frac{1}{4}$ in. (642 × 1,480 mm.)
London, Tate Gallery.

109. *Chichester Canal. c.* 1828.
Oil on canvas;
$25\frac{1}{2} \times 52\frac{3}{4}$ in. (647 × 1,340 mm.)
London, Tate Gallery.

110. *Calais Sands, low Water, Poissards collecting Bait.* R.A. 1830.
Oil on canvas;
$28\frac{1}{2} \times 42$ in. $(724 \times 1,067$ mm.)
Bury Art Gallery, Lancashire.

111. *'Santa Maria della Spina, Pisa.'* c. 1832.
Watercolour on buff paper;
$7\frac{1}{2} \times 6\frac{3}{4}$ in. (190 × 173 mm.)
Oxford, Ashmolean Museum.

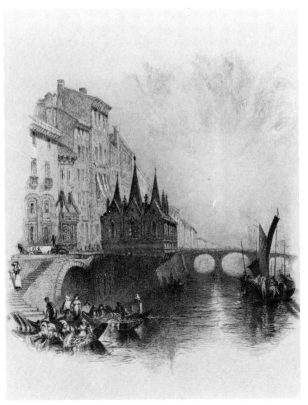

112. *'Santa Maria della Spina, Pisa.'* 1832.
Steel engraving by E. Finden;
$3\frac{1}{2} \times 3\frac{1}{8}$ in. (89 × 80 mm.) Actual size.
London, British Museum.

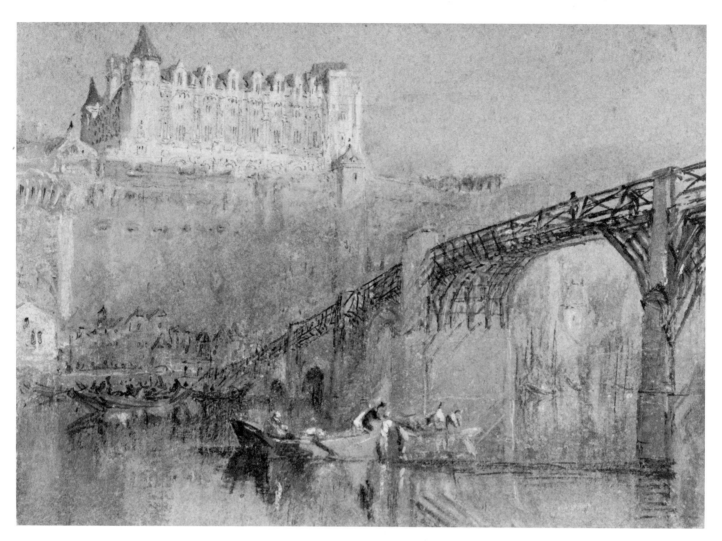

113. *'Château of Amboise.'* *c*. 1830. Watercolour and body-colour, with pen and
black ink, on grey paper; $5\frac{3}{8} \times 7\frac{3}{8}$ in. (136 × 188 mm.) Actual size.
Oxford, Ashmolean Museum.

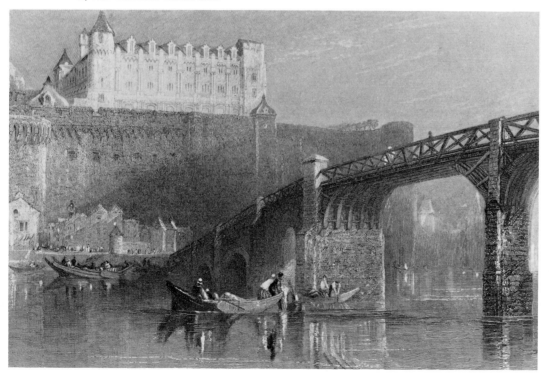

114. *'Château of Amboise.'* 1833.
Engraving on steel by J. B. Allen;
$3\frac{11}{16} \times 5\frac{11}{16}$ in. (94 × 145 mm.)
Actual size.
London, British Museum.

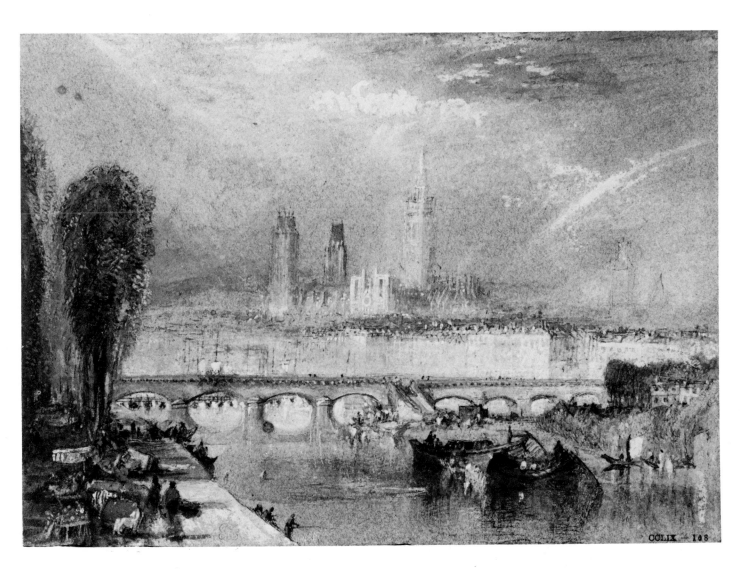

115. *Rouen, looking down River. c.* 1830.
Body-colour and watercolour on blue paper;
$5\frac{1}{2} \times 7\frac{1}{2}$ in. (140 × 191 mm.) Actual size.
London, British Museum (CCLIX 108).

116. *View on the Seine. c.* 1830.
 Body-colour and watercolour, on blue paper;
 $5\frac{1}{2} \times 7\frac{1}{2}$ in. $(140 \times 191$ mm.)
 London, British Museum (CCLIX 70).

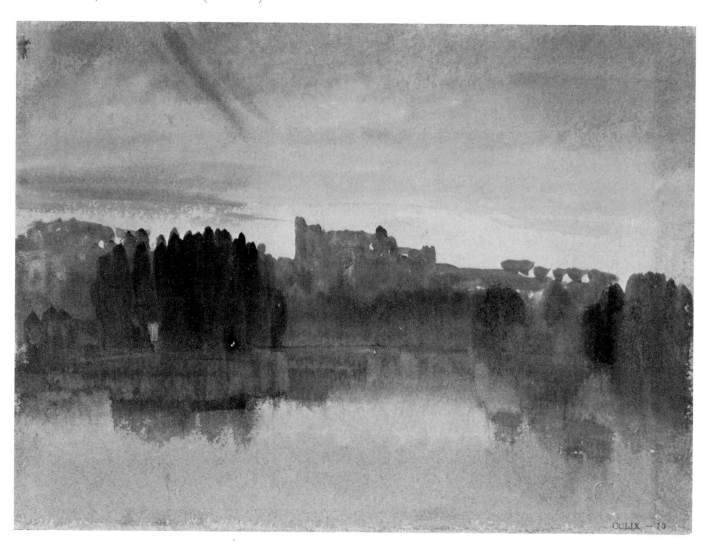

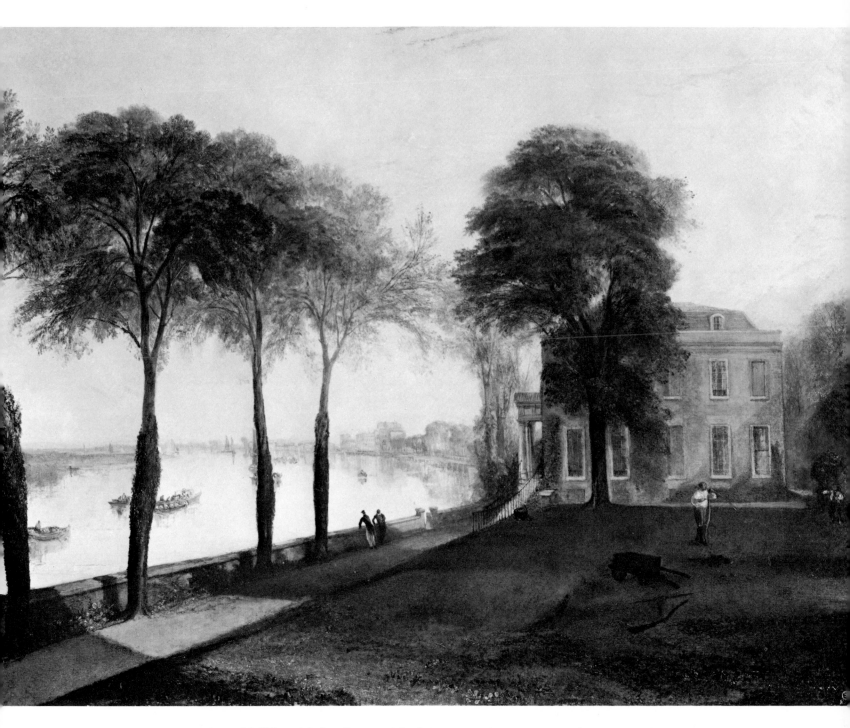

117. *The Seat of William Moffat, Esq., at Mortlake. Early (Summer's) Morning.* R.A. 1826.
Oil on canvas;
$36\frac{5}{8} \times 48\frac{1}{2}$ in. (930 × 1,232 mm.)
New York, Frick Collection.

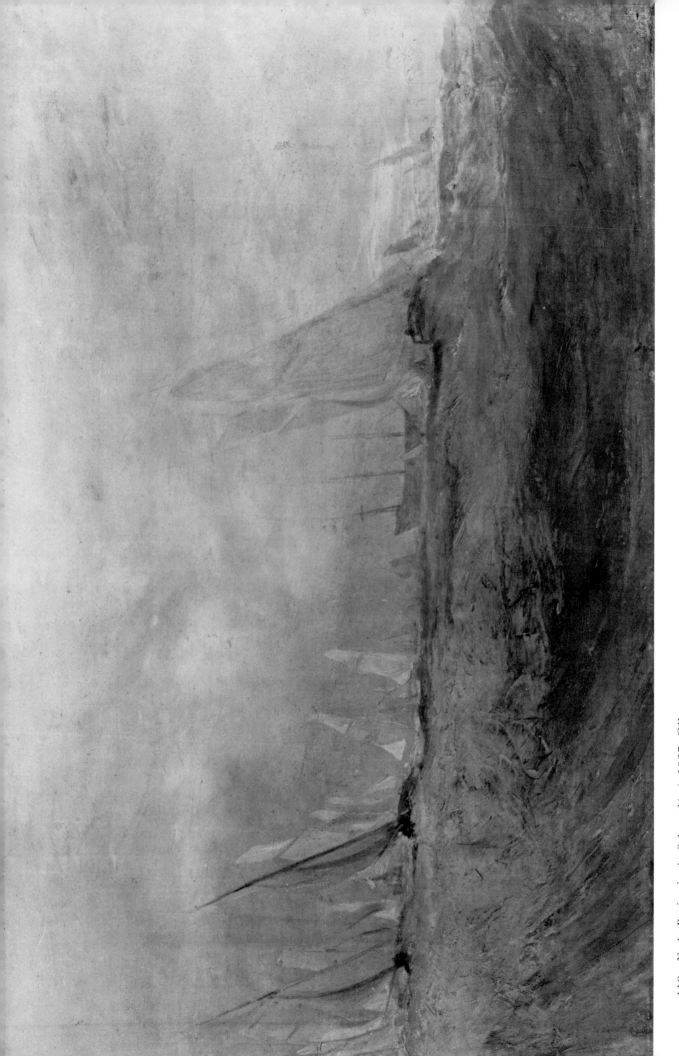

118. *Yacht Racing in the Solent, No. 1.* 1827. Oil on canvas; 18¼ × 28½ in. (464 × 724 mm.) London, Tate Gallery.

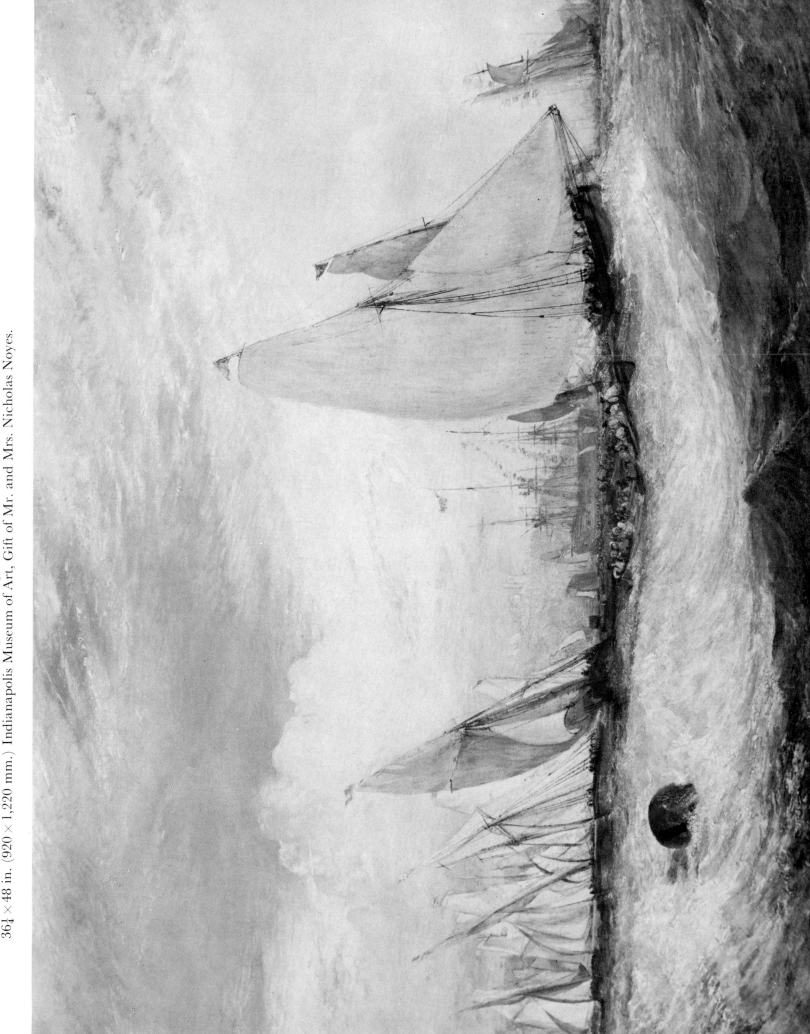

119. *East Cowes Castle, the Seat of J. Nash, Esq.: the Regatta beating to windward.* R.A. 1828. Oil on canvas; 36¼ × 48 in. (920 × 1,220 mm.) Indianapolis Museum of Art, Gift of Mr. and Mrs. Nicholas Noyes.

121. *Between Decks*. 1827.
Oil on canvas;
12 × 19⅛ in. (305 × 484 mm.)
London, Tate Gallery.

120. *(opposite) Boccaccio relating the Tale of the Birdcage*. R.A. 1828.
Oil on canvas;
48 × 36 in. (1,220 × 915 mm.)
London, Tate Gallery.

122. *Palestrina*. 1828; R.A. 1830.
Oil on canvas;
$55\frac{1}{2} \times 98$ in. (1,410 × 2,481 mm.)
London, Tate Gallery.

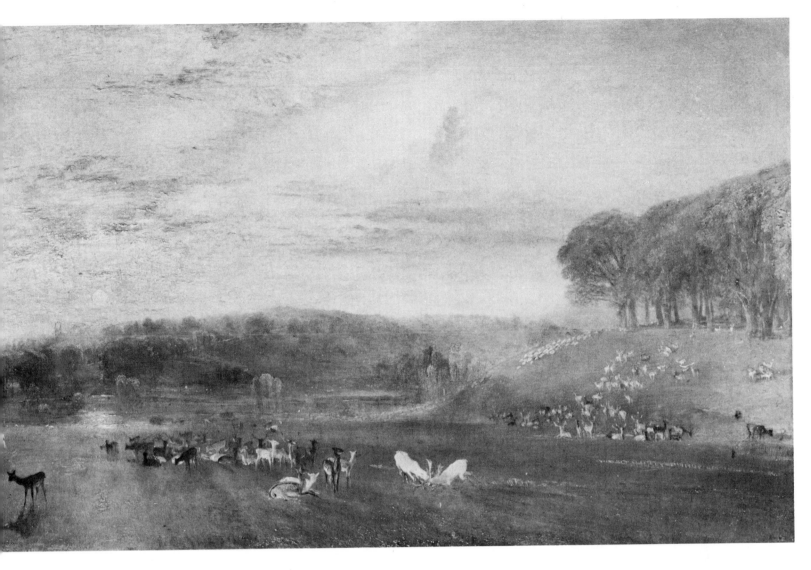

123. *The Lake, Petworth: Sunset, fighting Bucks. c.* 1830.
Oil on canvas;
$24\frac{1}{4} \times 57\frac{1}{2}$ in. (615 × 1,460 mm.)
Petworth House, Sussex.

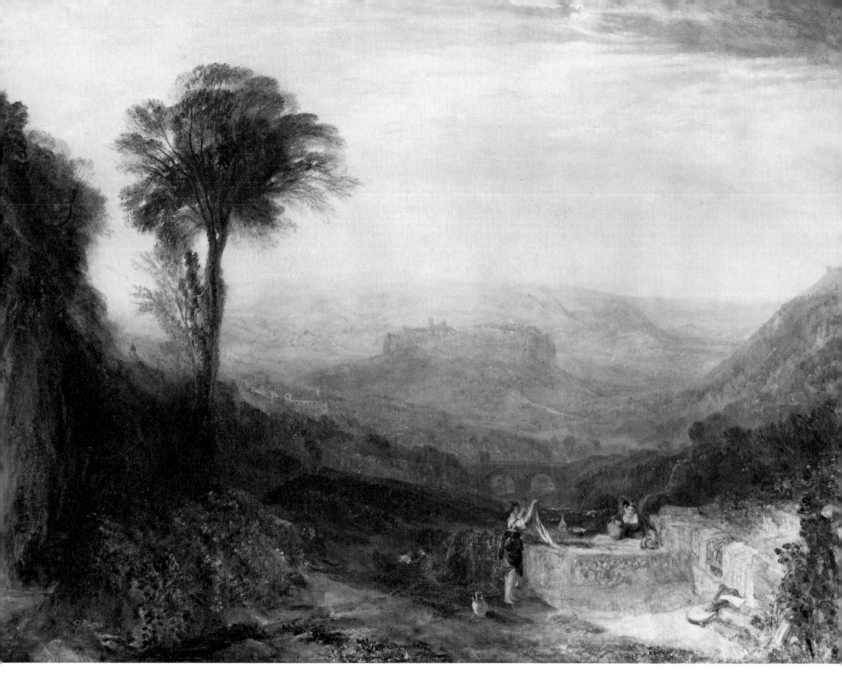

124. *View of Orvieto.* 1828; R.A. 1830.
Oil on canvas;
$36 \times 48\frac{1}{2}$ in. (915 × 1,232 mm.)
London, Tate Gallery.

125. *Coast Scene near Naples.* 1828.
Oil on board;
$16\frac{1}{8} \times 23\frac{1}{2}$ in. (410 × 597 mm.)
London, Tate Gallery.

126. *Regulus*. 1828; B.I. 1837.
Oil on canvas;
36 × 48 in. (915 × 1,220 mm.)
London, Tate Gallery.

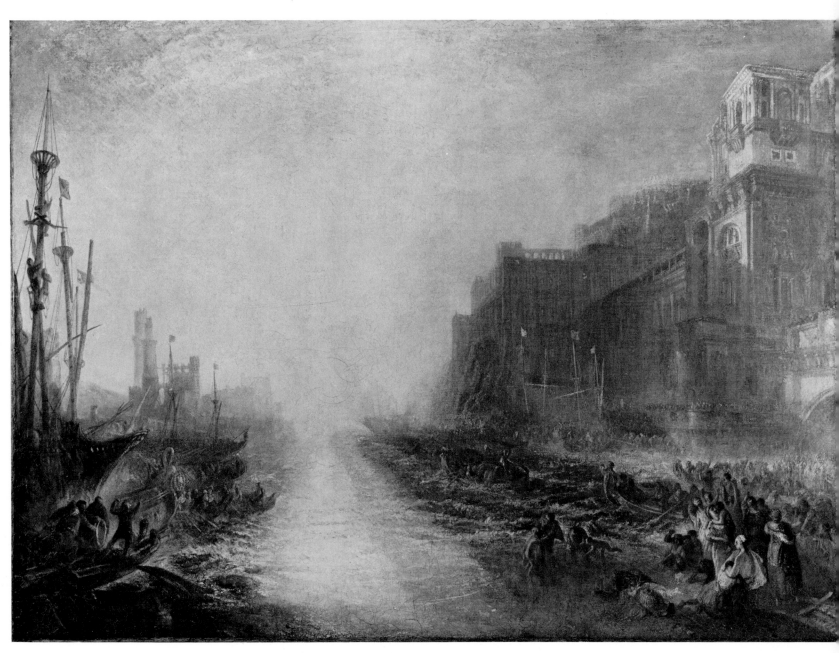

127. *Pilate washing his Hands.* R.A. 1830.
Oil on canvas;
36 × 48 in. (915 × 1,220 mm.)
London, Tate Gallery.

128. *(opposite) Jessica.* 1828, R.A. 1830.
Oil on canvas;
47 × 35 in. (1,194 × 889 mm.)
Petworth House, Sussex.

129. *Landscape at Petworth: Evening. c.* 1827–30.
Body-colour on blue paper;
$5\frac{1}{2} \times 7\frac{1}{2}$ in. (140 × 190 mm.) Actual size.
London, British Museum (CCXLIV 59).

130. *(opposite) The square Dining Room, Petworth. c.* 1827–30
Body-colour on blue paper;
$5\frac{1}{2} \times 7\frac{1}{2}$ in. (140 × 190 mm.)
London, British Museum (CCXLIV 108).

131. *(opposite) Petworth; playing Billiards. c.* 1827–30.
Body-colour on blue paper;
$5\frac{1}{2} \times 7\frac{1}{2}$ in. (140 × 190 mm.)
London, British Museum (CCXLIV 116).

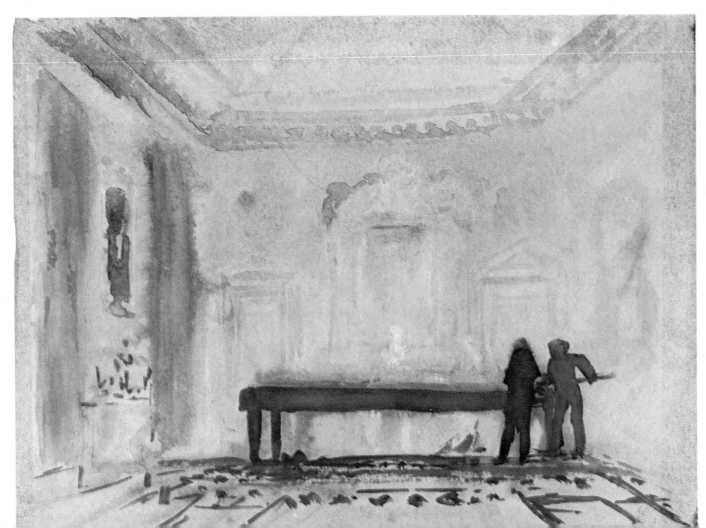

132. *The Burning of the Houses of Parliament.* 1834. Watercolour;
9¼ × 12¾ in. (235 × 324 mm.) London, British Museum (CCLXXXIII 2).

133. *The Burning of the Houses of Lords and Commons, October 16, 1834.* R.A. 1835. Oil on canvas; $36\frac{1}{2} \times 48\frac{1}{2}$ in. ($927 \times 1,232$ mm.) Cleveland Museum of Art, Ohio.

134. *Interior at Petworth. c. 1835–7.* Oil on canvas.
35¾ × 48 in. (908 × 1,220 mm.) London, Tate Gallery.

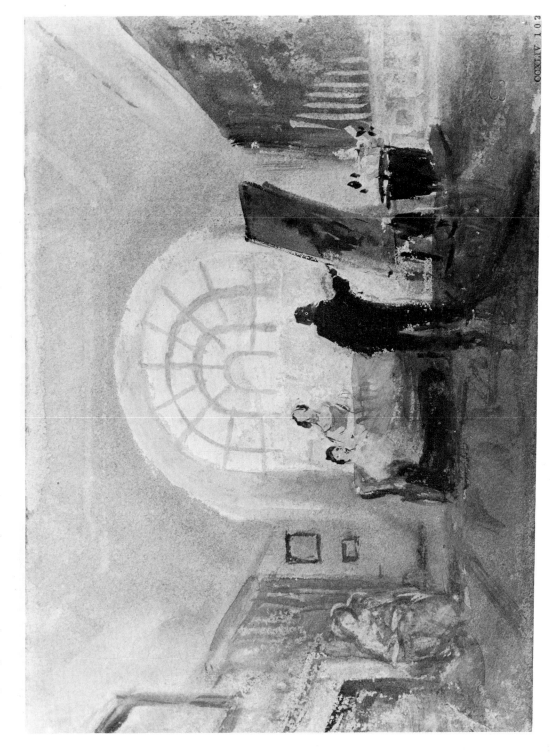

135. *Petworth; the Artist and his Admirers. c.* 1827–30. Body-colour on blue paper; 5½ × 7½ in. (140 × 190 mm.) Actual size. London, British Museum (CCXLIV 102).

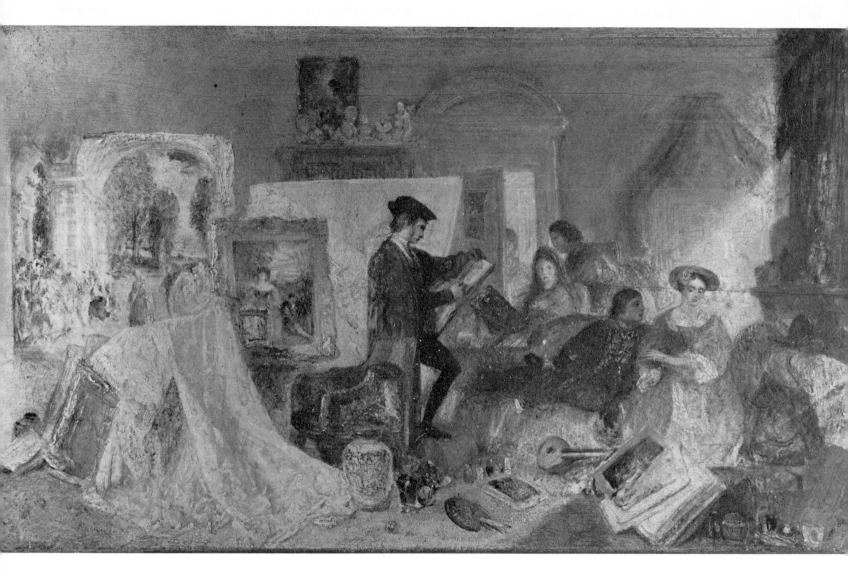

136. *Watteau Study by Fresnoy's Rules*. R.A. 1831.
Oil on panel;
$15\frac{1}{2} \times 27\frac{1}{2}$ in. (394×699 mm.)
London, Tate Gallery.

137. *(opposite) Music at East Cowes Castle. c.* 1835.
Oil on canvas;
$47\frac{3}{4} \times 35\frac{5}{8}$ in. ($1,212 \times 905$ mm.)
London, Tate Gallery.

138. *Life-boat and Manby Apparatus going off to a stranded Vessel making Signal (blue lights) of Distress.* R.A. 1831. Oil on canvas; 36 × 48 in. (915 × 1,220 mm.) London, Victoria and Albert Museum.

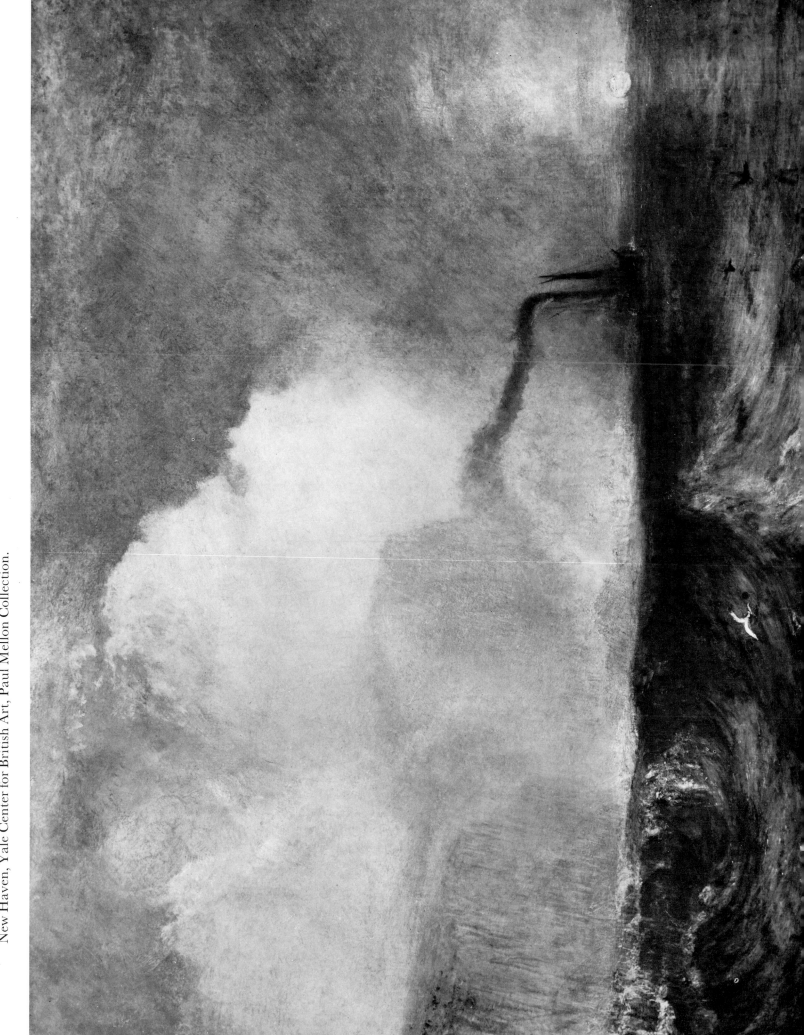

139. *Staffa, Fingal's Cave.* R.A. 1832. Oil on canvas; 36 × 48 in. (915 × 1,220 mm.) New Haven, Yale Center for British Art, Paul Mellon Collection.

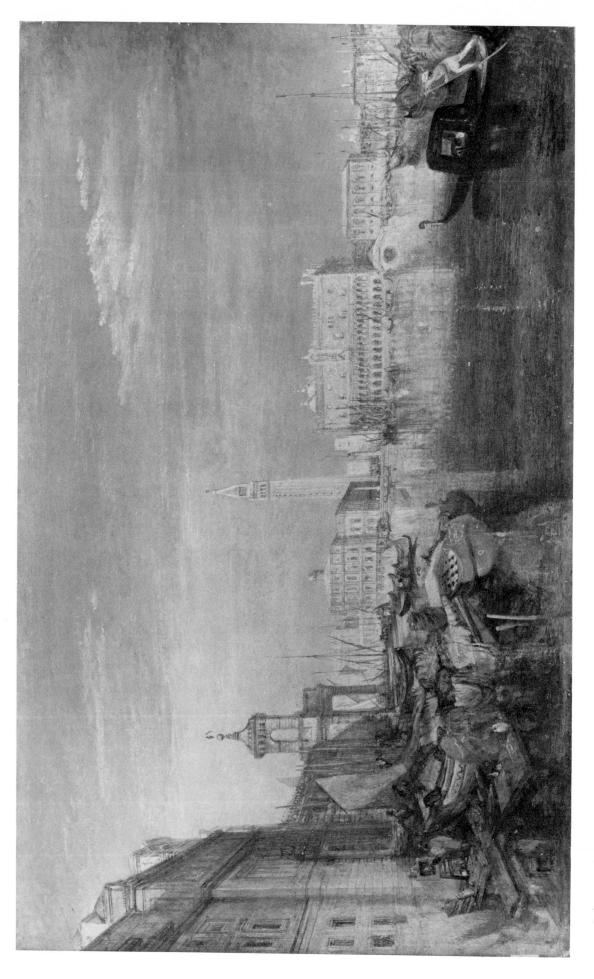

140. *Bridge of Sighs, Ducal Palace and Custom-house, Venice: Canaletti painting*. R.A. 1833. Oil on canvas; $20\frac{1}{4} \times 32\frac{1}{2}$ in. (515 × 825 mm.) London, Tate Gallery.

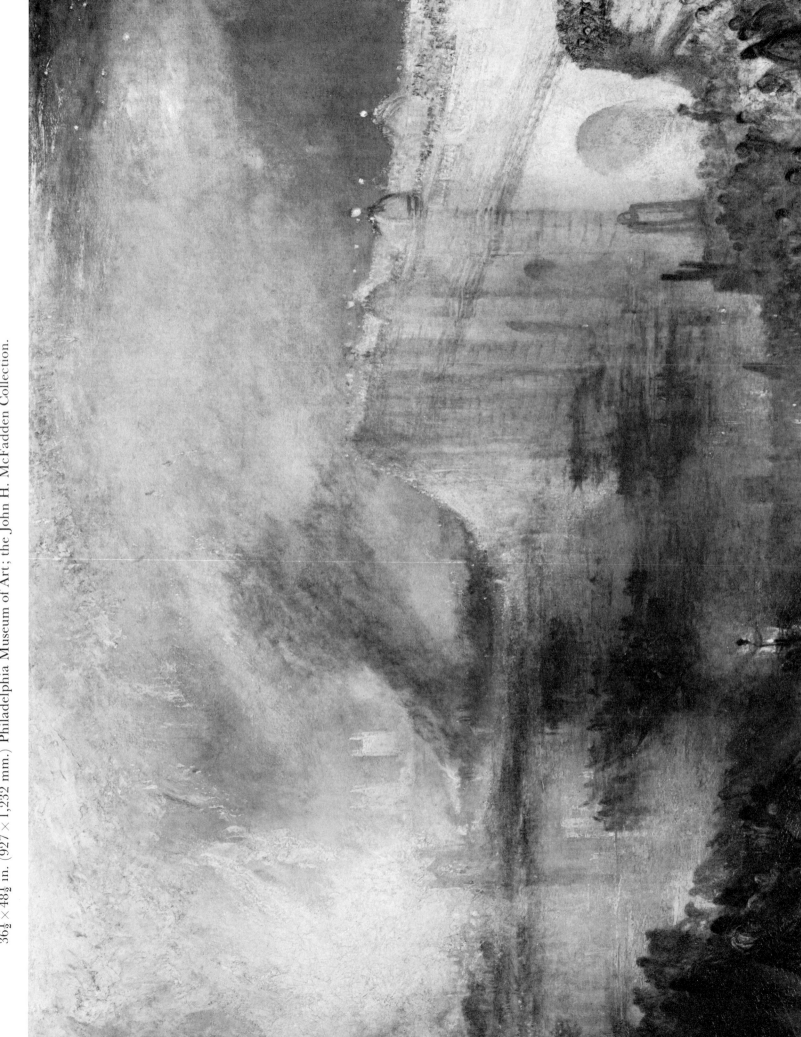

141. *(below) The Burning of the Houses of Lords and Commons, 16th of October, 1834.* B.I. 1835. Oil on canvas; $36\frac{1}{2} \times 48\frac{1}{2}$ in. (927 × 1,232 mm.) Philadelphia Museum of Art; the John H. McFadden Collection.

142. *The Parting of Hero and Leander—from the Greek of Musaeus.* R.A. 1837.
Oil on canvas;
57½ × 93 in. (1,461 × 2,362 mm.)
London, National Gallery.

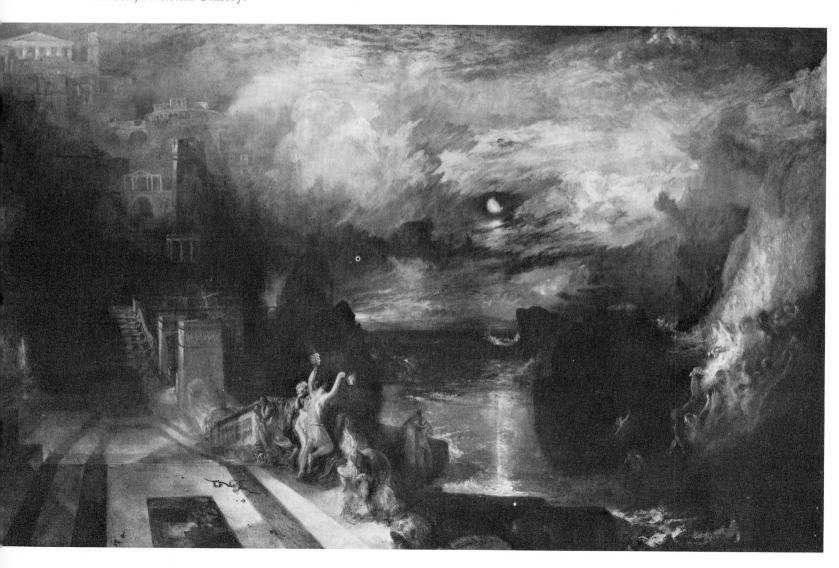

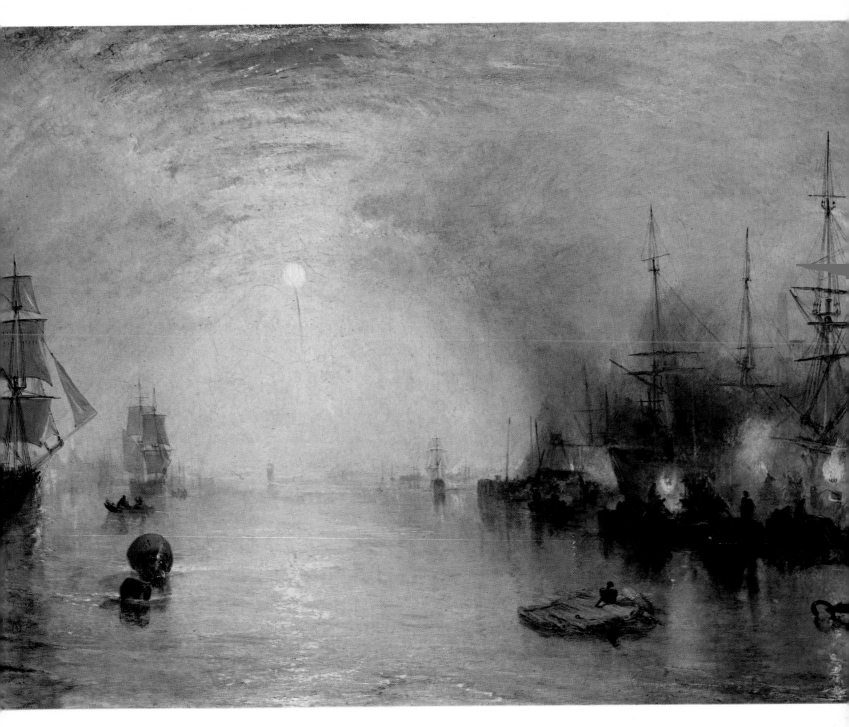

143. *Keelmen hauling in Coals by Night.* R.A. 1835.
Oil on canvas;
$36\frac{1}{4} \times 48\frac{1}{4}$ in. ($923 \times 1{,}228$ mm.)
Washington, National Gallery of Art (Widener Collection).

144. *A Fire at Sea. c.* 1835.
Oil on canvas;
$67\frac{1}{2} \times 86\frac{3}{4}$ in. (1,715 × 2,204 mm.)
London, Tate Gallery.

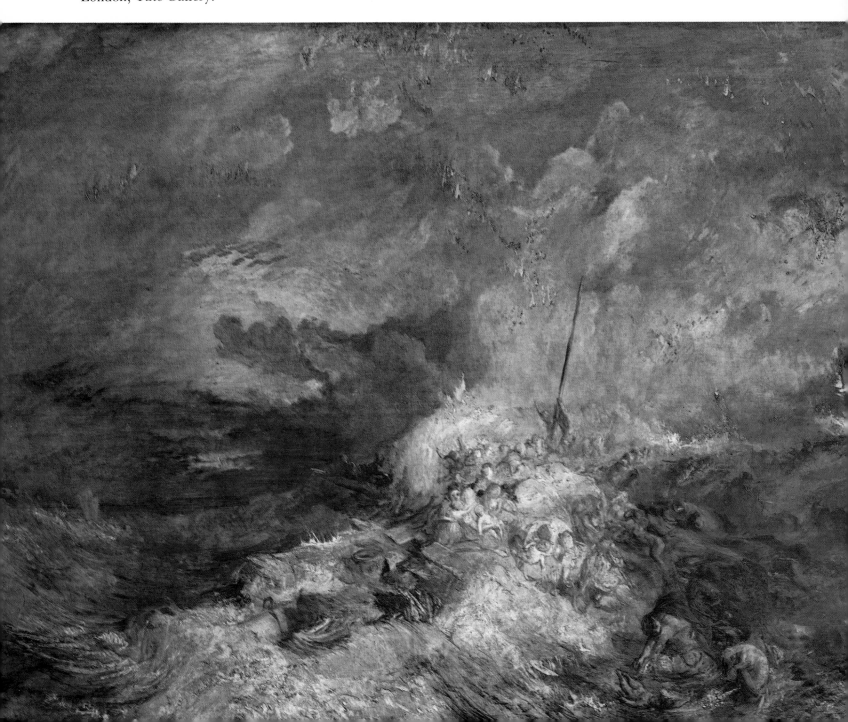

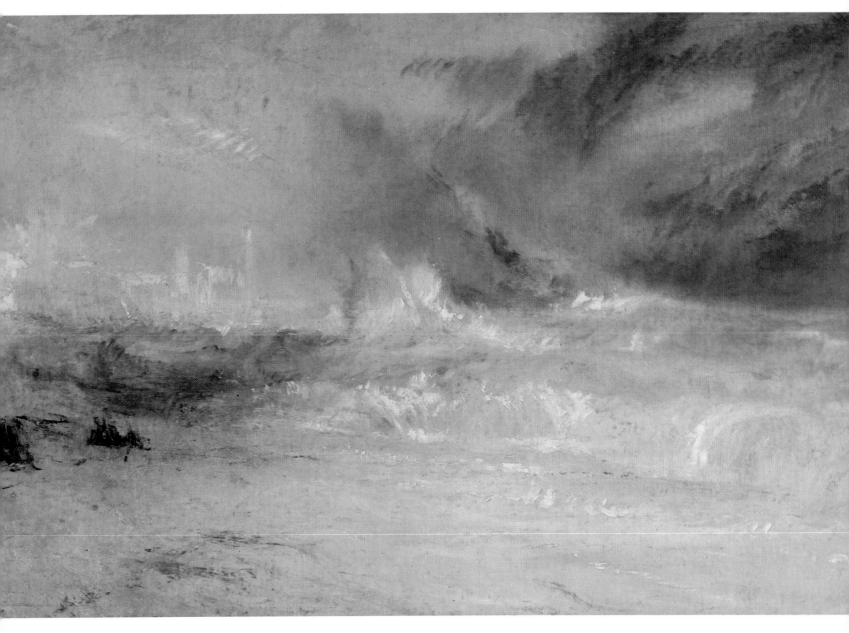

145. *Waves breaking on a lee Shore. c.* 1835.
Oil on canvas;
$23\frac{1}{2} \times 37\frac{1}{2}$ in. (597×952 mm.)
London, Tate Gallery.

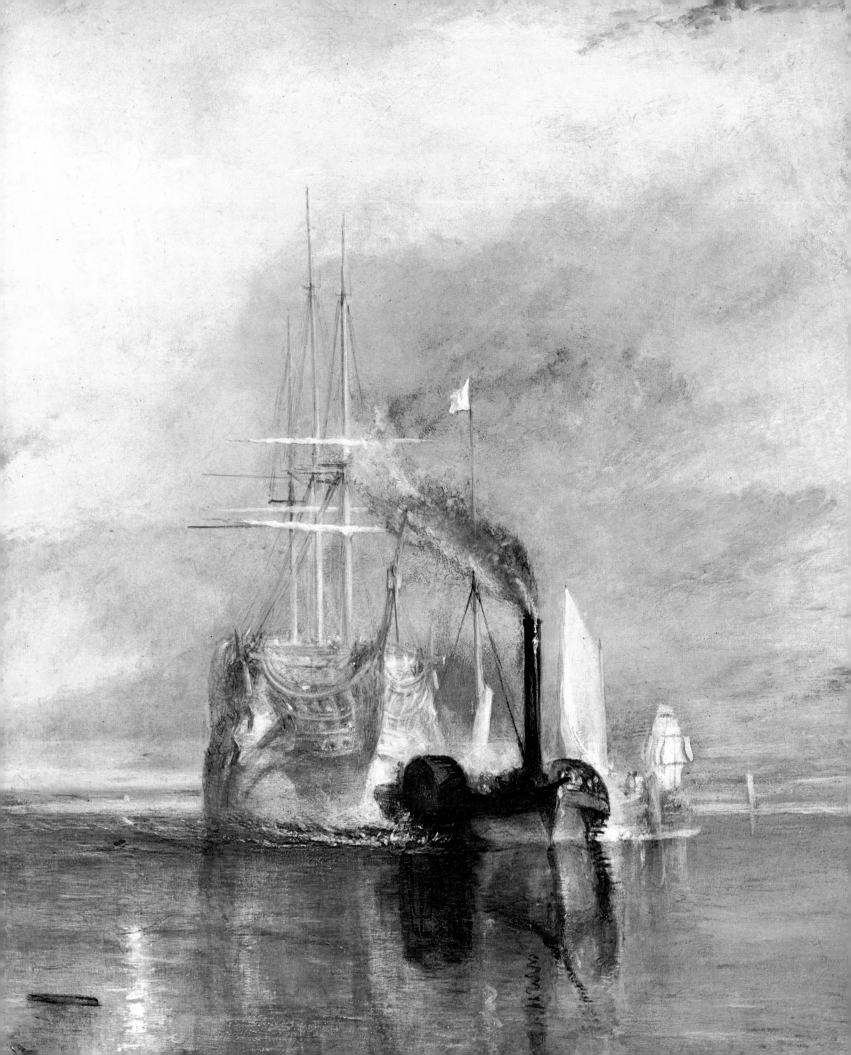

147. *Festive Lagoon Scene, Venice. c.* 1840–45.
Oil on canvas;
35¾ × 47¾ in. (910 × 1,212 mm.)
London, Tate Gallery.

146. *(opposite) The Fighting 'Téméraire' tugged to her last Berth to be broken up, 1838.*
Detail of Plate 152.

148. *Slavers throwing overboard the Dead and Dying—Typhon coming on* ('*The Slave Ship*'). R.A. 1840. Oil on canvas; 35¾ × 48 in. (910 × 1,220 mm.) Boston, Museum of Fine Arts.

149. *Heidelberg. c.* 1840. Watercolour; 14½ × 21⅝ in. (369 × 550 mm.) Edinburgh, National Gallery of Scotland.

150. *Light and Colour (Goethe's Theory) — the Morning after the Deluge — Moses writing the Book of Genesis.*
R.A. 1843. Oil on canvas; 31 × 31 in. (788 × 788 mm.) London, Tate Gallery.

151. *Shade and Darkness—the Evening of the Deluge*. R.A. 1843.
Oil on canvas;
$31 \times 30\frac{3}{4}$ in. $(788 \times 782$ mm.)
London, Tate Gallery.

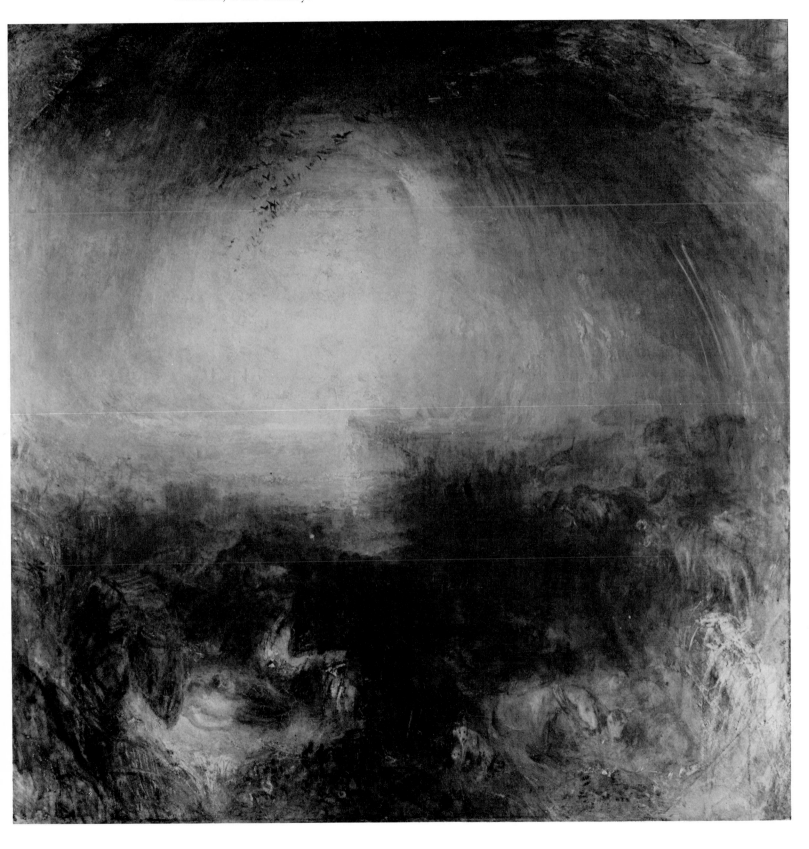

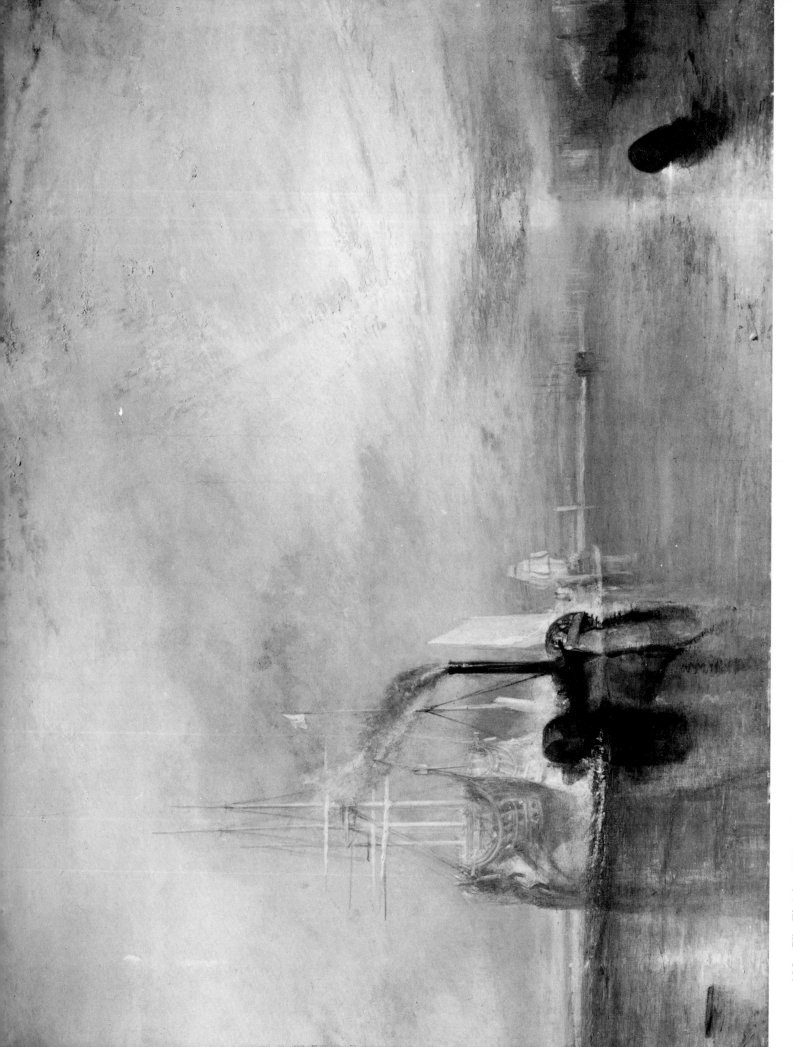

152. *The Fighting 'Téméraire' tugged to her last berth to be broken up*, 1838. R.A. 1839. Oil on canvas; 35¾ × 48 in. (910 × 1,220 mm.) London, National Gallery.

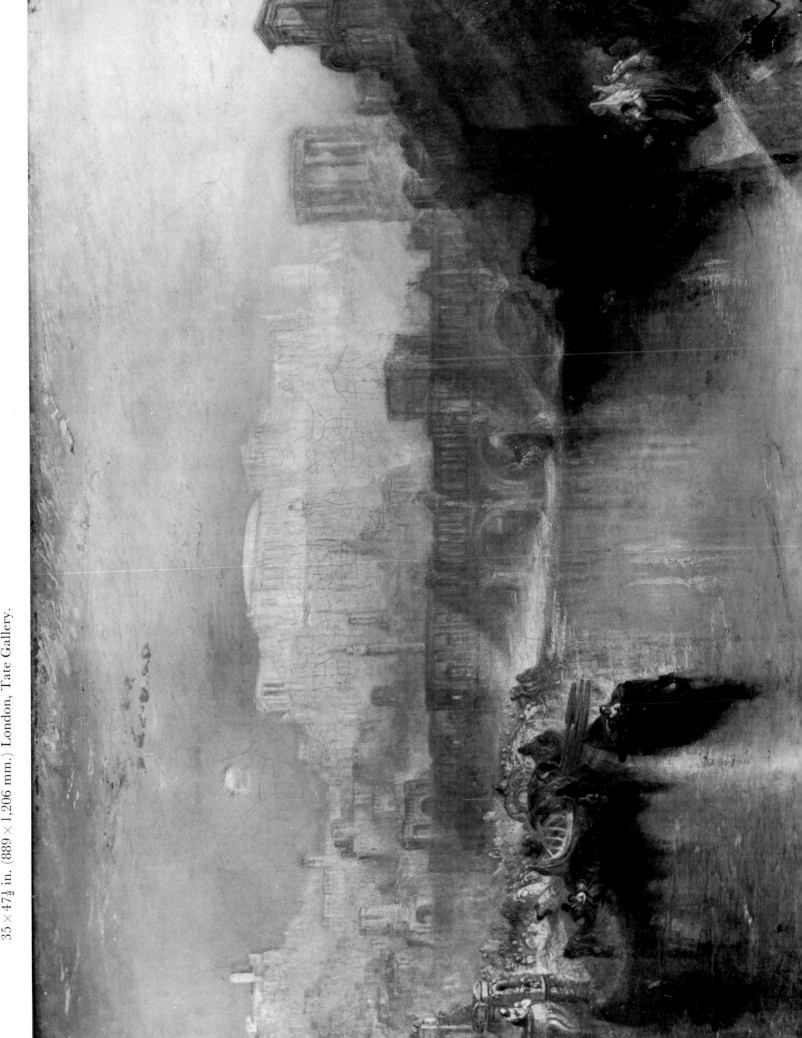

153. *Ancient Rome: Agrippina landing with the Ashes of Germanicus.* R.A. 1839. Oil on canvas;
35 × 47½ in. (889 × 1,206 mm.) London, Tate Gallery.

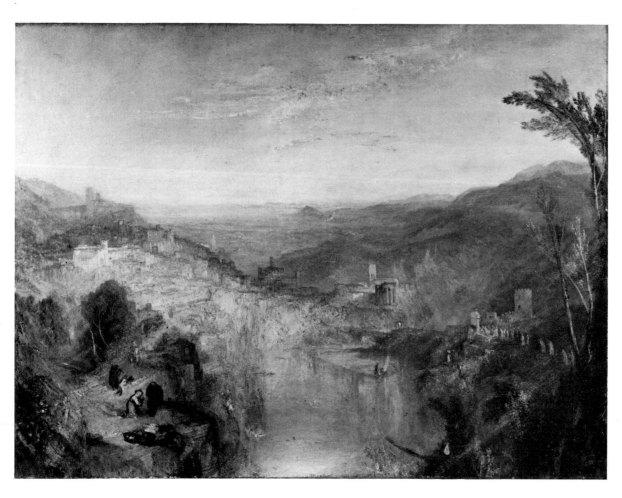

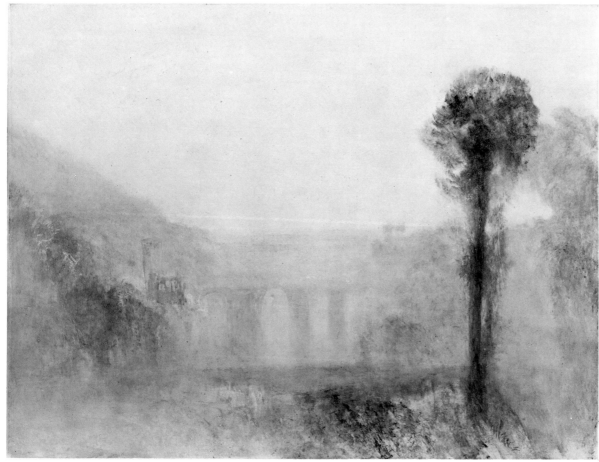

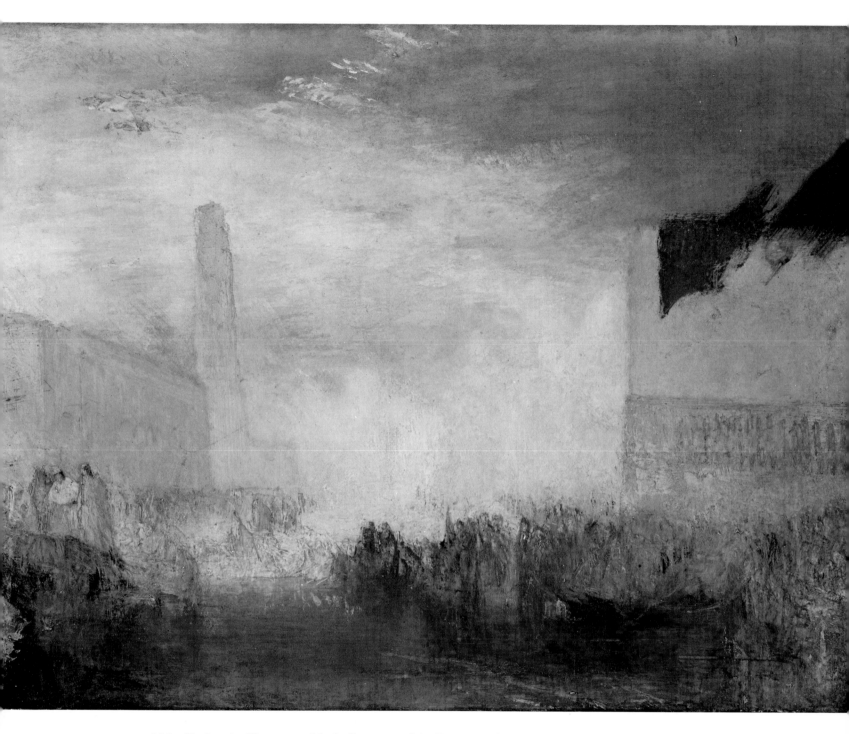

156. *Venice, the Piazzetta with the Ceremony of the Doge marrying the Sea. c.* 1835–40.
Oil on canvas;
36 × 47¾ in. (915 × 1,212 mm.)
London, Tate Gallery.

154. *(opposite) Modern Italy—the Pifferari.* R.A. 1838.
Oil on canvas;
36½ × 48½ in. (926 × 1,232 mm.)
Glasgow, Art Gallery.

155. *(opposite) The Ponte delle Torri, Spoleto. c.* 1840.
Oil on canvas;
36 × 48 in. (915 × 1,220 mm.)
London, Tate Gallery.

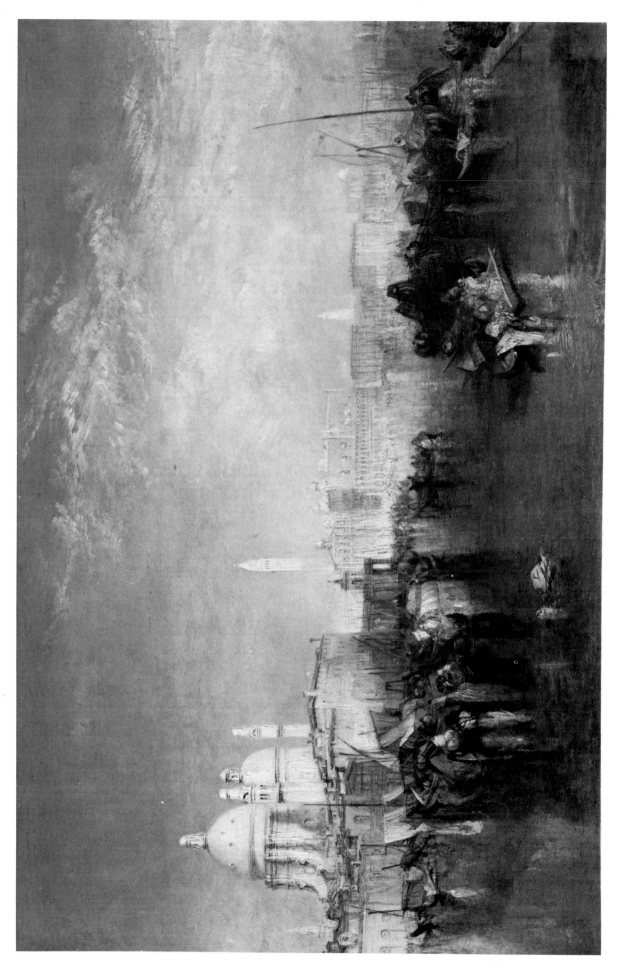

157. *Venice, from the Canale della Giudecca, Chiesa di S. Maria della Salute, &c.* R.A. 1840. Oil on Canvas; 24 × 36 in. (610 × 915 mm.) London, Victoria and Albert Museum.

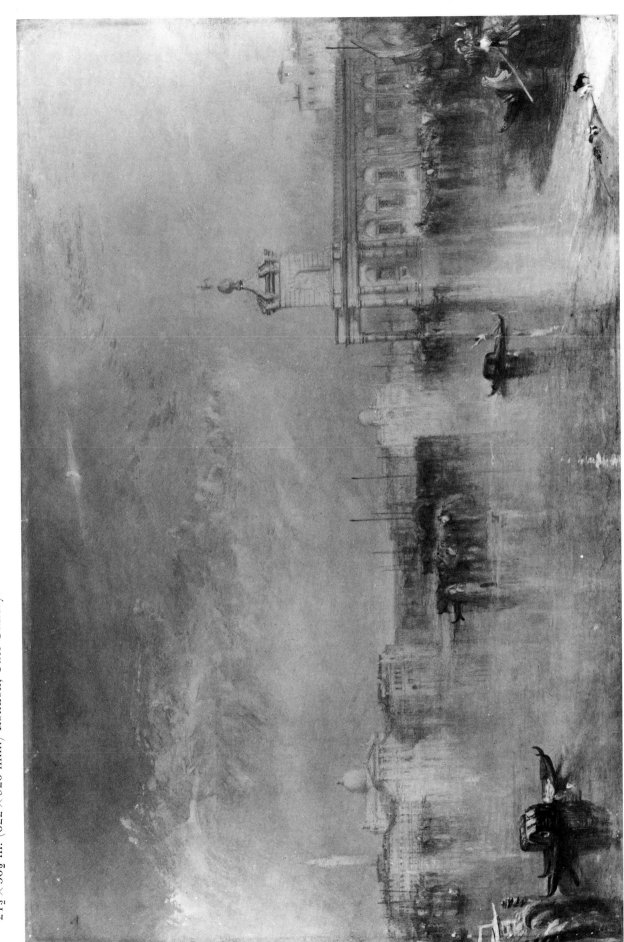

158. *The Dogana, San Giorgio, Citella, from the Steps of the Europa.* R.A. 1842. Oil on canvas;
24½ × 36½ in. (622 × 926 mm.) London, Tate Gallery.

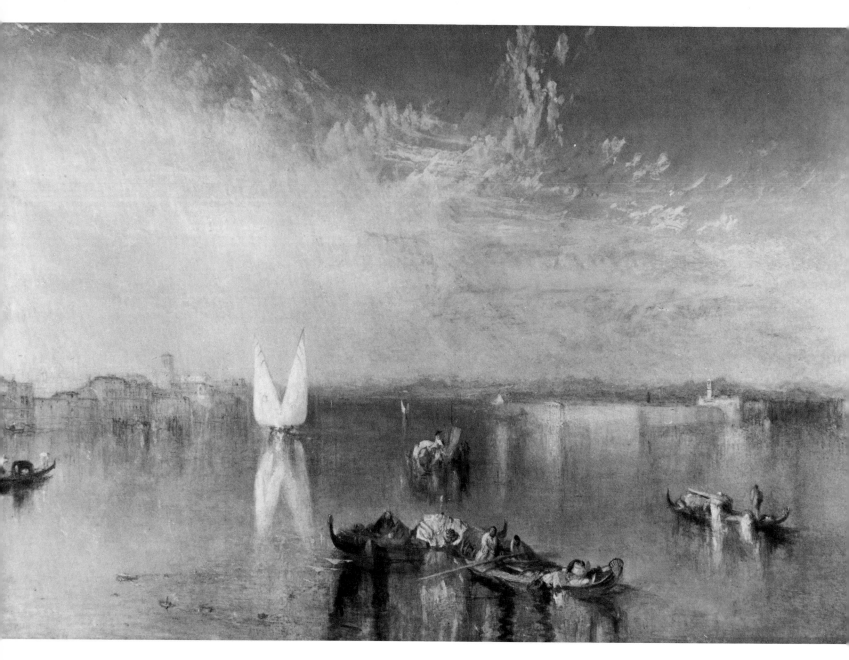

159. *Campo Santo, Venice.* R.A. 1842.
Oil on canvas;
$24\frac{1}{2} \times 36\frac{1}{2}$ in. (622×926 mm.)
The Toledo Museum of Art, Ohio (Gift of Edward Drummond Libbey).

160. *Schloss Rosenau, seat of H.R.H. Prince Albert of Coburg, near Coburg, Germany.* R.A. 1841.
Oil on canvas;
38¼ × 49⅛ in. (970 × 1,248 mm.)
Liverpool, the Walker Art Gallery.

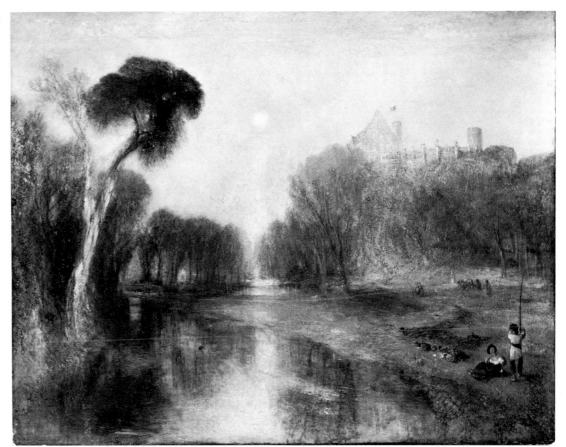

161. *Heidelberg Castle in the Olden Time.*
 c. 1840.
 Oil on canvas;
 52 × 79½ in. (1,320 × 2,020 mm.)
 London, Tate Gallery.

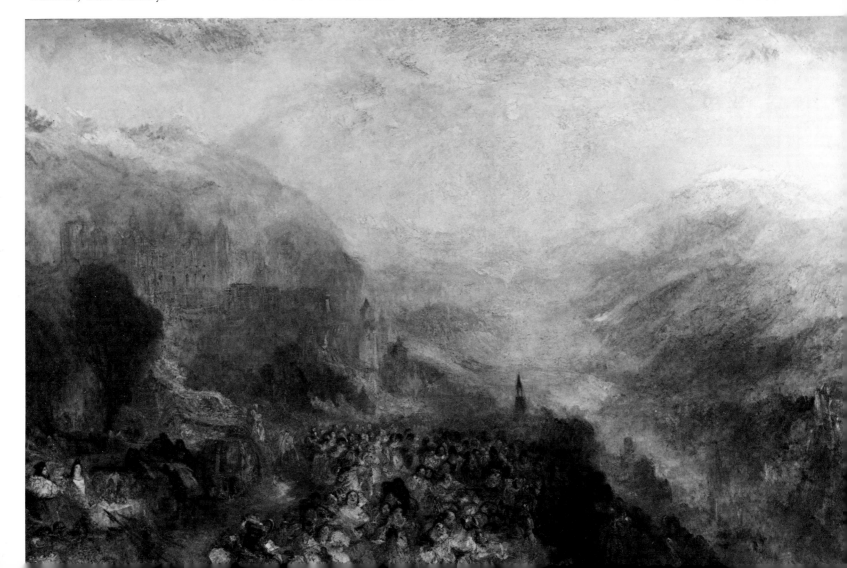

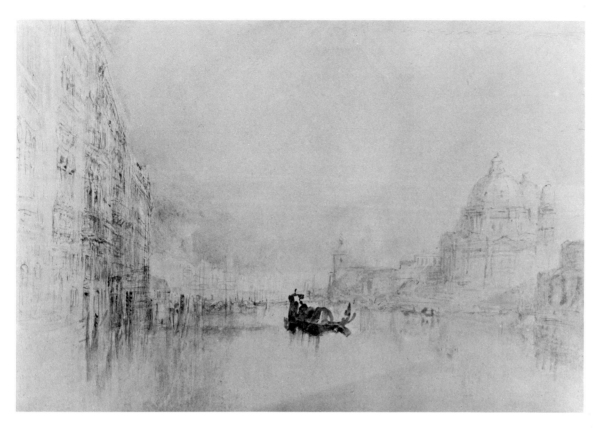

162. *Venice: the Grand Canal.* 1840. Watercolour over slight pencil indications, with pen and red and blue ink, and some heightening with white;
$8\frac{7}{16} \times 12\frac{3}{8}$ in. (215 × 315 mm.) Oxford, Ashmolean Museum.

163. *Venice: the Riva degli Schiavoni.* 1840. Watercolour, with pen and red and brown ink and some scraping out;
$8\frac{1}{2} \times 12\frac{1}{2}$ in. (217 × 317 mm.) Oxford, Ashmolean Museum.

164. *(opposite) St. Benedetto, looking towards Fusina.*
R.A. 1843.
Oil on canvas;
$24\frac{1}{2} \times 36\frac{1}{2}$ in..(622 × 926 mm.)
London, Tate Gallery.

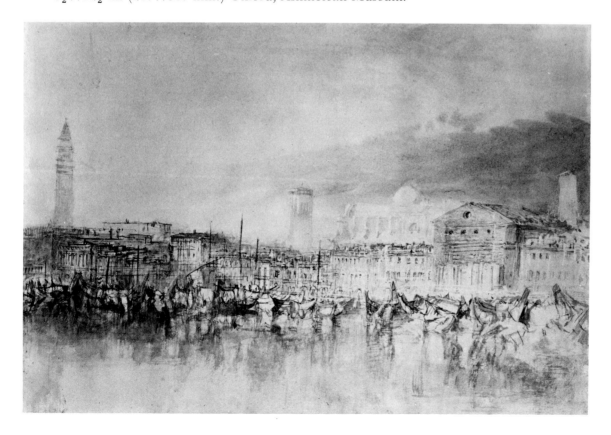

165. *(opposite) Venice Quay, Ducal Palace.* R.A. 1844.
Oil on canvas;
$23\frac{1}{2} \times 35\frac{1}{2}$ in. (597 × 902 mm.)
London, Tate Gallery.

166. *River, with a Distant Castle. c.* 1845.
 Watercolour;
 $10 \times 10\frac{1}{2}$ in. $(254 \times 267$ mm.)
 London, British Museum (CCCLXIV 148).

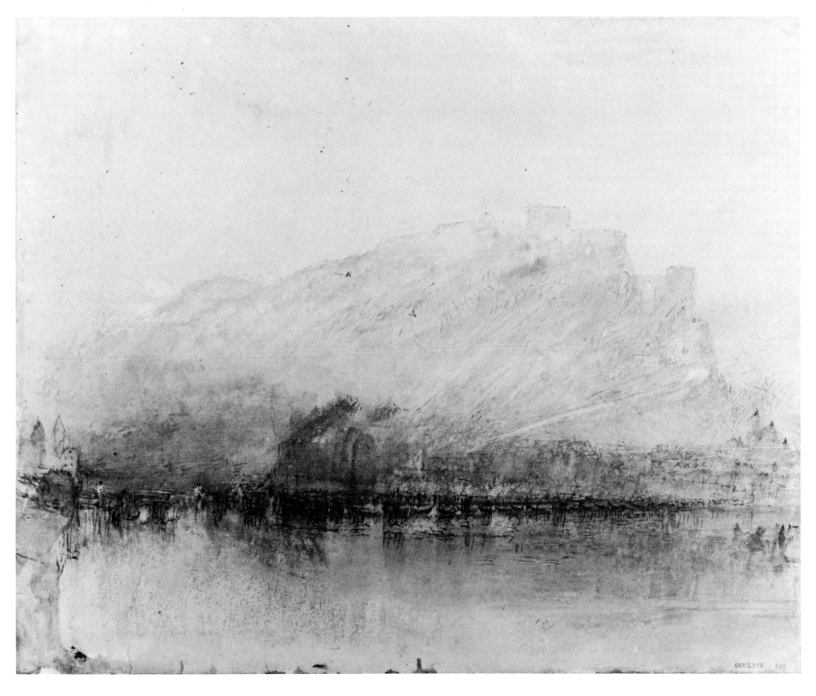

167. *Ehrenbreitenstein. c.* 1840.
Watercolour and pen and ink
irregular approx. $9\frac{3}{4} \times 11\frac{7}{8}$ in. (248×302 mm.)
London, British Museum (CCCLXIV 285).

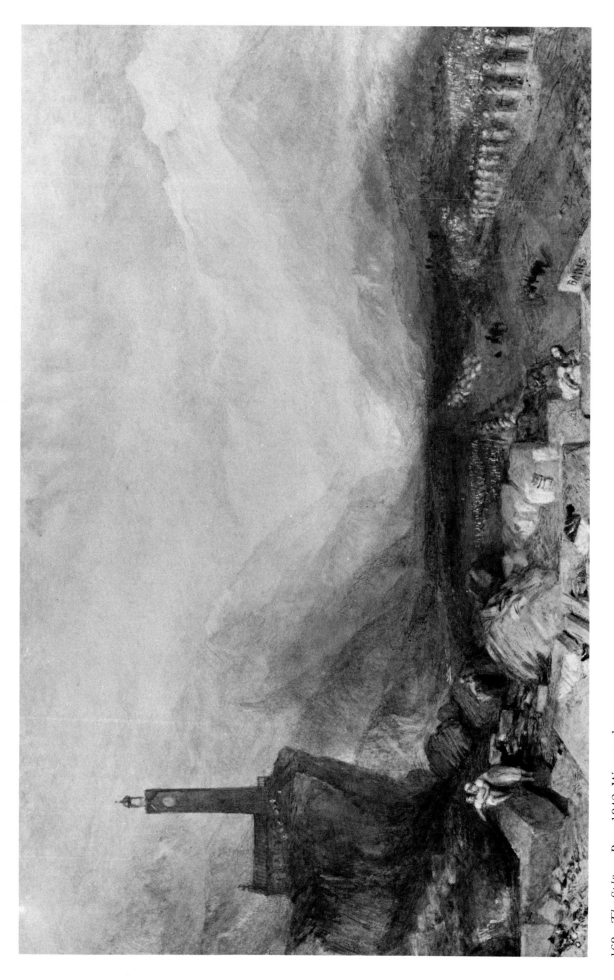

168. *The Splügen Pass.* 1842. Watercolour;
$11\frac{1}{2} \times 17\frac{3}{4}$ in. (292 × 451 mm.) Private Collection.

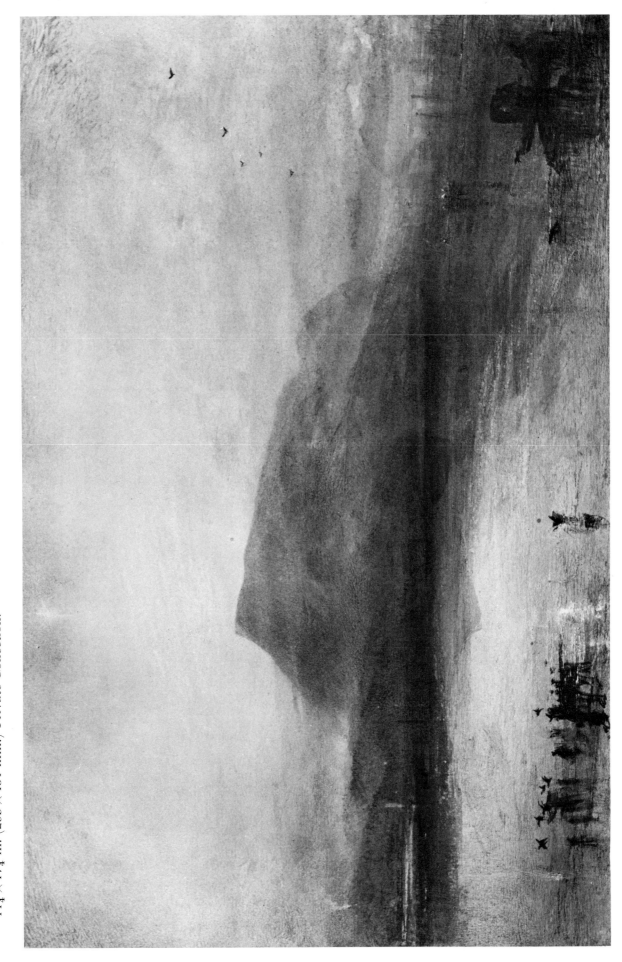

169. *Lake of Lucerne—Sunrise. The 'Blue Rigi'.* 1842. Watercolour; 11¾ × 17¾ in. (299 × 451 mm.) Private Collection.

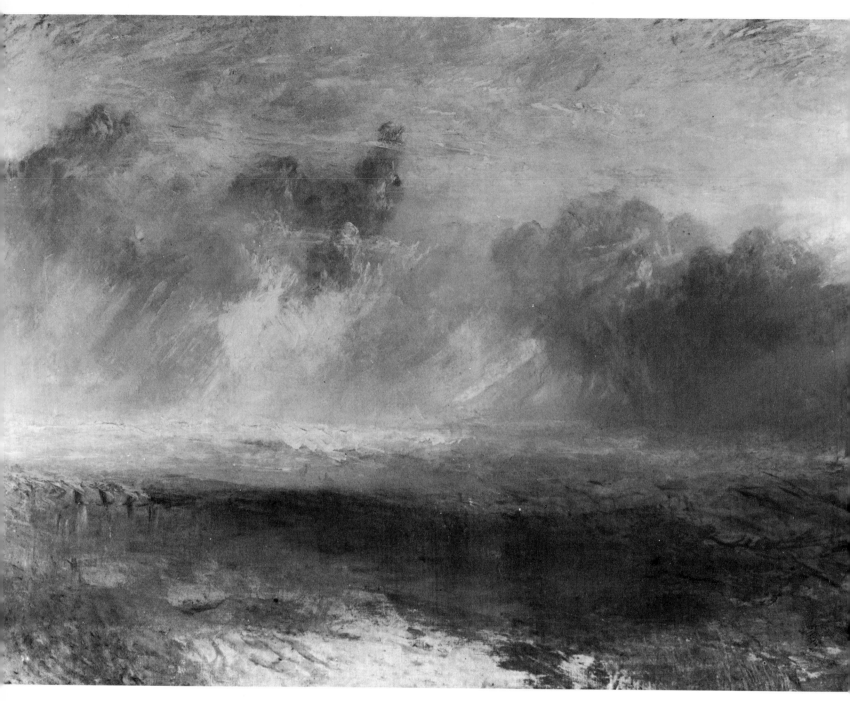

170. *Breakers on a flat Beach. c.* 1835.
Oil on canvas;
$35\frac{1}{2} \times 47\frac{1}{2}$ in. ($902 \times 1,206$ mm.)
London, Tate Gallery.

171. *(opposite) Dawn after the Wreck. c.* 1840.
Watercolour and body-colour;
$9\frac{5}{8} \times 14\frac{1}{4}$ in. (254×362 mm.)
London, Courtauld Institute of Art, University of London.

172. *(opposite) Lake of Geneva. c.* 1846–8.
Watercolour;
$14\frac{1}{2} \times 21\frac{1}{4}$ in. (368×540 mm.)
Indianapolis Museum of Art, Pantzer Collection.

173. *Snowstorm—Steamboat off a Harbour's Mouth.* R.A. 1842.
 Oil on canvas;
 36 × 48 in. (915 × 1,220 mm.)
 London, Tate Gallery.

174. *Peace—Burial at Sea*. R.A. 1842.
Oil on canvas;
$34\frac{1}{4} \times 34\frac{1}{8}$ in. (870×867 mm.)
London, Tate Gallery.

175. *Rain, Steam and Speed—The Great Western
 Railway.* R.A. 1844.
 Oil on canvas;
 35¾ × 48 in. (910 × 1,220 mm.)
 London, National Gallery.

176. *Whalers*. R.A. 1845.
Oil on canvas;
35 × 47 in. (889 × 1,194 mm.)
London, Tate Gallery.

177. *Norham Castle, Sunrise. c.* 1840–45.
Oil on canvas;
35¾×48 in. (910×1,220 mm.)
London, Tate Gallery.

178. *Sun setting over a Lake. c.* 1845.
Oil on canvas;
$35\frac{7}{8} \times 48\frac{1}{4}$ in. (912 × 1,225 mm.)
London, Tate Gallery.

179. *(opposite) Lucerne—Evening. c.* 1842.
Watercolour;
$9\frac{1}{4} \times 12\frac{7}{8}$ in. *(235 × 327 mm.)*
London, British Museum (CCCLXIV 324).

180. *(opposite) Lucerne by Moonlight.* 1843.
Watercolour;
$11\frac{1}{2} \times 18\frac{3}{4}$ in. (292 × 477 mm.)
London, British Museum (R. W. Lloyd Bequest).

181. *The Angel standing in the Sun.* R.A. 1846.
 Oil on canvas;
 31 × 31 in. (788 × 788 mm.)
 London, Tate Gallery.

182. *The Visit to the Tomb*. R.A. 1850.
Oil on canvas;
36 × 48 in. (915 × 1,220 mm.)
London, Tate Gallery.

183. *The Wreck Buoy. c.* 1809 and R.A. 1849.
Oil on canvas;
$36\frac{1}{2} \times 48\frac{1}{2}$ in. ($926 \times 1,232$ mm.)
Liverpool, Walker Art Gallery.

184. *(opposite) Norham Castle.* 1797.
Pencil;
$8\frac{1}{4} \times 10\frac{5}{8}$ in. (210×270 mm.)
London, British Museum (XXXIV 57).

185. *(opposite) Norham Castle.* 1801.
Pencil;
$6\frac{1}{2} \times 9$ in. (165×228 mm.)
London, British Museum (LIII 44a & 45).

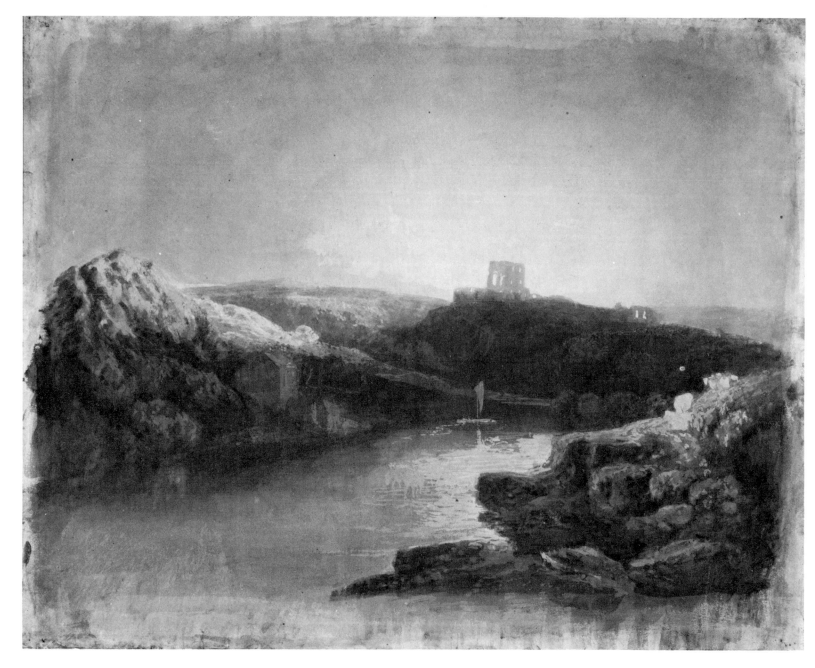

186. *Study for a Picture of Norham Castle. c.* 1798. Watercolour; 26 × 32 in. (660 × 813 mm.)
London, British Museum (L B).

187. *Norham Castle, on the Tweed. c.* 1815.
Pen and ink wash;
7½ × 10¾ in. (190 × 273 mm.)
London, British Museum (CXVIII D).

188. *(opposite) Norham Castle, on the Tweed.* 1816.
Mezzotint by C. Turner;
8¼ × 11½ in. (210 × 292 mm.) London, British Museum.

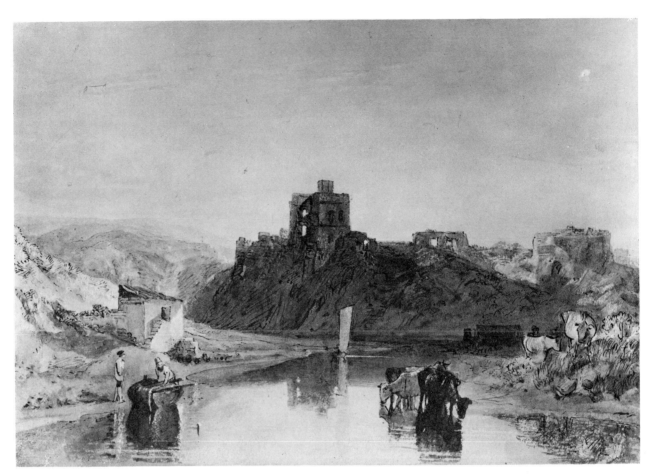

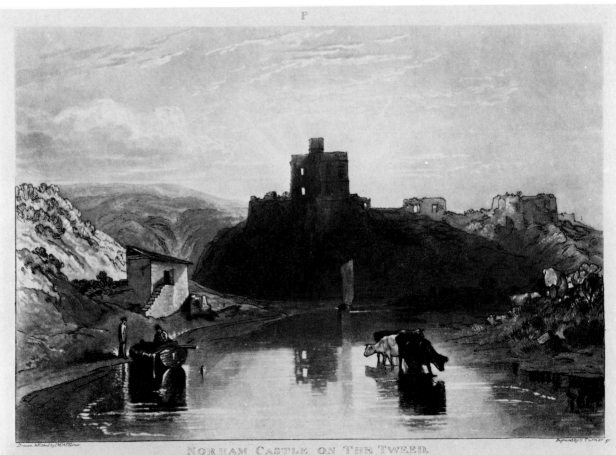

NORHAM CASTLE ON THE TWEED.

the Drawing in the Possession of the late Lord Lascelles

Publish'd 1 Jan 1816 by J.M.W Turner Queen Ann Street West

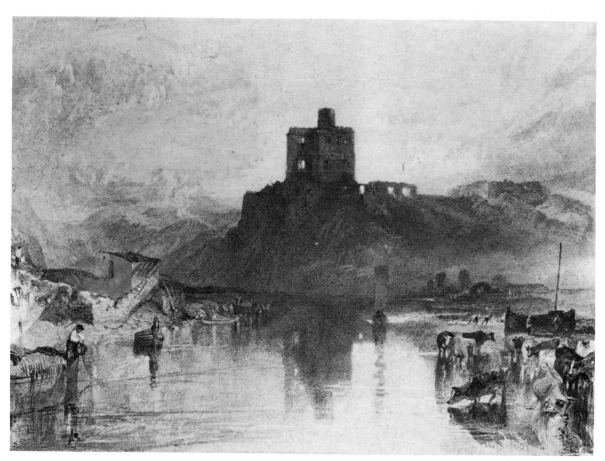

189. *Norham Castle, on the River Tweed. c.* 1824.
Watercolour;
$6\frac{1}{8} \times 8\frac{1}{2}$ in. (155×216 mm.
London, British Museum
(CCVIII O).

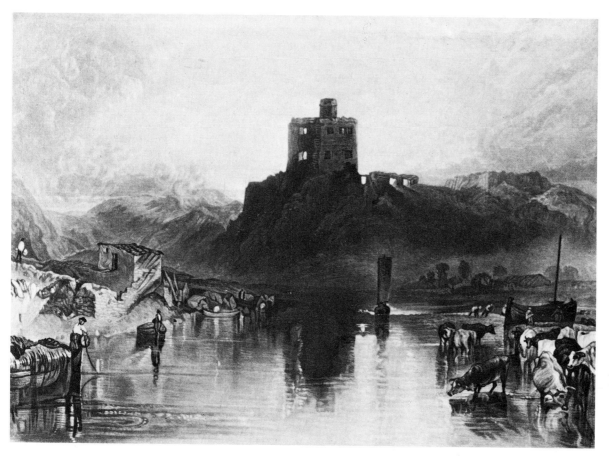

190. *Norham Castle, on the River Tweed.* 1824.
Mezzotint by C. Turner;
$6 \times 8\frac{1}{2}$ in. (152×216 mm.)
London, British Museum.

Notes on the Plates

(These notes should be read in conjunction with the *Introduction*. There is not a note for every plate, and where a plate is omitted in this section the work reproduced is usually fully discussed in the *Introduction*.)

1. Painted in about 1798, when Turner was twenty-three, this is one of the few self-portraits known today. Both this, and an earlier one of about 1792, which once belonged to Ruskin, show clearly the brightness and intensity of Turner's eyes, still very much in evidence in later portraits of Turner by other artists.

2. This satirical Rembrandtesque drawing provides many clues to Turner's interest in the fashion for technical theorising and experiments, which prevailed among English artists at the turn of the century. Draft verses inscribed on the back begin with the lines, 'Pleased with his work he views it o'er & o'er/And finds fresh beauties never seen before'. The drawing is fully discussed by John Gage in *Colour in Turner*, pp. 136–8.

3. John Thomas Smith (1766–1833) was a topographical artist and antiquary. He became Keeper of Prints and Drawings at the British Museum in 1816, and was a respected figure in the London art world.

4. This telling portrayal of Turner at work at the Royal Academy on varnishing day, should be studied in conjunction with E. V. Rippingille's vivid description of a similar scene, quoted on pp. 41–2. Turner showed several square paintings at the R.A. between 1840 and 1846, but they were all smaller than the canvas on which he is seen working here.

5. Probably made at the end of his life, in about 1850, this study shows Turner in heavy and somewhat shabby clothes looking singularly out of place; this impression is reinforced by the stubble on his chin and by the fact that he is wearing slippers. Turner never took much care about what he wore, nor did he often move in 'society'; indeed he would surely much have preferred to be holding a mug of ale than the tea-cup with which he is portrayed here.

6. This is one of a set of three small compositions painted by George Jones, R.A., one of the artist's executors, soon after Turner's death. The others show his body lying in state in the Gallery, and his burial in the Crypt of St. Paul's Cathedral. George Jones was a close friend of Turner, and must have been a frequent visitor to his Gallery in Queen Ann Street West.

7. Turner bought land at Twickenham in 1807, and started building Sandycombe Lodge (first called Solus Lodge) to his own designs in 1810. The garden was looked after by Turner's father, whose declining health led to the sale of the property in 1826. The house still stands today.

8. One of eight drawings exhibited by Turner at the Royal Academy in 1795, the last year in which he showed only watercolours. This luminous drawing shows him already at the height of his powers as a topographical draughtsman in the traditional manner; it was at this exhibition that the diarist Joseph Farington, R.A. first noticed Turner's work. Turner had visited Tintern in 1792, and perhaps again in the following year; there are several early drawings of Tintern in the Turner Bequest, though none is related to the present composition, of which there is, however, a weaker version in the R.W. Lloyd Bequest at the British Museum.

9. This ambitious composition displays Turner's early mastery of the current style of architectural draughtsmanship, and his emulation of artists such as Edward Dayes in bringing the subject to life by the inclusion of action and many figures on quite a large scale. Two sketches of the ruins of the Pantheon are also in the Turner Bequest (IX B and C).

10. Exhibited in 1798, the first year in which verses were allowed in the R.A. catalogue, this was accompanied by an adaptation of six lines from Thomson's *Spring* referring to a 'grand ethereal bow'. The composition is derived from an on-the-spot watercolour made on Turner's first visit to the Lake District, in 1797 (XXXV 84), in which there is no rainbow. The painting, which has probably darkened considerably, shows the strong influence of Richard Wilson.

11. See note to Plate 32.

12. A full account of the ten Oxford Almanack drawings and of the commission for them is given in the present author's *Ruskin and Turner*, pp. 55–

63. Turner was paid ten guineas per drawing. He delivered the final drawings in 1804.

13. Paul Sandby (1730–1809), a Founder Member of the Royal Academy, was one of the most influential and successful drawing masters of his day. He exhibited watercolours and gouache drawings regularly at the R.A., and in his last years also showed work in oils.

15. Thomas Girtin (1775–1802) worked almost exclusively in watercolours, and exhibited his drawings at the Royal Academy from 1794 onwards. This drawing is a well-known example of his later panoramic compositions, in which the rendering of atmosphere is particularly effective.

16. This is a fairly close copy, in which, however, the light effect is strengthened, of a drawing in Volume V of the Beckford Sketch-Books of J. R. Cozens, now in the Whitworth Gallery, Manchester. Numerous such wash copies of Cozens drawings were made for Dr. Monro by Turner, Girtin, Edward Dayes and others, and it is always difficult to give a specific attribution to them. Turner himself purchased several lots at Dr. Monro's sale in 1833, which are included in the Turner Bequest.

17. Like the view of Chepstow (Plate 14), this unfinished drawing shows close affinities with the work of Girtin at this time, both in the detailed outline and colouring of the windmill and in the freer rendering of the distant landscape. It is probable that the pencil drawing was made on the spot, and was then partially coloured in at a later time.

18. Known as 'The Cholmeley Sea Piece', this canvas can be identified with confidence as the first oil painting exhibited by Turner at the Royal Academy, in 1796. Turner toured in the Isle of Wight in 1795, but none of the surviving sketches are connected with this painting, which relies heavily on the influence of P. J. de Loutherbourg and Joseph Wright of Derby, who both specialised in moonlight scenes. Turner's life-long interest in the depiction of light is already clearly seen here, with the striking contrast between the cold light of the moon and the warm light of the lamp in the boat.

19. A contemporary reviewer compared this dramatic

interior with Rembrandt, and John Gage has suggested the influence of Piranesi. There is a slight pencil sketch of this scene in the 'Smaller South Wales' sketch-book (xxv 11), used on a tour in Wales in 1795, but this gives no indication of the light effect. The watercolour is dryly and quite thinly applied, and is brilliantly manipulated to render the shimmering effect of the light streaming in through the windows and door.

20. One of the most Wilsonian of Turner's paintings, this Italian scene precedes his first visit to Italy by many years. It is probably Turner's earliest effort in the classical tradition of historical landscape, with an historical, biblical or mythological subject as its theme. The composition is based on a drawing by Sir Richard Colt Hoare, whose part in the development of this picture is analysed by John Gage in a recent article, 'Turner and Stourhead: the Making of a Classicist?' in *The Art Quarterly*, XXXVII (1974), pp. 59–87.

21. Richard Wilson, R.A. (1713–82), was born in Wales, and, having been trained as a portrait painter, decided to devote himself almost exclusively to landscape during a lengthy visit to Italy which began late in 1750. The present canvas was painted during that visit, but Wilson continued with his Italian subjects throughout the remainder of his career. Ruskin rightly singled out Wilson as the founder of the British landscape school.

22. Exhibited at the Royal Academy in 1800, the first exhibition after Turner's election as an Associate, this was the earliest painting to be accompanied in the catalogue by some of Turner's own verses. When he was elected a full member of the Academy in 1802, Turner presented *Dolbadern Castle* as his Diploma Work, though he later tried, unsuccessfully, to exchange it for another (unidentified) painting. Thickly and solidly painted, it is typical of Turner's work under the influence of Wilson. Based on a number of drawings made during a visit to North Wales in 1798, it is already far more than a topographical or picturesque record, and has a strong romantic feeling, emphasised by the group of small figures in the manner of Salvator Rosa in the foreground.

23. When shown in 1800 this was the largest and most ambitious canvas that Turner had yet submitted to the Royal Academy, and it heralded the impact

of a new influence on the artist, that of Nicolas Poussin. Though he gave the painting the title of *The Fifth Plague of Egypt*, the lines from Exodus which accompanied it in the catalogue describe the Seventh Plague, that of thunder and hail, and these seem to be the main themes of the composition. It has been suggested that Turner gained inspiration for this painting from a storm he had experienced in the mountains of North Wales. Turner exhibited another Plague subject, *The Tenth Plague of Egypt*, in 1802 (Tate Gallery, No. 470).

24, 28. Turner exhibited a series of such exceptionally large and ambitious watercolours in the early 1800s. Their dark and heavy texture re-echoes that of his oil paintings at this time, and in this instance he was probably adapting his oil technique to watercolour rather than the other way round, which became his more usual custom.

25. Turner paid his first visit to Scotland in 1801, and spent about three weeks there, during which he used some six sketch-books, one of which was devoted to Edinburgh (LV). In this he achieves a new delicacy of touch, using a limited range of washes with greatly increased freedom and speed to suggest form and light.

26, 27. The 'Calais Pier' sketch-book (LXXXI) contains a number of studies connected with *Sun rising through Vapour*, including the one reproduced here. This sketch-book is devoted exclusively to studies connected with several of Turner's major canvases of this period, and there is no indication as to where, if anywhere, he witnessed the scene shown in the painting. This was unsold until 1818, when it was purchased by Sir John Leicester (later Lord de Tabley) for 350 guineas. At the sale following his death in 1827 Turner bought it back for 490 guineas. *Sun rising through Vapour* and *Dido building Carthage* (Plate 77) were the two paintings which Turner bequeathed specifically to the National Gallery, on condition that they were 'hung kept and placed . . . always between the two pictures painted by Claude'—the *Seaport* and '*The Mill*' from the Angerstein Collection. When the time came they were accepted on this condition, and today the two paintings by Turner are again to be seen next to the two by Claude.

29, 31. This composition was preceded by an exceptional number of preliminary studies and sketches. The initial source was probably a series of rapid studies, in various media on pink prepared paper, of waves breaking on a shore. These are in the 'Dunbar' sketch-book (LIV), one of those used on the Scottish tour of 1801. Two much slimmer sketch-books (LXVII and LXVIII) are largely devoted to studies of fishing boats in surf, such as Plate 29, more directly connected with *Fishermen upon a Lee-Shore* and another marine subject painted for the same patron, Samuel Dobree.

32, 11. Such dramatic and majestic marine subjects on a monumental scale played an important part in establishing Turner's reputation in the first decade of the nineteenth century. From the great variety of comment about the *Calais Pier* (see Plate 11) reported by Joseph Farington in his *Diary* it is clear that Turner's exhibits were already a focal point of interest among artists and those interested in the arts. The bold and free technique aroused much criticism, and a writer in *The Sun* saw in it 'a lamentable proof of genius losing itself in affectation and absurdity'. Modern critics have tended to see the earliest signs of Turner's mature genius in these marine paintings.

33, 34. See note to Plate 50.

35. Lowther Castle, Westmorland, was built for the 1st Earl of Lonsdale between 1806 and 1811 in Gothic style by Robert Smirke; it is a ruin today. Turner showed his pair of paintings of the house (which still belong to the Lonsdale family) at the Royal Academy in 1810. The evening scene is closely related to one of the three drawings of Lowther in the Ashmolean, and it also features a detailed study of a thistle in the foreground. The view of Petworth (Plate 62) was Turner's only other R.A. exhibit in 1810.

36, 39. The immediate impact of the Alps on Turner is best seen in the coloured drawings in the 'St. Gothard and Mont Blanc' sketch-book (LXXV), two of which are reproduced here. These are executed with the same freedom as the watercolours in the 'Edinburgh' sketch-book of the previous year, and in the same rather muted colours. Most of the large exhibition watercolours of Swiss subjects which Turner executed after his return to England are variants rather than direct adaptations of the on-the-spot studies. This applies to the two

reproduced here, which were both acquired by Walter Fawkes. It has been plausibly suggested by recent research that Fawkes may have accompanied Turner on his first Continental tour (David Brown, 'J. M. W. Turner in Switzerland,' 1973, unpublished B. A. dissertation, University of Leicester).

40. The evolution of this canvas and its companion view of Bonneville, also shown in the 1803 exhibition, was fully described and illustrated by Evelyn Joll in a pamphlet accompanying the exhibition of the latter at Thos. Agnew and Sons in July, 1974.

41, Claude's *Landscape with Jacob and Laban* is dated
42. 1654, and was acquired by its first English owner within about twenty years of that date. It was bought by the sixth Duke of Somerset for Petworth House in 1686, and it must be presumed that Turner had seen it before painting the closely related *Macon*. This does, however, also record a visit to that area in 1802. Having declined an offer of 250 guineas from Sir John Leicester during the R.A. exhibition, Turner sold it to the Earl of Yarborough for 400 guineas in the following year. The painting had been received with the usual mixture of praise and criticism. Among the most fulsome praise was that of the critic of the *British Press*, who referred to it as 'the First landscape of the kind that has been executed since the time of Claude Lorrain, on whose works, indeed, Mr. Turner has evidently and usefully fixed his eye; and we are bold to say, that he has even surpassed that master in the richness and forms of some parts of his pictures'.

43. Several drawings in the 'Calais Pier' sketch-book (LXXXI) are connected with the evolution of this unwonted composition, which borrows heavily from Titian's *Holy Family and a Shepherd*, formerly part of the W. Y. Ottley Collection sold in London in 1801 and now in the National Gallery. One of the sketch-book drawings shows the figures in an upright composition, in the landscape setting of Titian's famous *St. Peter Martyr*, which Turner studied in the Louvre in 1802; it had been removed from Venice by Napoleon. The Titian was well known in England through engravings, and it was particularly admired by both Turner and Constable, who each eulogised and analysed it in lectures.

44. In this somewhat theatrical composition even the rocks and mountains have an air of artificiality, as do the carefully posed figures. The actual subject of the painting is confused, and John Gage has suggested that it illustrates Turner's current interest in alchemy, probably under the influence of De Loutherbourg (*Colour in Turner*, pp. 136–9).

45, This canvas, which may have been included by
46. Turner in one of the first exhibitions in his own gallery, is reminiscent both in style and technique of the two Bonneville subjects of 1803. As in these the application of the paint is rather dry and flat, and this makes the influence of Poussin all the more apparent. The same dryness of technique is to be found in the watercolour study for this composition.

47– In 1804 Turner was living at Sion Ferry House,
49. Isleworth, a house situated behind the group of trees seen on the right of this composition. Turner designated the subject of this plate as 'Epic Pastoral'. The Ionic 'temple' on the River's bank is a shooting lodge built by Robert Mylne for the second Duke of Northumberland; it still stands today. Four of the five subjects issued as the thirteenth part of the *Liber Studiorum* feature a river; one of them is derived from the painting of Bonneville reproduced here as Plate 40.

50, Turner did not resume his annual sketching tours
51; after his first journey abroad in 1802, and for the
33, next few years most of the places he visited were
34. within easy reach of London. At this period his on-the-spot studies in watercolour and oils are unusually naturalistic for him, in keeping with the practice of several of the younger landscape artists of the day. Turner may well have decided to concentrate his sketching on scenery which he knew well in order to achieve this naturalism more easily. Despite their naturalism, the majority of these sketches, both in oils and watercolour, achieve a balanced pictorial composition, something which probably came instinctively to Turner.

52. Turner was probably fired to paint and exhibit this genre scene in the manner of Teniers by the great success the year before of the young David Wilkie's first exhibit at the Royal Academy, *Village Politicians* (Private Collection), which is also reminiscent of Teniers. In 1807 Wilkie showed another interior, *The Blind Fiddler* (Tate Gallery), and Farington records in his *Diary* (8 May) that

when Sir John Leicester enquired the price of the *Blacksmith*, 'Turner answered that He understood Wilkie was to have 100 guineas for His *Blind Fiddler* & He should not rate His picture at a less price'. Turner got his price, and himself paid 140 guineas for the canvas when he bought it back at the Leicester sale in 1827. The *Country Blacksmith* was Turner's most ambitious and successful interior with figures in a conventional manner.

53. This wonderfully fluent study belongs to a group of seventeen large oil sketches in the Turner Bequest of subjects on or near the Thames, which are all very freely and thinly painted on a whiteish ground. It is possible that some can be identified as the canvases referred to by the son of Turner's friend the Rev. H. S. Trimmer, in a reminiscence printed by Thornbury; Turner 'had a boat at Richmond. . . . From this he painted on a large canvas direct from Nature. Till you have seen these sketches, you know nothing of Turner's powers. There are about two score of these large subjects, rolled up, and now national property.'

54. For long known as 'Evening—the Drinking Pool', this evocative scene shows the strong influence of Rubens and Gainsborough, and emulates particularly their use of figures. The men on the left are barking chestnut trees for caulking or tanning.

55, Both versions of De Loutherbourg's *Avalanche in the*
56. *Alps* were owned by patrons of Turner—that reproduced here by Sir John Leicester and the other (still at Petworth) by Lord Egremont—and thus he would have been familiar with both. There can be little doubt about the connection between De Loutherbourg's and Turner's treatment of the subject, though it seems that, despite being neighbours in Hammersmith, the two artists were not on friendly terms. Turner did not visit the Grisons on his Swiss tour in 1802, nor could he have witnessed an avalanche, as he was there in September and October. However, the authenticity of the scene is based on his close observation of other parts of the Alps.

57. This was the first of Turner's great vortex-like compositions, and he was particularly concerned that it should be hung low in the Academy exhibition. It was also the first of Turner's paintings to illustrate the struggle between Carthage

and Rome, and John Gage has suggested that he saw this as a parallel to the conflict between England and Napoleonic France.

58. Turner's extensive studies from nature in the years around 1810 come to fruition in this canvas, which ignores all picturesque or topographical content and concentrates simply on an actual scene of countrymen at work early on a winter's morning. When exhibited it was accompanied by one line from Thomson's *Winter*: 'The rigid hoar frost melts before his beam'.

59. In a reminiscence quoted by Thornbury, Sir Charles Eastlake described 'a small portable painting-box, containing some prepared paper for oil sketches, as well as other necessary materials', which a Mr. Johns prepared for Turner's use while he was touring in Devonshire. He also records that 'one of the sketches was done in less than half an hour'.

60. See note to Plate 68.

61. Tradition (recorded by Farington) has it that Turner spent much of his time fishing in the lake while staying at Tabley in 1808. The folly-like round water-tower as well as a 'Gothic' boathouse still stand by the lake today. The pair to this view of Tabley House was bought by Lord Egremont at the Leicester sale, and is at Petworth.

63. Nothing is known of the early history of this painting, which does not seem to have been executed as a commission. It is based on a drawing in the 'Vale of Heathfield' sketch-book (CXXXVII, 3 and 4).

64– Aelbert Cuyp (1620–91) was the most popular
66. Dutch landscape painter among British collectors and connoisseurs in the later eighteenth and nineteenth centuries. His mellow treatment of water and his depiction of calm sunlight were especially influential on Turner in the years around 1810. This was remarked upon by many critics of the day and can be clearly seen in some of the country house 'portraits' reproduced here, and in *Dorchester Mead* and *Whalley Bridge and Abbey*. The former has only recently been identified as the painting of that title exhibited in Turner's Gallery in 1810; it was for long known as 'Abingdon, Berkshire, with a View of the Thames—Morning'.

67. Ruskin thought very highly of this drawing and often referred to it. In the catalogue of the 1878 Exhibition of his Turner drawings at the Fine Art Society he wrote, 'it shows already one of Turner's specially English (in the humiliating sense) points of character—that, like Bewick, he could draw *pigs* better than any other animal. There is also some trace of Turner's constant feeling afterwards. Sunshine, and rivers, and sweet hills; yes, and who is there to see or care for them?—Only the pigs.'

68, Turner had already provided illustrations for
69; several books by the antiquarian, Dr. Whitaker,
60. when he was commissioned to illustrate that author's *History of Richmondshire*, published in parts by Longman's between 1819 and 1823. Turner was paid twenty-five guineas for each of his twenty drawings, and they were sold by the publishers, soon after the work was completed, for about the same sum. Plates 60 and 68 belong to this series, while Plate 69, though dated 1816, was only used in 1823, when it was lithographed by J. D. Harding for a new edition of Whitaker's *History of Leeds*. Plates 68 and 69 belonged to Ruskin, who tried unsuccessfully to persuade Oxford University to purchase Plate 60 in 1884; his failure was a contributory factor in deciding Ruskin to resign the Slade Professorship.

70, These three drawings are all connected with
75, Walter Fawkes and Farnley Hall in Yorkshire.
76. Turner's friendship with Fawkes and the latter's patronage of Turner is discussed in the *Introduction* (pp. 22ff). Among the Turner drawings still at Farnley today are a series of the interior of the house, drawn in some detail in body-colours. One of these shows the *Dort* (Plate 86) hanging over the fireplace in the drawing room.

71. This drawing was engraved by W. R. Smith and the plate was published in 1822. Several other artists provided illustrations for *The Provincial Antiquities of Scotland*, including A. W. Callcott and the Rev. J Thomson. The exceptional success of this book has been attributed to Sir Walter Scott's text, rather than to the illustrations, of which twelve are after Turner.

72. This vast canvas is inscribed at the bottom left, 'Appulia in Search of Appulus learns from the Swain the Cause of his Metamorphosis'. Character-istically Turner has illustrated his own variant of Ovid's tale, to which he referred in the British Institution catalogue; Appulia is his own invention. However, the composition is not original, for it is closely based on the Petworth Claude, *Landscape with Jacob and Laban* (Plate 42), which Turner knew well. The somewhat Neo-Classical *Empire* figures were thought even worse than Claude's by William Hazlitt.

73, The Rhine had been popular with British travellers
74. and artists in the later years of the eighteenth century, and the romance and picturesqueness of the castles caught their imagination. Turner was the first recorded British artist to sketch on the Rhine after the Napoleonic wars. For him the chief subject-matter lay in the landscape and light of the great river rather than in the castles, which he usually integrated as relatively minor features in his compositions.

77. Inscribed with the title on a wall on the extreme left of the picture and signed *J. M. W. Turner 1815*, this work was one of Turner's own favourites. Tradition has it that he planned to be buried wrapped up in it, but it was, in fact, one of the two canvases which he bequeathed specifically to the National Gallery (see note to Plate 27).

78, Much has been made of the importance for
79. Constable of Sir George Beaumont's small Claude *Landscape: Hagar and the Angel* (Plate 79), which the baronet is said always to have taken with him on his travels. *Crossing the Brook* could well also be a derivation from this beautifully balanced composition, but adapted by Turner in reverse. It may be this fact that led Sir George to be so highly critical of Turner's canvas.

81. Though far less obviously than the *Dort* (Plate 86) this canvas also shows the influences of Cuyp's luminous treatment of sea and sky, and of Turner's own experience of Dutch light during his tour of 1817. The full title of the painting names a specific location. 'Brill Church bearing S.E. by S., Massensluys E. by S.' The figures in the boats in the foreground are particularly clumsy in execution, but play an important role in the balance of this open composition.

82, Turner made many drawings of the extensive view
83. from Richmond Hill, one of the most spectacular

to be found in and around London. The earliest of these dates from about 1795 (Turner Bequest XXVII K). Turner may have felt that he could not do full justice to this great view except on the monumental scale of *Richmond Hill*, the largest painting he exhibited. As in his other R.A. exhibit of 1819 (Plate 81), the figures play a vital role in the composition. These fashionable ladies, with their sloping shoulders and long necks, lend credence to the idea that Turner made use of dummies for some of his depictions of figures. However, the influence of Watteau's figure painting can also be cited. Whatever the source of such figure groups they leave little doubt that Turner had difficulty in painting them.

84. This important canvas was most successfully cleaned for the Turner Bi-Centenary Exhibition at the Royal Academy. As a result the delicate beauty of the distant view of Rome re-appeared as an essential element of this ambitious composition. The didactic and biographical character of the work has been fully discussed by John Gage (*Colour in Turner*, pp. 92–5), who considers it an 'art-historical picture', in which Turner reveals his admiration for Raphael and his attempts to compare himself with that 'universal' artist. The landscape canvas in the centre foreground is inscribed *Casa di Raffaello* and the plan near it *Pianta del Vaticano*. Thus Turner illustrates not only Raphael's range as a painter but also his activities as an architect.

89. This is inscribed on the stone at bottom left, *Liquidae Placuere Baiae*, a quotation from Horace alluding to the delight of the waters of Baiae. Turner visited this lovely spot from Naples and made numerous drawings there. When exhibited the painting was catalogued with the line 'Waft me to sunny Baiae's shore', but the mythological subject depicted and the symbolic white rabbit and snake all lead to a rather gloomy interpretation of Turner's intentions, which have been discussed by John Gage and others. The descriptive adjective most commonly used by contemporary critics of this much-praised canvas was 'gorgeous'.

93, 94. Turner made a number of sketches connected with the *Dieppe* during his brief visit to France in the early autumn of 1821. (Turner Bequest CCXI and CCLVIII, mistakenly dated in the *Inventory* 1824 and 1830 respectively.) In 1826 Turner exhibited a

companion to the *Dieppe*, which is now also in the Frick Collection in New York. Entitled *Cologne, the Arrival of the Packet-Boat: Evening*, this, like the *Dort* of 1818 (Plate 86), is indebted to the harbour scenes of Cuyp.

95– 101. Turner's first visit to Italy was the most extensive sketching tour that he ever undertook; it is discussed above in the *Introduction* (pp. 26–30). The pencil, ink and watercolour drawings reproduced here illustrate the great variety of drawing techniques which he used to record what he saw. He made full use of his thirty years' sketching experience to assemble a reference collection of Italian subjects sufficiently wide in its scope to last him for the rest of his life. (As a result he spent relatively little time actually sketching on his subsequent visits to Italy.) The success of this undertaking is demonstrated by the fact that Turner had not re-visited Venice when he began his great series of exhibited Venetian oils in 1833. The high point of his sketching in 1819 can be seen in the small series of Venetian watercolours (Plates 87, 88), which lend weight to the argument that some of the coloured drawings were executed out-of-doors.

102– 105. The large number of finished watercolours which Turner executed for British topographical engravings in the 1820s have been unjustly neglected in recent decades, though in the early years of this century they were, correctly, considered to be among Turner's outstanding achievements in that medium. Again and again they demonstrate his total mastery of technique and composition. That Turner was well served by his engravers can be seen when comparing the drawing (Plate 102) and the mezzotint (Plate 103) of *Totnes*.

107. The subject is from Book IX of Homer's *Odyssey*, and, as Ruskin noted, Turner closely followed Pope's translation of the text in details of the light and sea. However, most of the critics were upset by the strong colours of this canvas. One (*Morning Herald*, 5 May, 1829) described it as 'a specimen of *colouring run mad*—positive vermilion—positive indigo, and all the most glaring tints of green, yellow, and purple contend for mastery of the canvas, with all the vehement contrasts of a kaleidoscope or Persian carpet'.

108, 109; 123. Researches in the Petworth papers and records have not led to any fuller information concerning

Lord Egremont's patronage of Turner, and the artist's visits to Petworth. It has been suggested that after the death of his father Turner spent several Christmases at Petworth. It is to be hoped that John Gage's discovery of the descriptive passage in the Creevey Correspondence (see p. 34 above), and of Lord Egremont's interests in the Chichester Canal (Plate 109) and the Chain Pier at Brighton (the subject of the fourth canvas in this series) will be followed by the finding of more such evidence.

110. The figures are related to a drawing in the 'Rivers Meuse and Moselle' sketch-book (CCXVI 227), inscribed *Fisherwomen looking for bait*. Turner's accuracy of observation is evident here, for when figures are seen in a strong light walking or standing on wet sand they appear unnaturally tall, as in this painting.

111, 112. Though described as based on the sketch of another artist, W. Page, this view of the chapel at Pisa is closely related to a drawing in the 'Genoa and Florence' sketch-book (CCXXXIII 55), which Turner made when he visited Pisa in 1828. Turner produced twenty-six illustrations for Murray's edition of Byron (1832–4), and as he never visited Greece or the Near East the majority of the plates had to be based on drawings made on the spot by others.

113– 116; 92. Two of the *Rivers of France* drawings reproduced here (Plates 92, 114) belonged to Ruskin, who considered his group from this series a focal point of his own collection and then of his gift to Oxford. How Ruskin had acquired his twenty-seven *Rivers of France* drawings in 1858 was long something of a mystery, until it was discovered that the Mrs. Hannah Cooper from whom he purchased them in two lots was the niece of Charles Stokes, friend, stockbroker and patron of Turner. Stokes had bought twenty-four of these drawings from Turner through Mr. Griffith of Norwood in 1850 for 600 guineas. Ruskin paid 1500 guineas for these and three additional ones. It is ironical that Turner had apparently offered Ruskin the whole series for 25 guineas a piece, but his father thought that Ruskin 'was mad to want them', and declined to buy them. (See Luke Herrmann, *Ruskin and Turner*, passim, and 'Ruskin and Turner: A riddle resolved' in *Burlington Magazine*, CXII, 1970, pp. 696–9.)

117. This, like its companion piece, a morning scene shown in the following year (1827), was painted for William Moffatt. There are numerous studies connected with the two paintings in the 'Mortlake and Pulborough' sketch-book (CCXIII), which Turner used in 1825. The drawing on ff. 10–11 is a direct study for the present composition.

118– 121. These works and others connected with Turner's stay on the Isle of Wight as the guest of John Nash are discussed and illustrated by Graham Reynolds in a recent article ('Turner and East Cowes Castle' in *Victoria and Albert Museum Yearbook*, 1969, pp. 67–79). This influential visit was also well illustrated in the Turner Bi-Centenary Exhibition at the Royal Academy (Cat. Nos. 311–322).

122. It is not known why Lord Egremont declined the *Palestrina*, which Turner had painted specifically for him as a companion to the Petworth Claude (Plate 42). It was ultimately bought by Elhanan Bicknell, one of Turner's major patrons in his later years.

124, 126. Turner re-worked all his Roman exhibits when they were shown again in London. The third painting definitely exhibited in Rome was the *Vision of Medea* (Tate Gallery, No. 513), which was shown at the R.A. in 1831. The strong criticisms that these canvases received in Rome may well have been one reason for Turner's subsequent stand against the recently formed British Academy in Rome. It was a grave blow for the British artists living in Rome when the Royal Academy re-imposed the rule that its own members must be resident in Britain, and it was largely Turner who enforced that decision.

127. This scene illustrates the passage from Matthew, XXVII, 24, and clearly shows Turner's debt to Rembrandt. The Angerstein Collection, purchased as the initiation of the National Gallery in 1824, included two biblical interiors by Rembrandt, one of which, *The Woman taken in Adultery* (No. 45), features a similar concentration of light on the central figures.

128. Exhibited with a line from Shakespeare's *Merchant of Venice*: SHYLOCK: Jessica, shut the window, I say', and painted with Rembrandt's Jewish subjects much in mind. However, the dark and almost monochrome character of Rembrandt's

treatments of such subjects is replaced here by strong and glowing colours, among which red predominates.

129– The series of 116 body-colour drawings listed by
131, Finberg under the title 'Petworth Water Colours'
134, (CCXLIV) has long been recognised as one of the
135, most spontaneous and confident by Turner. They
137. range from highly detailed interiors such as Plate 130 to the most economical of impressions, as in *Teasing the Donkey* (CCXLIV 97). Reflecting the ease and spaciousness of life in the great house, they provide a very personal record of Turner's reactions to it: as Lord Clark has written so aptly, 'he set down in every scene, exactly what had touched or amused him, and nothing more' ('Turner at Petworth' in *The Ambassador*, August 1949). The paintings of Petworth interiors are just as personal, and it has been suggested that the *Interior at Petworth* (Plate 134) was painted by Turner in reaction to the news of Lord Egremont's death in 1837.

136. For a full discussion of the didactic qualities of this panel and of Turner's debt to Watteau see John Gage, *Colour in Turner*, pp. 91–2.

138. This work was probably painted for the architect John Nash, and was certainly in the sale of his pictures in 1835, when it was bought on behalf of John Sheepshanks. It is fully discussed by Graham Reynolds in 'Turner at East Cowes Castle' in *Victoria and Albert Yearbook*, 1969, pp. 75–8.

140. Graham Reynolds has suggested that this Venetian scene may have been inspired by those of Bonington, who had died in 1828 (*Turner*, 1969, pp. 158–60). It was recorded at the time of its exhibition that Turner's Venetian scene was painted in rivalry with the much younger William Clarkson Stanfield's *Venice from the Dogana*, also shown at the Royal Academy in 1833 and purchased by Lord Lansdowne.

142. The study connected with the *Hero and Leander* is on f. 57 of the 'Calais Pier' sketch-book (LXXXI), which Turner was using around 1802, and which includes studies for several other compositions such as the *Macon* (Plate 41) and *Hannibal* (Plate 57). Turner's prolonged use of this sketch-book is but one example of how essential his 'library' of sketch-books was for his painting.

143. The scene of this painting is on the Tyne. According to its first owner, Henry McConnell, it was painted at his suggestion as a contrasting companion to the Venetian scene which he had purchased at the Academy in the previous year. This was very probably the *Venice; Dogana and San Giorgio Maggiore*, now also in Washington (repr., Butlin and Rothenstein, *Turner*, pl. 98).

144. We know from Ruskin that this work was included in the first selection of paintings from the Turner Bequest temporarily exhibited at the National Gallery in 1857 (*Works*, XIII, p. 310). It was one of the very few paintings not exhibited during Turner's lifetime which was selected on that occasion. It is most instructive to compare this canvas with some of the great sea-pieces (such as Plates 11 and 32) of about thirty years earlier.

147, The Turner Bequest includes a number of un-
156. exhibited and incomplete Venetian compositions, among them two very faint impressions which were shown for the first time at the Turner Bi-Centenary Exhibition (Tate Gallery Nos 5487 and 5488).

148. In August 1869 Ruskin was appointed the first Slade Professor of Fine Art at Oxford. Some months previously he had sold some of his Turner drawings at Christie's, but had failed to sell *The Slave Ship*, which he now found 'too painful to live with'. However, in 1872 it was sold in America.

149, The romantic University city of Heidelberg, on
161. the Neckar, provided Turner with material for numerous drawings, several finished watercolours, and this canvas. In the finished works festive groups of figures play an important role, and it seems possible that Turner witnessed a carnival or other festival on one of his visits. In Plate 161 Turner has restored the castle which was partially destroyed in 1689, and the costumes suggest a seventeenth-century scene.

150, Much has been made of the symbolism, and re-
151. levance in Turner's philosophy, of this pair of canvases, which were both accompanied by melancholy lines from Turner's *Fallacies of Hope*. These points and the importance of Goethe's colour theories for Turner have been fully discussed by John Gage (*Colour in Turner*, pp. 173–88).

154. The large plates (each measuring 17 × 24 ins.) of *Ancient Italy* and *Modern Italy* were published in

1842, engraved by J. T. Willmore and W. Miller respectively. The story of these plates, in which Turner took a very active interest, is fully recounted by W. G. Rawlinson (*The Engraved Work of J.M.W. Turner*, Vol. II, pp. 338–41).

155. The location of this scene has·only been identified in the last few years; it was previously known as *Bridge and Tower*.

158. Turner stayed at the Hotel Europa during his last visit to Venice, in 1840 and possibly also on his earlier visits. The Turner Bequest includes many drawings and watercolours made from the hotel.

162, 163. There are still many unresolved questions in connection with the large number of Turner's later Venetian watercolour and body-colour studies in the Turner Bequest and in other collections. The problems have been succinctly summed up by Andrew Wilton on pp. 154–5 of the *Catalogue* of the Turner Bi-Centenary Exhibition. Ruskin was probably correct in suggesting that such drawings as those reproduced here were made on the spot, though Finberg believed that this applied only to the pencil outlines, which were coloured later.

168, 169, 180. Ruskin recounted his memories of the origin and execution of the 1842 and 1843 Swiss watercolours in the 'Epilogue' to the *Notes by Mr. Ruskin on his Drawings by the late J. M. W. Turner, R.A.*, published in connection with the exhibition of his collection at the Fine Art Society, New Bond Street, in March 1878. The 'Epilogue' did not appear until the third edition of this booklet, for Ruskin suffered his first attack of insanity in February 1878, and was unable to complete it in time for the opening of the exhibition. The 'Epilogue' was revised for the sixth edition. The fascinating and complex bibliographical story of these *Notes* and the 'Epilogue' is fully outlined in Volume XIII of the *Works* (pp. 393–402), where the text and all its variants are given on pp. 403–536. In view of the conditions under which the 'Epilogue' was written its reliability should perhaps be accepted with caution.

173. One of Turner's greatest vortex compositions, this canvas emphasises the hopelessness of man's struggle in face of the brute force of nature. It also demonstrates once again Turner's determination to record nature at first hand. In this instance he may have been deliberately emulating the example of the French painter Claude-Joseph Vernet, whose grandson, Horace Vernet, exhibited at the Salon of 1822 a large canvas showing his grandfather (sketch-book in hand) lashed to the mast of a ship to observe a storm. This episode in Joseph Vernet's life was first recorded in 1789, the year of his death. (The information about Vernet was communicated in an unpublished lecture by Philip Conisbee.)

174. Wilkie died on board the *Oriental* on 1 June 1841, and was buried at sea off Gibraltar at 8.30 that evening. *Peace—Burial at Sea* was painted in friendly rivalry with George Jones, R.A., whose own rendering of this melancholy scene was also shown at the R.A. in 1842, but is now known only in a watercolour version in the Brinsley Ford Collection.

175. This famous painting is the subject of John Gage's 'Art in Context' volume, *Turner: Rain, Steam and Speed*, published in 1972. Here the well-known account by Lady Simon of a train journey in wild weather when 'an elderly gentleman, short and stout, with a red face and a curious, prominent nose. . . jumping up to open the window [of a railway carriage], craning his neck out, and finally calling to her to come and observe a curious effect of light', is given little credence. The place recorded in the painting is the Maidenhead railway bridge, built to Brunel's design between 1837 and 1839, the subject of some controversy as it was considered unsafe by critics of the Great Western Railway. The chief railway event of 1844 was the opening of the Bristol and Exeter extension of the G.W.R., which more or less coincided with the opening of that year's summer exhibition at the Royal Academy. These and several other points show how very up-to-date Turner was in this famous 'document' of the railway age.

176. Three of the whaling pictures are in the Tate Gallery and one is in the Metropolitan Museum, New York. There are several studies related to these compositions in general terms in the 'Whalers' sketch-book (CCCLIII). John Gage has pointed out (Turner Bi-Centenary Exhibition *Catalogue*, B 109) that Turner's interest in whaling may have arisen as a result of his contacts with Elhanan Bicknell, one of the major patrons of his later years, who was a whaling entrepreneur.

177; 184-190. The village of Norham is pleasantly situated in the meadows on a bend of the River Tweed. At the far

end of the main street rise the splendid ruins of the Castle, once the chief northern stronghold of the Bishops of Durham. The steep bank of the river is to the north and west, and a deep ravine lies to the east. Turner first visited Norham during his Northern tour in the summer of 1797, when he made the rapid pencil study (Plate 184) in the 'North of England' sketch-book. He used this drawing in connection with the large watercolour study reproduced as Plate 186, which is very experimental in its use of washes and wiping out, and then executed two finished watercolours with similar compositions, of which one was shown at the Royal Academy in 1798 (No. 43), with a quotation from Thomson's *Seasons*. These two drawings are now in British private collections. Turner saw Norham again in 1801, when he passed through on his way to Scotland. On this occasion he made ten pencil studies of the castle, including Plate 185, in the 'Helmsley' sketch-book. Comparison of Plates 184 and 185 shows how simplified the later drawing has become; it concentrates on the outline of the castle against the sky, which is the principal feature in Turner's *Liber Studiorum* rendering of this scene (Plates 187 and 188). There is no evidence that Turner took up Norham between 1801 and his work on the *Liber* drawing in about 1815, and he certainly did not re-visit Norham between these dates. Nor had he been to Norham again before his next development of the subject, the glowing watercolour of Plate 189, which was engraved in mezzotint by Charles Turner in 1824 for *The Rivers of England* (Plate 190). In this drawing and plate the monochrome sombreness of the *Liber* version is replaced by brilliant colour and light. Turner was at Norham again in 1831, and there are drawings of the castle in the 'Abbotsford' sketch-book (CCLXVII). One of Turner's illustrations for Cadell's edition of Scott's *Prose Works* was *Norham Castle—Moonrise*, engraved in 1834 by William Miller (Rawlinson, No. 522); this is the only finished view of Norham in which the sun does not appear. The sun is an essential element in the two or three 'Colour Beginnings' in the Turner Bequest identified as being of Norham, and sunlight is, of course, the main theme of *Norham Castle, Sunrise* (Plate 177). This delicate and glowing canvas is the climax of all Turner's renderings of Norham Castle. It is usually dated *c*. 1835–40, but the later date suggested here seems more likely, for it was only in his final years that Turner achieved such total understanding of the qualities of colour and light.

180. Accompanied in the catalogue by two verses from Revelations, XIX, beginning: 'And I saw an Angel standing in the sun; and he cried with a loud voice'. The companion to Plate 180 in the 1846 Exhibition was entitled *Undine giving the Ring to Masaniello, Fisherman of Naples* (Tate Gallery, No. 549). Masaniello was a Neapolitan revolutionary, and it is difficult to find a link between the two pictures.

183. Originally painted in about 1809, *The Wreck Buoy* was sent down to London from Scotland by Mr. Munro of Novar, so that Turner could show it at the Royal Academy in 1849. When he saw it again Turner was dissatisfied with it, and anxiously watched by Munro, he re-painted it, though exactly to what extent is hard to determine. Turner did not alter his other R.A. exhibit of this year, the Titianesque *Venus and Adonis*, painted in about 1803 and also lent to him by Munro of Novar.

Bibliography

Many books about Turner have been published, but sadly few of these have added greatly to our knowledge of his art and life. A selection of the most valuable books and catalogues is listed here in chronological order of publication.

John Ruskin, *Modern Painters*, 5 vols., London 1843–60.
A classic, which, especially in its first volume, provides valuable insight into the work of Turner. It is included as volumes III to VII in the *Library Edition* of *The Works of Ruskin*, 39 vols., London 1903–12, which contains all his writings on Turner.

Walter Thornbury, *The Life of J. M. W. Turner, R.A.*, 2 vols. London 1862; 2nd edition, 1 vol., London 1877.
The first full-length biography of Turner. Though based partly on many contemporary reminiscences of the artist, this work has become notorious for its inaccuracies and distortions, which greatly influenced subsequent opinion on Turner.

Samuel and Richard Redgrave, *A Century of British Painters*, 2 vols., London 1866; 2nd edition, 1890; Phaidon Press edition, 1947.
Includes an excellent chapter on Turner, and is a mine of information about his contemporaries by an artist and a writer on art who knew them.

P. G. Hamerton, *The Life of J. M. W. Turner, R.A.*, London 1879.
A serious biography by a leading later nineteenth-century critic, now almost forgotten.

C. F. Bell, *The Exhibited Works of J. M. W. Turner, R.A.*, London 1901.
The first, rather dry, work of 'modern' research, which contains useful descriptions of works and details of provenance.

Sir Walter Armstrong, *Turner*, London 1902.
A huge and luxurious volume, which has a balanced text, useful illustrations, and list of works, still valuable though now out of date.

W. G. Rawlinson, *Turner's Liber Studiorum, a Description and a Catalogue*, London 1906; *The Engraved Work of J. M. W. Turner, R.A.*, 2 vols., London 1908 and 1913.
These comprehensive reference books provide the groundwork for the study of all the engraved work by and after Turner.

A. J. Finberg, *A Complete Inventory of the Drawings of the Turner Bequest*, 2 vols., London 1909.
An essential, though now sadly outdated, tool for working among the Turner Bequest drawings in the British Museum. Since its publication all references to these thousands of drawings follow the numeration established in the *Inventory*.

A. J. Finberg, *Turner's Sketches and Drawings*, London 1910.
The most scholarly of several contemporary illustrated publications.

National Gallery, Millbank (Tate Gallery), *Catalogue — Turner Collection*, London 1920.
A largely descriptive catalogue of the majority of the oil paintings in the Turner Bequest, and other paintings by Turner in the National Collections, and a list (based on Finberg's *Inventory*) of several hundred exhibited drawings and watercolours.

A. J. Finberg, *The History of Turner's Liber Studiorum with a new Catalogue Raisonné*, London 1924.
A handsome volume in which each plate is well illustrated in several states. It gives ample material for the study of the *Liber*.

A. J. Finberg, *In Venice with Turner*, London 1930.
Though now superseded in many of its conclusions this book contains useful illustrations and lists.

Bernard Falk, *Turner the painter: his Hidden Life*: London 1938.
Described as 'a frank and revealing biography' it is largely fictional, but includes a list of the books that Turner had in his own library.

A. J. Finberg, *The Life of J. M. W. Turner, R.A.*, Oxford 1939; 2nd edition, 1961.
The only full and reliable biography of Turner, based on the author's life-long study of the artist. It includes a good bibliography and a valuable list of Turner's exhibited works. The 2nd edition was revised by the author's widow, and has a supplement to the list of exhibited works.

Sir Martin Davies, *National Gallery Catalogues; British School*, London 1946; 2nd edition 1959.
The first edition includes full entries for over 100 paintings by Turner; the second for only 15.

Kenneth Clark, *Landscape into Art*, London 1949.
A stimulating book with a most sensitive appraisal of Turner.

Exhibition Catalogue, *J. M. W. Turner, R.A.*, Whitechapel Art Gallery, London, 1953.
The first major post-war exhibition. The catalogue includes a very useful chronological list of 'Turner's Travels in Great Britain and Europe'.

Martin Butlin, *Turner Watercolours*, London and Basel 1962.
A selection of thirty-two fine reproductions, supported by an informative introduction and excellent notes.

John Rothenstein and Martin Butlin, *Turner*, London 1964.
A succinct survey of Turner's career, based on a comprehensive selection of plates.

Mary Chamot, *The Early Works of J. M. W. Turner*, London (Tate Gallery) 1965.
Martin Butlin, *The Later Works of J. M. W. Turner*, London (Tate Gallery) 1965.
Two small picture books providing useful introductory texts and a selection of 30 reproductions each.

Lawrence Gowing, *Turner: Imagination and Reality*, New York 1966.
The well-illustrated catalogue, with a provocative text, of an exhibition devoted to Turner's late work held at the Museum of Modern Art.

Jack Lindsay, *J. M. W. Turner—His Life and Work*, London 1966.
Described as 'a critical biography' this presents Turner from a modern, and rather psychological, point of view. It is good on the part that literature and poetry played in Turner's work, on which the same author's *The Sunset Ship—The Poems of J. M. W. Turner* (Lowestoft 1966) is also useful.

Exhibition Catalogue, *Loan Exhibition of Paintings and Watercolours by J. M. W. Turner, R.A.*, Messrs. Thos. Agnew & Sons, London, 1967.
An outstanding exhibition held to mark the 150th Anniversary of Agnew's, the leading dealers in the works of Turner for over a century. Full catalogue entries compiled by Evelyn Joll.

Martin Butlin, *Watercolours from the Turner Bequest*, London (Tate Gallery) 1968.
A selection of 24 colour reproductions with a brief supporting text in English, German and French.

Luke Herrmann, *Ruskin and Turner*, London 1968.
A fully illustrated *catalogue raisonné* of the Turner drawings in the Ashmolean Museum, Oxford, with introductory chapters on 'Ruskin as a Collector of Turner Drawings' and 'Turner as a Draughtsman'.

John Gage, *Colour in Turner—Poetry and Truth*, London 1969.
A compilation of several studies in depth of various aspects of Turner's work, this is a book which provides much new material and thinking.

Graham Reynolds, *Turner*, London 1969.
A readable, balanced and well-illustrated account of the artist's life and work.

John Gage, *Turner: Rain, Steam and Speed*, London 1972.
An illuminating and scholarly study of this well-known masterpiece, in the 'Art in Context' series.

Exhibition Catalogue, *J. M. W. Turner*, Nationalgalerie, Berlin, 1972.
The standard foreign capital loan exhibition of paintings and drawings from the Turner Bequest enriched by a few loans from other sources.

Gerald Wilkinson, *The Sketches of Turner, R.A. 1802–20: genius of the Romantic*, London 1974.
A personal selection from Turner's early sketchbooks in the British Museum, with numerous, sadly misleading, reproductions.

A.G.H. Bachrach, *Turner and Rotterdam*, Rotterdam 1974.
Devoted to the reproduction of the sketchbook studies of Rotterdam of 1817, 1825 and 1841, many identified in detail for the first time. The introduction makes a good case for a re-evaluation of the Netherlands' place in Turner's work.

Gerald Wilkinson, *The Sketches of Turner, R.A. 1802–20: genius of the Romantic*, London 1974.
A sequel to *Turner's early sketch-books*; there is no improvement in the standard of reproduction.

Exhibition Catalogue, *Turner 1775–1851*, The Royal Academy, London, 1974–5.
Helpful introductory essay and comments by Martin Butlin, John Gage and Andrew Wilton. Some very full catalogue entries, especially for the paintings, with new information and ideas.

Index

INDEX OF NAMES